HOW TO FEED A STARVING ARTIST COOKBOOK

Favorite Recipes from Artists of the West

Compiled and edited by
Miriam Ross Wolf

Cover and chapter illustations by
Herb Mignery

Recipe artwork by
the Artists

MOUNTAIN PRESS PUBLISHING COMPANY
Missoula, Montana
1983

Library of Congress Cataloging in Publication Data
Main entry under title:

How to feed a starving artist cookbook.

 Includes index.
 1. Cookery, American—West (U.S.) 2. Artists—
West (U.S.) I. Wolf, Miriam Ross.
TX715.H8474 1983 641.5 83-17226
ISBN 0-87842-151-3
ISBN 0-87842-157-2 (pbk.)

Mountain Press Publishing Company
P.O. Box 2399
Missoula, Montana 59806

PREFACE

Random Thoughts on Feeding Artists

(Starving and Otherwise)

How to feed a starving artist? . . . quickly, probably . . . or regularly . . . or perhaps best of all, with love.

I have, in my time, fed a great many, if not starving, at least struggling artists — and a good number of successful ones as well. Everything from late-night spreads of scrambled eggs with green chilies to full blown Mexican fiestas with chicharones and cabrito.

During the years when I was involved with the Desert Southwest Art Gallery in Palm Desert, California and Trailside Galleries in Jackson, Wyoming, I showed the works of more than a hundred living artists and I did so with considerable pride. There were many occasions when artists shared room and board with me and my children. They forgave a good many hastily-put-together meals, because they knew they were most welcome and that we shared a common bond and interest. The fact that most of those hundred-plus artists are still my friends says something nice — either for my food, my loyalty or their sincere appreciation for efforts I was able to make on their behalf. I believe caring is more important when one is breaking bread with artists (or anyone else) than all the gourmet meals in the world.

In considering how one should feed an artist, one should be more aware of the appearance of food than we often are. I learned early in life, from an exceedingly good cook, that a meal of pork roast, rice and lightly buttered cauliflower may be tasty, but it still needs the addition of cinnamon apples or pickled beets and a sprig of parsley to present a picture-perfect plate that stimulates the eye as well as pleases the palate. Everyone enjoys food when it is appealing to the eye, but artists are more sensitive to this quality than most folk. No matter how ravenous an artist might be, in my experience, he or she will be more appreciative of food that is colorful and imaginative in its presentation.

I had the distinct pleasure of hosting the very first trailride banquet of the Cowboy Artists of America which was held in a big teepee in Jackson Hole. We had cowboy steaks, ranch beans and old-fashioned apple dumplings. It was a far cry from the sumptuous — and sometimes elegant — spreads the CAs have these days on their annual ride and get-together. But we were all so enthusiastic about the newly-formed organization and were so embued with the possibilities of its success that few of us who shared that night will ever forget it.

I have, on occasion, let my enthusiasm outweigh my better judgment about a supper party. During the early days in Jackson, I lived with my two youngest children in a 30-foot Airstream trailer. One night I invited Mae and Olaf Wieghorst, Joanne and Wayne Hennes and Bill Zimmerman to share a meal. The three men all weighed over 200 pounds each and stood at least 6'3" or more! When I finally got them all wedged into the dining nook of that trailer, it was a wonder that it didn't tip up on its end! It turned out to be what is fondly known as a very 'intimate' gathering! The food was

good and plenty of aquavit and beer soon belayed any complaints about crowded quarters!

We had the first one-man show that Brownell McGrew had held in many years at the Desert Southwest Art Gallery in the spring of 1967. The exhibit included 35 pieces and it was an eagerly awaited event, to say the least. Over 1000 patrons and friends came for the preview reception, staying late to admire and talk and buy. Finally, when the last guest had reluctantly departed, I took Brownie, his wife Ann, his daughter Jill and my daughter Amanda to the Shadow Mountain Club for a quiet dinner. I ordered a double Jack Daniels (much needed after a long and demanding day!) and four Shirley Temples for my non-alcohol-drinking guests. The waitress brought the drinks, placed mine first and then passed the tall, frosty pink punches to Ann and the girls. As she set the last drink in front of Brownie — a giant of a man — she took one look at him and said, "If I had known this was for you, I would have brought you a *Roy Rogers!*"

The staff of life for me has not been bread — although I am greatly addicted to the wonderful crusty rolls that come from Bavarian kitchens. Rather, the support of my life has been the wonderful friends with whom I have been blessed. I know of few things I would rather do than gather some of them around my table, share good food, stimulating talk and warm companionship. I have long said that cooking was the only creative activity I engage in. For many years I have been surrounded by many artistic and talented people and it has given me incentive to improve and expand any talent I might have in the culinary area — one place in which I have come out ahead of all those talented artists I've known! There are very few of them who do not have some very early and perhaps "not-so-successful-artworks" out in the market place, floating around, being a source of distress! And I? Well, my creative efforts are long gone — subject only to the criticism that they have left an extra pound or two in scattered places!!

Written on the Orient Express
between Meunchen and Wien,
on a sere November day

Ginger K. Renner

INTRODUCTION

It would seem that any human activity as common and time consuming as the preparation of food would long ago have made culinary experts of us all. But, alas, we have only to recall a few of the many disappointing trips from plate to palate to admit that in the cook's kitchen, as in the artist's studio, practice does not necessarily make perfect.

Although gourmet perfection is an elusive victory partially dependent on the variables of garden and grocery, many of us believe it deserves more effort than we usually give. Like an artistic masterpiece, a winning dish begins with planning, and in the case of cooking, that plan is called a recipe. The bringing together of such plans for victory in the kitchen has been the goal and challenge of this cookbook's creator, Miriam Ross Wolf. The initial idea for the book came on her way home from an art show in 1979. From then on she was determined to see it through and despite discouragement and delays, she never gave up. Fortunately for all of us reconstructed chow hounds and enthusiastic art lovers, the end result is this unique, informative and entertaining cookbook.

Miriam was born and raised in the farming community of Greenville, Texas, where good food and pretty girls abound. She enjoyed a variety of occupations until 1974 when she discovered and totally committed her career to the field of Western and wildlife art, first, during her tenure at Texas Art Gallery in Dallas, Texas and later at Altermann Art Gallery, also in Dallas, where she met and eventually married wildlife sculptor, Bob Wolf. Together with her son, Alex, they now live in their beautiful studio home in northern Colorado. There among the deer and raccoons, owls and eagles, they have found a paradise in nature, protected by the rugged red cliffs of Owl Canyon. In this idyllic atmosphere, Bob's work has been inspired and Miriam has found encouragement to pursue her free-lance writing and art sales career.

Painting, writing, sculpting and singing are all art forms which we recognize as art, but they are not the only means of creative expression. Cooking is also an art, and although married to an artist, Miriam is not repressed in her own creativity. It emerges daily from her aromatic kitchen, where she delights in originating and testing recipes. Family and frequent guests acclaim the good food in the Wolf house, where after dinner stomach-patting is a born-again ritual!

When Miriam asked me to write this introduction, she also requested my favorite recipe, so that she could include it with the others in this cookbook for starving artists. I have such a recipe, but it is not for food and it is not concocted in the kitchen. It is an art collector's recipe for *Un Artiste Fin* (One Fine Artist), and I have been testing it at Leanin' Tree for a third of a century. It is a recipe to please the eye and not the palate, a recipe which calls for a raw, starving but talented artist and eventually serves him up as a successful and accomplished fine artist to a hungry and appreciative public.

There is no mystique to the creation of a great piece of art, just as there is not to the preparation of a succulent stuffed quail. Both are the result of human endeavor, but when done by a master, they are somehow

elevated to a level beyond the ordinary, to be savored and remembered. Is that not a goal lofty enough for an artist or cook, to bring joy and pleasure to those who would view or taste the finished creation? As was first said about all good food by Curnonsky, the Prince of Gastronomes, "a good soup must taste of all the things of which it is made." Likewise, a painting or sculpture testifies to its own artistic ingredients, and does not fool for long by size or frame, price or patina.

The preparation of *Un Artiste Fin* commences with years of study. Acquiring the basics of drawing, form, composition and color is not unlike gathering the freshest of vegetables and tenderest of meats, and the selection of proper herbs and spices. An artist friend of mine once referred to his years of grinding out small, low-priced paintings as essential "factory time." To me that compares to the evolutionary, hand-me-down training a good cook often gets as a child. Would we expect a person who had never spent time in a kitchen to prepare a delicious seven-course dinner? The idea is preposterous, but no more so than the "overnight" conversion of carpenters and cowboys to sculptors and painters.

Just as a gourmet cook is constantly referring to recipes and searching out new and innovative ways to prepare the same basic foodstuffs, so must a fine artist continue to maintain his library of references and collection of material. The artist needs to be "eating out" in the studios of great artists, constantly searching for that elusive perfection and must be willing to learn from his peers and the masters. Perhaps most importantly, the fine artist will have learned to look at his own work and know when his "recipe" has flopped. And, rather than serve less than his best, will toss it in the garbage and try again. That requires the rare courage and determination which are the final ingredients in my recipe for *Un Artiste Fin*!

Followed closely, and even with minor adaptations, my recipe will bring success to the starving artist. To bring happiness to the artist's table, just follow these recipes from our many mutual friends in western and wildlife art. Congratulations to Miriam Wolf for bringing together this magnificent collection. As I travel through our country visiting old friends and new in my lifelong quest for good art, I look forward to never having to eat in another restaurant!

Ed Trumble

Ed Trumble, President
Leanin' Tree Publishing Co.

TABLE OF CONTENTS

ACKNOWLEDGMENTS

I am especially grateful to all the participating artists and their spouses who gave so unselfishly of their time and talents by sharing their exceptional ideas, recipes and artwork. Also kudos to Herb Mignery for the delightful cover and chapter illustrations. My husband, Bob and my son, Alex, deserve special recognition for their support and patience — and for their promotion of the book above and beyond the call of duty. (They also happily taste-tested many of the dishes and gave them their wholehearted seal of approval!)

A very special thanks goes to all collectors and supporters of Western and wildlife art for their continued patronage and encouragement which "feeds" many a starving artist!

The following recipes are the artists' personal favorites — to be looked forward to, enjoyed, shared with good friends and remembered with pleasure. May they each bring you love at first bite!

Good fortune and good eating,

Miriam Ross Wolf

Chapter I

PRELIMINARY SKETCHES

Appetizers
Dips
Beverages

Appetizers

Olga and Paul Calle
Stamford, Connecticut

Paul Calle has achieved considerable recognition for his finely detailed oil paintings and pencil drawings. His selection as an official artist of the National Aeronautics and Space Administration's Fine Art Program gave him the unique opportunity to record the achievements of the U.S. Space Program. Later, as Chairman of the Department of Interior's "Artists in the Parks" Program, he traveled widely throughout the West. His imagination was stimulated by the majesty of the Western scenes he saw and to Paul, his portrayals of the West in art are a realistic challenge and a personal commitment to depict America's past with the same sense of history that guided his hand while recording our nation's space explorations. In addition to major corporate and private collections, his work is in the permanent collections of many fine American museums and, under the auspices of the U.S. Information Office, his paintings and drawings have been exhibited at museums in Poland and the U.S.S.R. He is the recipient of the Franklin Mint Gold Medal for Distinguished Western Art and is the author of "The Pencil" published by Watson Guptill, now in its sixth printing. He is also a founding member of the Northwest Rendezvous Group and as a participant has been a consistent award winner.

Crab Mold

- 1 can Tomato soup
- 1 8-ounce package cream cheese
- 1 package Knox gelatin
- ¼ cup cold water
- 1 6½-ounce can crab meat
- 1 cup mayonnaise
- ¾ cup chopped celery
- ¾ cup chopped onion
- 1 teaspoon Worcestershire sauce
- ¼ teaspoon Lawry's seasoned salt

Heat soup; add cream cheese and mix with wire whisk. Soften gelatin in ¼ cup cold water, then add to soup mixture. Add rest of ingredients. Spray a mold with Pam or grease lightly with salad oil. Pour mixture into mold and refrigerate overnight. Unmold and serve with crackers or party rye bread.

"We served this to a large group of artists and their spouses in the midst of a lively discussion about techniques and paintings in progress. *After* it was consumed, conversation resumed with vigor."

5

Marilyn and Robert K. Abbett
Bridgewater, Connecticut

One of America's contemporary art masters, Bob Abbett is skilled in the genres of western, sporting and portrait art. With degrees from Purdue and the University of Missouri and studies at the Chicago Academy of Fine Arts as a background, he has illustrated an impressive number of books and has exhibited at the Society of Illustrators. Widely recognized for his characteristic dog portrayals, Abbett has been featured in the January, 1982 issues of Sports Afield *and* Gun Dog *magazines. He is a member of the Society of Animal Artists and the Society of Illustrators. On several occasions he has been selected to design conservation stamps such as the Second Annual Buzzard and the First Annual Trout Unlimited Stamp prints in 1981 and the Turkey and Ruffed Grouse Stamp prints in 1982. Currently residing in Connecticut, but originally from the Midwest, the Abbetts own a second home and studio in Arizona where Bob is able to research his western creations more fully. His work is in the permanent collections of the Old West Museum in Cheyenne, Wyoming and the Cowboy Hall of Fame in Oklahoma City.*

Chicken Liver Pate

- ■ **1 pound chicken livers**
- ■ **1 medium onion, chopped**
- ■ **2 Tablespoons butter**
- ■ **2 Tablespoons vermouth**
- ■ **salt and pepper to taste**
- ■ **2 hard boiled eggs, chopped**
- ■ **2 Tablespoons parsley, chopped**

Drop chicken livers into boiling water to cover and simmer until barely done. Drain. Chop onion in food processor. Add butter, vermouth, salt and pepper. Blend until smooth. Fold in eggs and parsley.

"If I come in from a hunt empty-handed, adding this to the cocktail hour does wonders for my bruised disposition."

Patricia Warren © 1961

Salmon Loaf

- ■ 1 cup pink salmon
- ■ 1 8-ounce package cream cheese
- ■ 1 Tablespoon minced onion
- ■ 1 teaspoon Horseradish
- ■ 1 teaspoon Worcestershire sauce
- ■ 1 dash Liquid Smoke
- ■ parsley
- ■ pecans

Blend all ingredients and chill in mold. Unmold and top with parsley flakes and pecans.

"I have served this delicate blend of fish and cheese to many a starving artist. Each has appreciated its light texture and flavors. It is excellent served just before a main course of two-inch-thick T-bone steaks grilled over a mesquite fire!"

Patricia Warren and Ken Johnson
Fort Worth, Texas

Throughout the history of art, artists have been captivated by the female form as subjects for their paintings and sculpture. Patricia Warren is one of those artists. Be it an old German woman selling flowers at a market in Frieberg, the proud Navajo grandmother watching her young granddaughter dance her first ceremonial dance at the Santa Clara Pueblo or a mature and sensual hostess charming a guest at her inn in the French countryside, the women Patricia portrays bespeak an earthy quality of strong character, pride and beauty. Pat received her art education primarily by osmosis from those artists she follows and admires. While she attributes contemporary tutoring to her father, Melvin C. Warren, and Ramon Froman, she feels she is very fortunate to be associated with many great artists of this era. "I ask them often for advice and guidance. They provide much of the technical knowledge and keep the spark ignited." She works in a variety of media including oil, charcoal and pastel with an emphasis on bronze. Her newest efforts in stone carving came about after much encouragement from New Mexico sculptor Allan Houser. "The stone," Pat says, "is a strong disciplinarian. It frees a sculptor from becoming obsessed with modeling and gets him back to basics — line and form."

Sharon and Grant MacDonald
Kerrville, Texas

Grant MacDonald began drawing when he was a small boy and, with encouragement from his parents, studied art throughout his academic career. He received a Bachelor of Fine Arts degree from the University of Mississippi and a Masters degree from the University of Texas at Austin. He began painting professionally in 1971 and has gained well-deserved recognition for his sensitive and realistic paintings of wildlife, contemporary western scenes, landscapes and portraits.

The "Now Famous" Cheese Ring

- 1 pound sharp Cheddar cheese, grated
- 1 cup pecans, chopped
- ¾ cup mayonnaise
- 1 medium onion, grated
- 1 clove garlic, pressed
- ½ teaspoon Tabasco
- 1 cup strawberry preserves

Combine first 6 ingredients and mix well. Mold into a ring. Fill center with strawberry preserves. Serve with crackers.

"An interesting and delicious combination of flavors!"

JAMES BOREN

western *...artist*

Mary Ellen and James Boren
Clifton, Texas

James Boren was born in Waxahachie, Texas. After serving in the U.S. Navy and Marine Corps during World War II, he went on to receive his Bachelor and Master of Fine Arts degrees from the Kansas City Art Institute. After graduation, he taught in the Fine Arts department of St. Mary College near Leavenworth, Kansas for three years. An important step in his career was when he became the first Art Director of the National Cowboy Hall of Fame in Oklahoma City. He has been a member of the Cowboy Artists of America since 1968, having served as President for two terms and as Secretary-Treasurer and Director. To date, he has received nine gold medals and eight silver medals in a variety of media at the CAA's annual competitions and also received the Colt Award in 1977. Jim was selected "Artist of the Year" for the state of Texas in 1976. He is a member of the Grand Central Galleries in New York, the Art Council for the Western Heritage Sale in Houston, Texas and the Board of Trustees for the CAA's Museum in Kerrville, Texas. He is also the subject of the book James Boren: A Study in Discipline published by Northland Press.

Beer Batter Onion Rings

- 1½ cups all-purpose flour
- 1 teaspoon salt
- 1½ cups beer
- 3 large onions, cut into ½" slices
- hot salad oil
- salt to taste

Combine flour and 1 teaspoon salt; stir in beer and beat until smooth. Let stand three hours. Separate onion slices into rings; dip into batter and fry in 2 inches of hot salad oil (375 degrees) until golden brown (about 3 to 5 minutes). Sprinkle with salt and place in a 200 degree oven until ready to serve. Makes 6 servings.

Note: Cooked onion rings can be frozen and reheated in a 400 degree oven until crisp (about 15 minutes).

"These onion rings are good with anything, but are especially good as an appetizer or served with steak or hamburgers."

Debbie and Mort Künstler
Cove Neck, New York

Mort Künstler has gained considerable recognition for his historical illustrations. The son of an amateur artist, he spent three years as an art major at Brooklyn College, where he also became a four-sport letterman, and then a year at UCLA before returning to his native Brooklyn to complete his formal art training at Pratt Institute. Mort met his wife Debbie, now a successful Interior Designer, at Pratt and she left school to support them until Mort's career was launched. Mort began doing illustrations for hardcover books and paperbacks involved with historical illustration, dealing with World War II themes and others. A turning point in his career was when he became associated with National Geographic. He also did posters for movies, such as "The Hindenburg" and "The Poseidon Adven-

ture," and other work such as cover illustrations of Patty Hearst and the Mayaguez rescue mission for Newsweek. He began to sell the original art work. "It was a bonus that I could sell the originals," he explains, "An illustration, if the subject matter is right, is a painting." He has had several successful one-person shows and a book of his art 50 Epic Paintings of America was published by Abbeville Press in 1979. Mort's career got another unexpected boost when he was chosen to create a series of paintings of the space shuttle by Rockwell International, the prime contractor to NASA for the project. His paintings are included in numerous museums and he is also included in a number of books on American Art. Among the most noteworthy is Great American Illustrators by Walt Reed.

Ceviche Mananitas

■ 1 pound raw fish fillets (sole or flounder) cut into 1"x½" pieces

■ 1 pinch salt

■ 2 Tablespoons lemon juice (or juice of one lemon)

■ 1 cup white vinegar

■ 1½ cups tomato juice

■ 2 Tablespoons catsup

■ 1 teaspoon Worcestershire sauce

■ 1 large onion, chopped

■ 1 large tomato, chopped

■ Tabasco sauce to taste

■ 1 Tablespoon olive oil

■ ½ teaspoon oregano

■ 20 small green olives, stuffed

■ ½ pound cooked, shelled shrimp

■ 1 4-ounce can green chiles, chopped

Marinate fish pieces in salt, lemon juice and white vinegar overnight. Next day, add all other ingredients. We like it spicy so I add a lot of Tabasco sauce. Add it gradually until it suits your taste. Stir it all together. Let stand in refrigerator another day and then serve.

Note: I serve it in shrimp cocktail glasses with saltines. Eat with a teaspoon instead of a fork. It improves with age, so don't be concerned about leaving it in the refrigerator for several days. In fact, the older, the better!

"We lived in Cuernavaca, Mexico for two years and our favorite restaurant was Las Mananitas. We ate there twice a week and we always had Bob Krauss' Ceviche. I finally asked him for the recipe and have made a few changes through the years. For instance, the addition of the shrimp was my idea, and, of course, I have to use whatever chiles I can find on Long Island! The Mexican version is much stronger — that's why I have to spice it up with Tabasco. At any rate, it's a favorite around here and my greatest pleasure was when a Mexican couple asked me for the recipe! That's the height of flattery!

Nancy Boren
Clifton, Texas

Nancy Boren remembers that during her grade school days her dad was always very good about letting her, along with her brothers, play around the studio while he was working. Over the years, she began to sketch and paint and after high school, entered Abilene Christian University where she received her Bachelor of Fine Arts degree. She has exhibited her work in Oklahoma, Texas and Arizona and is a member of the Southwest Watercolor Society. She enjoys working in oils and drawings as well as watercolors.

Pickled Mushrooms

- ⅓ cup red wine vinegar
- ⅓ cup salad oil
- 1 small onion, thinly sliced and separated into rings
- 1 teaspoon salt
- 2 teaspoons dried parsley flakes
- 1 teaspoon prepared mustard
- 1 Tablespoon brown sugar
- 2 6-ounce cans mushroom crowns, drained

In small saucepan, combine all ingredients except mushrooms. Bring to boil. Add mushrooms. Simmer 5 to 6 minutes. Chill in covered bowl several hours, stirring occasionally. Drain and serve. Makes 2 cups.

"Very good served alongside a dish of marinated artichoke hearts or fresh carrot and celery sticks — great for cocktail parties."

Miriam and Bob Wolf
Laporte, Colorado

Bob Wolf's bird and wildlife bronzes have earned him a position of prominence among wildlife artists of today. He calls his art "Wildlife Moments" and they depict his thoughts, experiences and dreams of yesterday, today and tomorrow. His art is his way of communicating much of the best of his life to others who may or may not have enjoyed similar times. He says, "I try to capture the spirit or mood of an event — a reflection — a fleeting glimpse — of a moment to be remembered that I may never see again." Bob credits the launching of his art career to successful shows and collector support he received in the early '70s. While he also enjoys working in watercolor and oil, he devotes a great deal of his talent and effort to wildlife sculpture. His original works are first sculpted in wax or clay, then cast in bronze. His bronzes are cast in small, limited editions and are signed, numbered and dated. Bob's work has an honesty and exactness of detail, yet manages to portray the individual personalities of the birds and mammals he skillfully sculpts. Each piece depicts his deep reverence for wildlife while conveying beauty, poignancy or humor. Bob gets many of his inspirations from the area in which he and his wife Miriam live, located near the rugged red rock cliffs of Owl Canyon overlooking scenic Bonner Peak in Northern Colorado.

September Sunset
- 1 large can bean dip, warmed
- 1 4-ounce can green chilies, chopped
- 1 5¾-ounce can black olives, chopped
- 3 eggs, hard boiled
- 1 recipe of your favorite avocado dip
- 4 ounces Cheddar cheese, shredded
- 1 large tomato, chopped
- Nacho chips or your favorite corn chips
- sour cream (optional)

Arrange chips on heat-proof serving platter. Spoon on warmed bean dip, then spread avocado dip on top. Sprinkle with chilies, olives and cheese, in that order. Broil until cheese is bubbly and light brown. Garnish with eggs and tomato. Dollop sour cream on top and then get ready to make another batch!

"We discovered this recipe at the 1980 MONAC art show in Spokane, Washington. It is so good, you can't eat just one! Thanks to Colleen Brandon for sharing it with us."

Artists of the Rockies and the Golden West

Betty Harvey-Manson and John Manson
Colorado Springs, Colorado

The first issue of Artists of the Rockies *was published in December, 1973. John, having been involved in advertising since the time of his early art training in Milwaukee, observed on his frequent trips to Santa Fe that there was a lack of available art magazines, especially those that featured the realism of the Southwest, and decided to fill this void. The magazine was well received and in 1975 it was awarded a Gold Medal for the Best Western Art Magazine by the prestigious National Academy of Western Art at the Cowboy Hall of Fame in Oklahoma City. Because of the strong interest from the Western states, Manson broadened the magazine's scope and changed the title to* Artists of the Rockies and the Golden West. *Now, readers from all over the world enjoy the articles which feature some of the finest artists and art available in this country. The magazine is referred to in art circles as "the collectors' magazine." Betty, the associate editor, has been with the magazine since its inception.*

Stuffed Mushrooms Parmigiana

- 50 small or 25 medium fresh mushrooms
- 2 Tablespoons butter
- 1 medium onion, chopped
- 2 ounces pepperoni, diced
- ¼ cup green pepper, finely chopped
- 1 small clove garlic, minced
- 12 Ritz crackers, finely chopped
- 3 Tablespoons Parmesan cheese, grated
- 1 Tablespoon parsley, snipped
- ½ teaspoon seasoned salt
- ¼ teaspoon dried oregano, crushed
- dash pepper
- ⅓ cup chicken broth

Wash mushrooms and remove stems. Finely chop stems and reserve. Drain caps on paper towels. Melt butter in skillet; add onion, pepperoni, green pepper, garlic and chopped mushroom stems. Cook until vegetables are tender but not brown. Add cracker crumbs, cheese, parsley, seasoned salt, oregano and pepper. Mix well. Stir in chicken broth. Spoon stuffing into mushroom caps, rounding tops. Place caps in shallow baking pan with ¼" water on bottom. Bake, uncovered, for about 25 minutes in 325 degree oven.

"This recipe is also excellent as a main course or side dish. Just use large mushrooms (approximately 12). Your guests will think you're a real gourmet cook when you serve this one!"

Dips

Carolyn and D. G. Hines
Jackson, Wyoming

Don Hines is a Wyoming native, born and raised in Casper, who has lived and worked in Jackson since 1967. Trained as a painter, sculptor and goldsmith, he devotes a great deal of his time to working with and creating one-of-a-kind jewelry pieces. He approaches his craft as sculpture in miniature, working in gold with a combination of diamonds and precious gems. Recently, he has begun to spend more time creating new paintings and bronze sculptures. He and Carolyn have a shop on the Town Square in Jackson which features his work.

Tomato and Green Chile Salsa

- 1 28-ounce can whole tomatoes
- 2 jalapenos, tops and seeds removed
- 1 slice of large onion
- 1 clove garlic
- 1 4-ounce can green chilies, diced
- 1 teaspoon dill weed
- ¼ teaspoon cayenne pepper
- generous pinch oregano

Drain tomatoes. Put tomato liquid, two jalapenos (more if you like it hotter), onion and garlic into blender and blend well. Add tomatoes, green chilies, dill weed, cayenne and oregano. Blend briefly so that mixture remains rather chunky. Heat on low to mix flavors. Do not boil. Will keep refrigerated for a week or more.

Jalapenos come 6 or 8 to a can. The tops and seeds should be removed and unused peppers stored in a jar (without metal top) or plastic container with fresh water and ½ teaspoon vinegar. They will last for several weeks and are ready for use this way.

"This salsa is excellent heated and served with chips, burritos, rellenos or used in guacamole, meatloaf, etc."

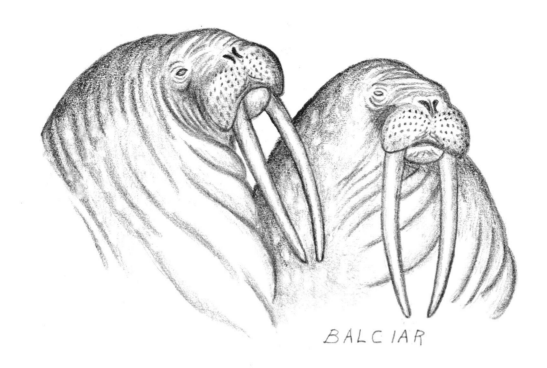

BALCIAR

Bonnie and Gerald Balciar
Arvado, Colorado

Gerald Balciar was born in Wisconsin and moved to the Denver area at the age of 19 where he still resides with his wife Bonnie and their three children. He worked in the taxidermy profession until 1973 when he began working with bronze and marble sculpture full time. He has had no formal art training, but devotes much of his time to the study of wildlife and its habitat. He recently completed a magnificent 14' bronze statue of an elk which is located at the Wildlife World Museum in Monument, Colorado. He is an award-winning member of the National Sculpture Society and a member of the Society of Animal Artists.

Hot Sauce

- ½ bell pepper, diced
- 1 medium onion, diced
- 2 stalks celery, diced
- ½ of whole jalapeno pepper
- ½ teaspoon salt
- ½ teaspoon pepper
- ½ teaspoon garlic salt
- 1 10-ounce can tomatoes with green chilies
- 1 16-ounce can whole tomatoes, drained
- 1 cup catsup

Put bell pepper, onion, celery, jalapeno pepper, salt, pepper and garlic salt in blender. Add juice from the can of tomatoes with green chilies and blend briefly, just to mix. Add the tomatoes with green chilies and the *drained* can of whole tomatoes, peeled. Blend just to mix. Stir in 1 cup of catsup. If you wish, add ½ cup finely diced celery, bell pepper, and onion to give sauce body. Do not blend. Refrigerate any leftover sauce.

"We have enjoyed eating a hot sauce at our favorite Mexican restaurant for many years and wanted to make our own version. After analyzing a few take-out orders, we came up with this recipe which is even more pleasing to our palates. We use it as a dip with nacho cheese-flavored chips and it's also good on tacos, tostados, burritos and omelets."

Ina and Fritz White
Loveland, Colorado

Fritz White's multi-faceted talent is clearly visible in each of his dynamic bronzes. They reflect his understanding for the true essence of the West and the heritage etched into the faces of his characters. His skillful blending of spiritual and historical authenticity is readily recognized and enjoyed by many western art lovers and collectors. Born and raised in Milford, Ohio near the Little Miami River, Fritz grew up with three of his favorite things in life; drawing, football and a canoe. After completing his formal art education, he worked as a commercial artist, direct mail specialist and manager of a trade publishing firm before pursuing a fine art career in 1962. Over the next ten years, he established himself as one of the finest contemporary sculptors of the American West. In 1973 his dramatic bronze compositions earned him a membership in the Cowboy Artists of America. He was further honored by his fellow CAA members with the "Best of Show" Award and the Gold Medal for Sculpture in 1974, the Silver Medal for Sculpture in 1975 and 1981, and the Gold Medal for Sculpture again in 1982. He and Ina, along with four children, make their home in Loveland, Colorado where he is in the process of restoring and preserving a 75-year-old church and adjoining Sunday school and house, to be used as "live-in studios" for other artists moving into the area.

Spinach Dip in Sheepherder's Bread

- ■ 1 10-ounce package chopped spinach (thawed and well-drained)
- ■ 1 cup sour cream
- ■ 1 cup mayonnaise
- ■ 2 Tablespoons chives or onion flakes
- ■ 1 teaspoon dill weed
- ■ 1 teaspoon oregano
- ■ 1 teaspoon seasoned salt

Mix all ingredients. Cut off top of Sheepherder's bread and scoop out center. Line with cabbage leaves. Put spinach dip in center. Use top and sides (broken into pieces) for dipping.

Note: Mary and Vern Tossey have a wonderful Sheepherder's Bread recipe in Chapter IV that is great with this dip!

Charmalee and Don Prechtel
Creswell, Oregon

Don Prechtel, a native Californian and mostly self-taught artist, works out of his home/studio in Oregon as well as co-producing and directing the Oregon Trail Western Art Show and Auction in Eugene, Oregon. He teaches oil painting at Lane Community College in Eugene and travels the region in search of settings for his paintings, many of which carry historical themes. This busy artist has received many awards for his efforts and is a founding member of the Northwest Rendezvous Group. Don says, "All my energies and efforts channel toward one goal: to put into my art the people I've met, the places I've been and the things I've done. Personal travel and observations converge to produce what I hope is a glimpse into our American heritage, past and present."

Cottage Cheese Dip

- ■ 1 pint cottage cheese
- ■ 1 teaspoon onion salt
- ■ 2 teaspoons Worcestershire sauce
- ■ ½ teaspoon Horseradish (fresh is better; can use dehydrated)

Mix thoroughly. Let stand for 30 minutes before serving.

"A quick and easy dip to serve with crackers or vegies. It came from my mother-in-law, Eileen O'Neil."

Chipped Beef Dip

- ■ 1 8-ounce package cream cheese
- ■ 2 Tablespoons milk
- ■ 1 2½-ounce package chipped beef cut into small pieces
- ■ 2 Tablespoons green onion, chopped
- ■ ⅛ teaspoon pepper
- ■ 1 cup sour cream
- ■ ½ teaspoon Worcestershire sauce
- ■ dash lemon juice
- ■ dash garlic salt
- ■ 1 2-ounce jar pimientos, drained and chopped
- ■ ½ cup walnuts, chopped

Margaret and Bob King
Helena Arts Council
Helena, Montana

The Helena Arts Council sponsors the annual Western Rendezvous of Art shows held each August in Helena, Montana. The untiring efforts and dedication of this council have made possible shows which rank among the top art exhibitions in the country. The Helena Arts Council also sponsors a fall festival of the arts known as Electrum, an arts scholarship "Shakespeare in the Park," and an on-going program of promoting the artistic and cultural climate in their area.

In saucepan, blend cheese and milk until cheese is melted. Stir in rest of ingredients except pimientos and walnuts. Remove from heat, add pimientos. Pour into bowl; sprinkle with walnuts and serve. You can do this on top of the stove or heat in the oven at 350 degrees for 15 minutes. Serve hot with chips or crackers. Note: You can also thin this recipe with more milk and serve on toast or biscuits.

Beverages

Mitch Billis
Boothbay Harbor, Maine

Mitch Billis was born in upstate New York, educated at Clarkston College and the University of New Hampshire. He came West and earned his doctorate in mathematics from the University of Utah. He then taught that subject at Montana State University in Bozeman, Montana for eight years. He began painting in 1972, with no formal art training and only intermittent study with other artists. In 1976 Mitch resigned his professorship to become a full time artist, a decision which has obviously paid off. He has won numerous awards and in 1978, the American Watercolor Society selected one of his paintings for its traveling exhibits. A member of the Northwest Rendezvous Group, this fine watercolorist is consistently invited to participate in national juried shows, including those of the prestigious American Watercolor Society.

Best Hot Buttered Rum

- 2 ounces dark rum
- 2 Tablespoons maple syrup
- 1 Tablespoon butter
- 8 ounces hot water
- dash nutmeg

Cover rum, maple syrup and butter with hot water. Sprinkle nutmeg on top, to taste. We make our own maple syrup, so we can afford to be generous with it!

"I recall reading a recipe for hot buttered rum once when I was young, (I think it was in *Northwest Passage*), that is the best one I've ever found. Dark rum, pure maple syrup and a fistful of butter topped with a sprinkle of nutmeg really hits the spot on a cold Maine day. The proportions of the above ingredients can be varied to suit your taste."

Laura and Hawley Woolschlager
Omak, Washington

Laura Woolschlager began her formal art training at the age of seven at the Catherine Lord Studio in Evanston, Illinois, continued at Redlands University in California and received her B.A. degree (magna cum laude) in painting and design from Syracuse University. She is the recipient of numerous awards and is a member of the American Artists of the Rockies Association. Her work has been exhibited extensively throughout the West. "My paintings are images of the West, a contemporary view of past and present. Rather than literal portrayals of a people, the land or the wild, my intent is the visualization of a common spirit not bounded by regional or racial exclusivity. The selection of subject is the means by which the dimensions of the idea are conveyed. If only the subject is perceived there is a picture, but there is no art. To communicate through color, form and line is a demanding, unending, but equally exciting and joyous process."

Strawberry Champagne

- **1 quart fresh strawberries (wild ones if you can find them)**
- **½ cup powdered sugar**
- **1 cup champagne (or white wine)**
- **sprigs of fresh mint**
- **1 bottle champagne (does not have to be an expensive brand)**

Hull strawberries and cut in halves. Place in glass bowl; sprinkle with powdered sugar and drizzle 1 cup of champagne (or white wine) over top. Chill for about an hour. Anticipate! Drain the berries. Reserve liquid. Fill a large champagne or wine glass ⅓ full of this liquid, then add champagne to fill. Add 1 whole strawberry and a sprig of mint. Enjoy!

"A great summer evening splurge for a special occasion such as winning "Best of Show," the Irish or Reader's Digest Sweepstakes *or* for drowning your sorrows if you didn't! Best enjoyed after dark when the first hay-cutting is down, with no moon so you can see all the falling stars. Should be shared with someone special.

Jean and Sam Senkow
Bondurant, Wyoming

Sam Senkow is a modern-day mountain man in the truest sense. Born in rural Pennsylvania, he later became the seventh adopted son of Pearl S. Buck. He started his career in gunsmithing by waiting on gun tables which eventually led him to the building of his first firearms at the age of eight. He has traveled to Austria and Germany where he studied primitive weaponry, German poetry and acting, while refurbishing rifles for the state's museums. Sam creates fine firearms by forging the barrel and lock, making the stocks and carving the finished piece with his own personal style and technique. Some of his most intricate rifles take up to 900 hours to complete. In the U.S., Sam has made 33 movies for National Geographic, Encyclopedia Britannica *and the* Foreign Information Bureau. *For these movies, he served as technical advisor, actor, lifestyle expert on primitive skills and provider/maker of historical weapons and accoutrements. Sam is most at home in the mountains of the West near Bondurant, Wyoming where he now lives with his bride Jean, who is the creator of exquisite quilled gun cases, saddles and clothing.*

HM

Uzvarets

- ¼ **cup butter**
- 2 **quarts olinberries (blueberries, blackberries or raspberries are good also)**
- 2 **sticks cinnamon, crushed**
- 12 **cloves**
- 1½ **cups sugar**
- 1½ **gallons water**
- ¼ **cup hops**
- 1 **cup mint leaves**

Melt butter in a deep 12" fry pan. Add berries and fry to the consistency of pulp over low heat. Add 1 stick cinnamon, crushed; 6 cloves and ¾ cup sugar. Simmer for 20 minutes. Pour into a large pot, add other stick cinnamon, crushed and remaining ¾ cup of sugar. Do not stir the cinnamon and sugar into the fruit. Cover and bake at 200 degrees for 15 minutes. While the fruit mixture bakes, bring 1½ gallons of water to a rolling boil. Add hops, mint leaves and remaining 6 cloves. Remove from heat and allow to steep for 5 minutes. Stir fruit mixture into the tea slowly; return to heat and simmer for 1 hour. While simmering feel free to sample the brew and adjust spices to your liking. Serve either strained or right from the pot.

"There are many Ukrainian specialty drinks. Uzvarets is a drink that has a strong flavor and is served hot or cold, in a small glass during a meal. A large glass of spring water and a shot of Stolichnaya vodka served neat should accompany the Uzvarets; as should hard-boiled eggs."

Patricia Warren and Ken Johnson
Fort Worth, Texas

Long Island Iced Tea

- ½ **ounce Vodka**
- ½ **ounce Gin**
- ½ **ounce Rum**
- ½ **ounce Triple Sec**
- 1½ **ounces Sweet & Sour Mix**
- **iced tea**

Pour first five ingredients in tall Collins glass. Top off with iced tea. Pepsi or Coke could be substituted. Add a squeeze of lemon or lime, if so desired.

"This recipe was introduced to me by friends and fellow connoisseurs of the arts, who believe that preliminaries are the basis for every great piece of art. It is especially nice served under the portal of an old sod house with a panoramic view of old Santa Fe below."

Janene Grende Utter and Rick Utter
Bonners Ferry, Idaho

Janene's natural ability and aptitude for detail are beautifully expressed in the exquisite bird and animal paintings she produces. She begins with hours of careful observation and sketching of wildlife in their natural habitat before recreating them in gouache. Janene began painting when she was 15. She has been named one of the Outstanding Young Women of America and is a member of the Women Artists of the American West. She is the recipient of several awards and was chosen by the Museum of Native American Cultures (MONAC) as their artist in residence for September 1980. She has also had one of her paintings on the cover of the Quarter Horse Journal *and has paintings in collections in England, Japan, New Zealand, and Canada as well as the U.S.*

Brandy Slush

- 1 cup water
- 4 tea bags
- 8 cups cold water
- 1 12-ounce can frozen lemonade concentrate
- 1 12-ounce can frozen orange juice concentrate
- 2 cups brandy
- 7-Up

Boil 1 cup water and tea bags for 1 minute. Let stand for 5 minutes. Remove tea bags and add 8 cups cold water, lemonade concentrate, orange juice concentrate and brandy. Put in several plastic containers and freeze. Stir several times during the freezing process so that alcohol doesn't separate. To use, just take from freezer, mix ½ slush and ½ 7-Up for a fabulous drink during the long, hot days of summer.

"When I want to be fancy, I take a thin slice of orange or lemon rind and twist it onto the rim of the glass. This is a very refreshing drink and makes an excellent non-alcoholic drink by omitting the brandy."

Miriam and Bob Wolf
Laporte, Colorado

Wolfers

Choose your favorite Wolfer. Let ice cream soften slightly. Put all ingredients in blender and blend to smooth consistency. Serves two.
"One sip and you'll howl!"

Rocky Mountain Wolfer

- 1 ounce Brandy
- ½ ounce white Creme de Cocao
- ½ ounce Creme de Menthe
- 2 scoops chocolate chip ice cream

Howlin' Wolfer

- 1 ounce Creme de Menthe
- 1 ounce Brandy
- 2 scoops vanilla ice cream

Velvet Wolfer

- 1 ounce Triple Sec
- 1 ounce brown Creme de Cacao
- 2 scoops vanilla ice cream

Spanish Wolfer

- 1 ounce Kahlua
- 1 ounce white rum
- 2 scoops vanilla ice cream

Pink Wolfer

- 1 ounce Chocolate Cherry liqueur
- ½ ounce Creme de Cassis
- 2 scoops vanilla ice cream

Brandy Wolfer

- 2 ounces Brandy
- 1 scoop lemon ice cream
- 1 scoop orange sherbet

40/100 Yucca Sandy

Sandy Scott
El Paso, Texas

Sandy Scott was born in Dubuque, Iowa and raised in Tulsa, Oklahoma. She studied at the Kansas City Art Institute before becoming an animation background artist for Calvin Motion Pictures. She later opened her own studio in San Francisco specializing in commission portraiture of animals and people. Since 1976, her etchings have been placed in the country's leading galleries. Special recognition of her talents and potential in graphic arts has been enthusiastically expressed by Southwest Art, Gray's Sporting Journal, Art Voices/South, and numerous newspapers. Honors culminated with her 1978-79 winter show at the Cowboy Hall of Fame in Oklahoma City. She was the first to have a one-woman exhibition at the museum and also the first person to show etchings. Sandy was one of 50 artists from this country selected to participate in the First American Western Art Exhibition in Bejing (Peking) China in November of 1981. A book about her technique and work, Masters of Western Art by Mary Carroll Nelson and published by Watson-Guptill, became available in 1982. A licensed pilot, she flies her own airplane between studios in El Paso, Ruidoso and Canada. Each spring Sandy releases a new portfolio of 16 etchings and has recently begun introducing wildlife sculptures to her collectors as well.

Make Your Own Kahlua

- ■ **4 ounces instant espresso coffee**
- ■ **4 cups boiling water**
- ■ **8 cups sugar**
- ■ **3 cups vodka**
- ■ **2 cups brandy**
- ■ **2 vanilla beans**

Mix coffee and water well. Add sugar and stir. Add remaining ingredients and mix well. Store in jug for 30 days. Stir every 5 days.

Molasses Beer

- 1 gallon water
- 1 gallon molasses
- 1 3-pound can malt extract
- 1 pint fresh, female hop flowers
- 1 cake yeast
- 1 teaspoon sugar
- 1 cup warm water
- tepid water
- bitters

Doug Marcy
Estes Park, Colorado

Doug Marcy depicts life in today's West with an emotion that can only come from one who has experienced it. He was raised and lived most of his life on the Lazy 97 ranch in the windswept sandhills of scenic western Nebraska. His artistic skills were not discovered until he entered the University of Nebraska and took a course in drawing to improve his drafting technique. He graduated with a Bachelor of Fine Arts degree and then tried his hand at different jobs. His hands and heart were always with the pencil and he eventually settled on raising his Angus cattle, breaking his Morgan horses and spending long hours drawing and sketching. He traveled the rodeo circuit for a while, where he picked up an additional wealth of material. Marcy's drawings, like his subjects, are authentic and sensitive portraits created with the soft and subtle shadings of a pencil. He also works in oil and acrylic. "It is a challenge for me to portray the contemporary West in all its moods: loneliness and companionship, joys and humilities, hardships and rewards. What I try to capture through my art is the personality of a people, place and time." Due to the support and encouragement of collectors of his art, Doug actively participates in several national invitational shows each year.

Heat one gallon of water to boiling and slowly add one gallon of molasses together with a three-pound can of malt extract. This viscid, viscous mass of sticky corruption is then stirred with a fairly clean 2x4 until just at the point of boiling. Then one pint of fresh, female (don't ask!) flowers is stirred in. Then the kettle is moved to the back of the cook stove and allowed to cool, or "gather body" as grand-daddy calls the process. A cake of yeast and a teaspoon of sugar are dissolved in one cup of warm water and added to the molasses liquid as soon as it is lukewarm. This lethargic libation is then poured into a ten-gallon crock and stirred as the crock is filled with tepid water. At this point you can add just a bit of bitters (infused in a cup of boiling water) to cut the rummy flavor. Cover the crock to allow the mixture to ferment in privacy. What happens next is an awe-inspiring wonderment of the kind that invokes tail-tucking in the meanest of curs and inspires devoted jug-huggers to repent on weekdays. The crock almost seems to come alive as it rocks and quakes with the fermentation. Hop leaves and molasses solids sink and rise again and again in mysterious gyrations, peregrinations, pirouettes, bumps and grinds until suddenly at the end of about a week all is quiet and a sweet stimulatin' liquor is born. Grand-daddy always cautions that seven days of fermentation at 72 degrees is a minimum and that the beer must be allowed to go completely "dead" (until the yeasts are inactive). Even then, the beer is to be bottled in heavy, sterilized containers (bottles) and capped tightly. Molasses, like honey, often contains unknown sugars that are prone to stimulate yeasts in the bottle and produce gases which can have the possible consequences of sudden, violent eruptions that saturate the interior of your storage shed with a somewhat odoriferous, palpable atmosphere and an uneven wall coating with the consistency of melted bubble gum!

"This ole' time libation ain't for everybody, but served chilled, does provide a real gratifyin' addition to those relaxin' summer evenins when the "Front Porch Rockin' Chair Assembly" meets to discuss the propensity of a libidinous angleworm and other adult dissertations of national concern. In addition, as an added benefit, a bottle of this oral antiseptic left open will turn into a fine sour malt vinegar that is an excellent marinade for meat or fowl."

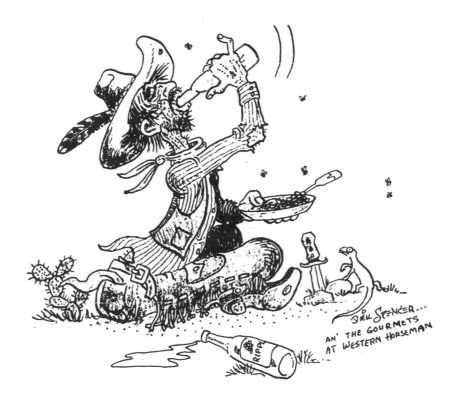

"Table wine is a long-established part of western dining..."

(Nuthin' like a vintage ripple to wash down a mess o' frijoles!

Drawing courtesy of Dick Spencer

Miriam and Bob Wolf
Laporte, Colorado

Sangria Blanca

- **1 gallon white wine, chilled**
- **2½ cups Grand Marnier**
- **1 cup sugar**
- **40 ounces club soda, chilled**

Combine wine, Grand Marnier and sugar in punch bowl. Stir until well blended. When ready to serve, stir in club soda and add ice ring:

Ice Ring For Punch Bowl

Arrange thin lemon, lime and orange slices in a single layer in 6- to 6½-cup mold (you can use bundt pan for bigger ring). Add maraschino cherries around center of mold. Pour water into mold to *partially* cover fruit; freeze. When frozen, add water to fill mold ¾ full; freeze. At serving time, unmold and float, fruit side up, in punch bowl.

"This is a great party punch recipe. We serve it at Christmas time and use alternating red and green cherries for the ice ring. The Grand Marnier really makes this punch special!"

Chapter II
PREPARING THE "PALETTE"

Soups
Salads & Salad Dressing
Vegetables

Soups

Francis and William F. Reese
Bellevue, Washington

Born in Pierre, South Dakota and raised in eastern Washington, Bill Reese was trained at Washington State University and the Art Center of Design in Los Angeles. After working as a commercial artist for 13 years, he made the move to full-time fine art in 1971, with the support of his wife Fran, who is his business manager. Bill's move was the right one, as is attested by the numerous awards he has received throughout his career. He has been featured in several fine art magazines, including Art West, Artists of the Rockies and American Artist. Bill is a highly-motivated artist and enjoys leaving something in all of his paintings to the imagination of the viewers. A founding member of the Northwest Rendezvous Group, Bill is also a member of the Northwest Watercolor Society, the Pastel Society of America, the Whiskey Painters of America, and the National Academy of Western Art.

Cheese Soup

- 1 medium onion, chopped
- ½ 4-ounce can green chilies
- 1 48-ounce can tomatoes, cut in pieces
- ¼ teaspoon cumin
- ¼ teaspoon oregano
- salt and pepper to taste
- ½ to 1 pound Jack cheese
- 1 pint Half and Half or milk

Saute onions in small amount of butter or margarine. Combine with green chilies, tomatoes, cumin, oregano, salt and pepper and simmer for 15 minutes. Add Jack cheese and stir until just melted. Add Half and Half or milk; simmer on low heat until hot. Do not boil. Note: Sometimes the cheese is a little gooey, but it's still great! You can use canned skim milk for a lighter flavor if you wish.

"We were given this recipe by Kathy Perhacs, a sculptor friend. We serve this soup with warm flour tortillas laced with honey and butter. Alongside a fresh, green salad and fresh fruit, it makes a very nice lunch or dinner."

Martha and John Leone
Roxbury, New York

Martha Blair Leone was born and raised in New York state. She started her career in art by earning a Bachelor of Fine Arts degree at the Rhode Island School of Design, followed by ten years as a commercial artist and five years as a freelance artist. In 1970 she married John Leone, the western artist and in 1974 they moved from the crowded streets and noisy subways of Manhattan to their acreage in the mountains of Roxbury, New York. Martha paints in the Primitive or Naive style using her own added sophisticated sense of design and color to produce charming and vibrant panels depicting the joys of country life.

Escarole Soup

- ■ 1 large head escarole
- ■ 3 medium onions, chopped
- ■ 3 cloves garlic, minced
- ■ oil for frying
- ■ 1 large can Canelini beans
- ■ Parmesan cheese

Wash and tear escarole into small pieces, then cook in water just to cover until tender, about 15-20 minutes. Do not drain. Meanwhile, saute onion and garlic in oil until transparent; add beans and their liquid and cook on low heat for about ten minutes. Add onion/bean mixture to escarole; stir to heat through. Serve with a sprinkle of Parmesan cheese and a loaf of good, crusty bread. Note: Tiny meatballs or thin slices of sweet sausages are also good in this.

"John's mother taught us this one. It is a great "Fall-into-Winter" soup and is wonderful on a cold day."

Judy and John R. Kline
Helena Arts Council
Helena, Montana

Chili Verde Soup

- ■ 1 pound pork, cut into small cubes
- ■ 3 Tablespoons flour
- ■ 3 Tablespoons shortening
- ■ 1 cup onion, chopped
- ■ 1 clove garlic, minced
- ■ 1 16-ounce can tomatoes, chopped
- ■ 3 4-ounce cans chopped green chilies
- ■ ¼ teaspoon oregano
- ■ 2½ teaspoons salt
- ■ 2 cups water
- ■ 2 cups carrots, diced (optional)
- ■ 1 4-ounce can sliced mushrooms (optional)

Dredge pork in flour. Melt shortening in dutch oven and brown pork. Add onion and garlic and cook until soft. Add remaining ingredients and simmer, covered, for 1 to 2 hours. Serves 4 to 6.

"We don't know where the original recipe came from, but we have adapted to our own taste over the years. If you *must* have beans in it, you can add a can of kidney beans. I also add a pound of browned ground beef sometimes. This is a great hearty soup that makes a meal served with a salad and sourdough bread. Ice cream for dessert, of course!"

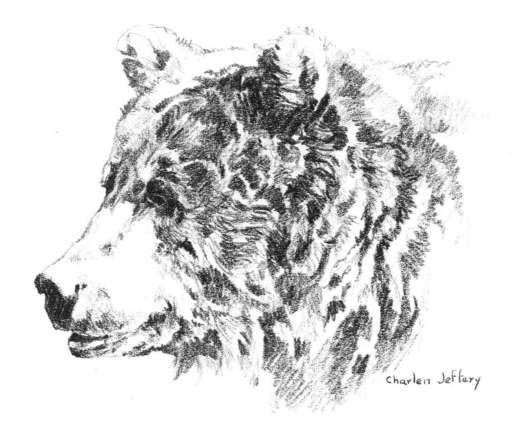

charlen Jeffery

Charlen and E. Leroy Jeffery
Anchorage, Alaska

Charlen Jeffery cannot remember when drawing and painting were not a part of her life. Her intense desire to create with a brush began as a child and progressed to and beyond her Fine Arts degree from Seattle Pacific University. A life spent among the beauties of the Northwest and Alaska has provided a unique dimension of inspiration for her. Her versatility in subject matter and media has won her recognition at many juried art shows. She is a member of the Alaska Watercolor Society, the Artists' Guild of Anchorage and the Society of Animal Artists.

Italian Cheese Chowder

- 1 16-ounce can whole tomatoes
- 1 15½-ounce can garbanzo beans, drained
- ½ pound zucchini, sliced
- 2 onions, chopped
- 1½ cups dry, white wine
- ¼ cup butter
- 2 teaspoons salt
- 2 teaspoons instant minced onion
- 1 teaspoon dried basil, crushed
- 1 bay leaf
- 2 cups Monterey Jack cheese, grated
- 1 cup Romano cheese, grated
- 1 cup whipping cream

Preheat oven of 400 degrees F. Combine first 11 ingredients in a 4-quart baking dish. Cover tightly and bake 1 hour, stirring once or twice. Blend in remaining ingredients. Cover and bake until cheese melts, about 10 minutes. Serve immediately. Serves 6 to 8.

Dixie and George Morse
Prairie Village, Kansas

Auctioneer George Morse was born in Macon County, Missouri and received his degree in Agriculture at the University of Missouri. Having been very active in auctioneering purebred livestock in the U.S. and Canada since 1958, he and his wife Dixie began collecting western art in 1970. Most of their purchases were made during special gallery shows and sales. In those days, there were very few contemporary western works sold by the auction method. Then, a few years later, in conjunction with Texas Art Gallery, the first of many auctions was held. It was a success and from that small beginning, many other similar shows followed suit and are being staged all across America.

Posole
- 1½ pounds pork
- 1 medium onion, chopped
- 3 stalks celery, chopped
- salt to taste
- 2 Tablespoons chili powder
- 2 4-ounce cans green chilies
- 1 teaspoon cumin
- 1 teaspoon oregano
- 3-4 16-ounce cans hominy

Drawing courtesy of Ken Ottinger

Cover pork with water. Add onion, celery and salt. Simmer until well done, about 2 hours. Remove pork and cut into chunks. Put back into liquid and add remaining ingredients. Simmer on low heat for 30 minutes. Serves 12.

"The longer it sits the better it tastes! This is a great Mexican stew and is especially good with salad and corn bread."

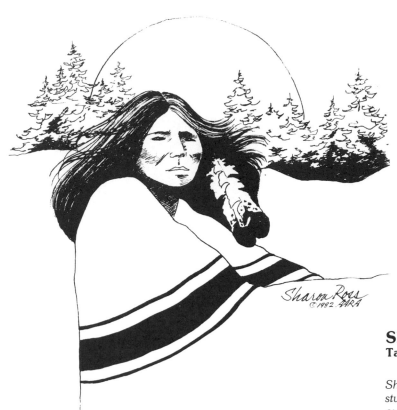

Sharon Ross
Tacoma, Washington

Sharon Ross works in many media, creating landscapes, character studies and portraits of the American West. A growing awareness of our western heritage has led to a keen desire to portray the faces of our time and our past. "Mood and feeling are very important in my work. Faces have a special challenge that grows more interesting with every completed painting. My present interest in Indian themes comes from a deep respect for their spirituality and from the similarity to John Muir's notion that we should walk through the wilderness without leaving evidence of our passage. The Indians lived his philosophy. I am trying to learn all I can of their ways before the white man came into their lives and also, the way it is for them today."

Potato Soup

- 6 medium potatoes, peeled
- salt and pepper to taste
- 8 slices bacon
- bacon drippings
- 1 medium onion, chopped
- 3 stalks celery, chopped
- 1 16-ounce can whole kernel corn
- 3 cups milk

Slice peeled potatoes about ⅛ inch thick. Rinse and put in large sauce pan; cover with water, salt and pepper to taste and bring to boil. Reduce heat and simmer about 20 minutes or until tender. Fry bacon until crisp, drain and set aside. Saute onion and celery in bacon drippings about 15 minutes or until tender. When potatoes are done, drain off most of the liquid and mash potatoes slightly to thicken. Add crumbled bacon, onion, celery, corn and milk. Stir and simmer over low heat. Serve with rolls or crackers. Makes 4 to 6 servings. servings.

"This soup is something my mother always made for cold, crummy days or when my brother or I was sick and had recovered enough to be hungry again. For the past ten years it has become our family's traditional Christmas Eve supper before we open our gifts."

Anne and O. J. Gromme
Portage, Wisconsin

Owen J. Gromme has earned the respect and admiration of art collectors and his fellow artists with paintings that reflect his lifelong love of wildlife and their natural environment. At an age when most men are well into retirement, Owen Gromme's immense talent and versatility are enhanced by equal amounts of exuberance and vitality. He first gained national acclaim by winning the Federal Duck Stamp competition in 1945. Thirty years later, he was selected as the Ducks Unlimited artist of the year and was further honored by being chosen to design Wisconsin's first state duck stamp. Owen's studio is located in southern Wisconsin, in a peaceful country home where he and his charming wife Anne have resided since his retirement as curator of the Milwaukee Public Museum. In 1941 he began painting a series of 323 American birds which was published in 1963 in the book titled Birds of Wisconsin. *He has lived to see the body of his work equal, in the opinion of many art historians, that of Audubon, Wilson and Fuertes, whom he greatly admires.*

Soup with Danish Dumplings

- 2-3 pounds soup meat or bones
- water
- 2 Tablespoons salt
- 1 medium onion, chopped
- 1 stalk celery, chopped
- 1 bay leaf
- 3 allspice
- 6 peppercorns
- 1 pound carrots, sliced
- 1 cup peas
- 1 cup green beans, sliced
- 1 potato, sliced
- 1 medium onion, chopped
- 1 turnip, sliced
- 1 kohlrabi, sliced
- 2 stalks celery, sliced
- parsley

Cover meat or bones with water in slow cooker or stock pot. Add salt, onion, celery, bay leaf, allspice and peppercorns. Cook overnight on very low heat. Remove meat/bones from broth. Cut meat from bones and save. Discard onion, celery and spices. Set broth in refrigerator or cold place to let fat rise and harden. Remove fat and discard. Cook or steam remaining vegetables in separate pot until just crisp. Do not overcook. You can use any vegetables that you have on hand if you wish.

Dumplings

- ¼ cup butter
- 1 cup flour
- 1 cup boiling water
- 1 teaspoon salt
- 4 eggs

Put butter, flour and boiling water in heavy skillet over medium-high heat. Stir and turn over mixture until it becomes a ball and does not stick to pan. Allow to cool, then add salt. Add eggs, one at a time, beating well after each addition. This works well in a food processor or mixmaster. Add the saved meat to the soup broth and heat to just below boiling. Drop the dumplings onto hot broth by teaspoonful and cook 3 to 5 minutes. (Dip the teaspoon into hot broth first and the dumpling will slide off spoon easier.) Do not let mixture boil or dumplings will fall apart. When serving, add the hot vegetables to each bowl of broth and dumplings.

Anne's mother came from the island of Jylland in Denmark and she remembers having this soup often while she was growing up. "She filled it full of crisp, fresh vegetables and it was usually a main meal for us. The dumplings are especially good. To this day, soup is not soup to me, unless it has dumplings!"

Salads & Salad Dressings

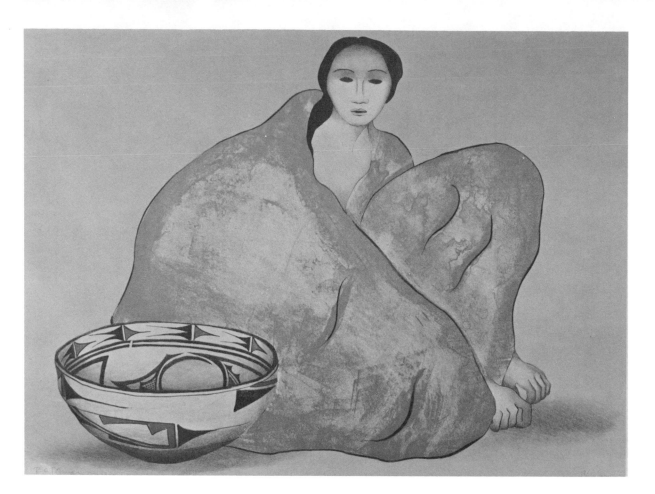

R. C. Gorman
El Prado, New Mexico

R. C. Gorman's images of Navajo women have made him universally famous. His images have an expression of elemental strength and grace that are perhaps unequaled in the world of contemporary art. They are paintings and drawings that have nothing to do with ideas, everything to do with essence. Drawings are the heart of an artist's work and Gorman's mastery of the medium elicits meaning and emotion from each gestural stroke. Northland Press of Flagstaff, Arizona has published several of Gorman's books, including: R. C. Gorman: The Lithographs; R. C. Gorman: The Posters; R. C. Gorman: The Drawings, and Nudes and Foods: Gorman Goes Gourmet Cookbook. In addition, the complete Gorman Graphics book has been printed in Japan in four languages and was produced as a deluxe edition book by Houston Fine Arts Press.

Avocado Salad
- **2 plump and ripe avocados, peeled**
- **2 hot, fresh, roasted green chilies, chopped**
- **2 cloves fresh garlic, finely chopped (the small Mexican garlic is hotter)**
- **4 sprigs fresh cilantro, chopped**
- **2 squeezes fresh lemon juice**
- **1 pinch salt**

Mash the peeled and de-seeded avocados with fingers. Add the de-seeded, chopped green chilies, the finely chopped garlic, chopped cilantro, fresh lemon juice and salt. Mix with fork.

Roasted chilies: Soak chilies in water for five minutes. Place in 350 degree oven for about 40 minutes; keep turning. (The aroma must be timed for when the guests are arriving!) When roasted, place chilies in a damp towel for 20 minutes. Peel and chop. Suggested Luncheon Menu: Lamb Chops, Fat French Fries, Avocado Salad, Tomato and Onion Vinaigrette: served with Veuve Clicquot Champagne and Apricot Meringue for dessert.

"I love to eat and to paint large and beautiful Navajo women! This recipe is my absolute favorite in the world. It's simple, but the secret is that *all* the ingredients are super fresh — otherwise, forget it! No Ortega canned chilies, garlic powder, dried cilantro, artificial lemon juice, over-ripe or under-ripe avocados. (Thank God they don't can avocados!) Serve this salad as a side dish with steak, any Mexican dish or as a dip.

42

Sharon and Charles D. Rogers
Thornton, Colorado

Charles D. Rogers holds true to his contemporary style of expression by preserving western scenes of today and yesteryear. With his pure colors and strong design in watercolor, he captures wildlife in its true environment. He teaches at the Foothills Art Center in Golden, Colorado and conducts watercolor workshops throughout the region.

Hot Potato Salad

- 6 slices bacon
- 1½ teaspoons salt
- ½ teaspoon celery seed
- ½ teaspoon pepper
- 2 Tablespoons sugar
- 3 Tablespoons flour
- ⅓ cup vinegar
- ⅔ cup water
- 4 pounds (8 cups) potatoes, cooked and diced
- 1 medium onion, finely chopped
- 3 eggs, hard boiled and sliced
- parsley

Fry bacon, drain on paper towel and set aside. Add dry ingredients to hot bacon grease and blend. Mix vinegar and water together, then add to skillet and cook mixture until thickened. Add potatoes and onions; stir until well blended. Place in buffet server to keep warm or serve right from the pan. Garnish with crumbled bacon slices, eggs and parsley.

"This is best when served with German sausage and catsup! You can use German sausage in place of the bacon if you prefer."

43

HM

Betty Harvey-Manson and John Manson
Artists of the Rockies & Golden West Magazine
Colorado Springs, Clorado

Artist Pleasing Spinach Salad

- 1 large bunch fresh spinach
- 6 slices bacon
- 2 Tablespoons flour
- 3 Tablespoons sugar
- ⅓ cup vinegar
- ½ cup water
- salt and pepper to taste
- 2 eggs, hard boiled and sliced

Wash spinach, remove stems and drain. Fry bacon until crisp. Drain on paper towel and set aside. Add flour to bacon grease in skillet and stir continuously until flour browns. Mix sugar, vinegar and water together, then add to browned flour in skillet. Stir over low heat until thick. When ready to serve, pour hot dressing over spinach. Garnish with crumbled bacon and eggs.

"Even people who don't like spinach will rave about this one!"

HM

Temple and Tom Beecham
Saugerties, New York

Tom Beecham was born on a ranch in Kansas and learned the drama of Indian fights, cattle drives and cowboy life from firsthand witnesses. A move to Western Colorado when he was twelve changed his life dramatically, exposing him to a virtual "wildlife paradise." In the mid-forties, he spent two years in the Navy, stationed in the South Pacific. After studying fine arts for four years, he painted for a large number of publishing firms until 1972 when he began to paint for galleries and commissions full-time. Whether depicting a western scene or wildlife art, Tom strives for quality in every painting. His works represent composition in the finest sense of the word, creating a melody of color and patterns. Tom is a member of the Society of American Historical Artists.

Molded Gazpacho with Avocado Dressing

- 2 envelopes unflavored gelatin
- 4 cups tomato juice
- ¼ cup red wine vinegar
- 2 teaspoons salt
- 2 cloves garlic, minced
- ¼ teaspoon pepper
- 3-4 drops Tabasco sauce
- 2 large tomatoes (1 cup), peeled and chopped
- 1 cup green pepper, chopped
- 1 cup cucumber, diced, seeded and pared
- ½ cup onion, finely chopped
- ¼ cup pimientos, chopped

Lightly oil a 6½-cup ring mold. In medium saucepan, sprinkle the gelatin over ½ cup tomato juice. Stir over low heat until gelatin is completely dissolved. Stir in remaining tomato juice, vinegar, salt, garlic, pepper and Tabasco sauce. Pour into large bowl and refrigerate for two hours or until mixture is the consistency of unbeaten egg whites. Stir in drained tomatoes, green peppers, cucumbers, onion and pimientos. Distribute evenly. Pour into mold. Chill 4 hours or until firm. Unmold onto plate (place warm, damp towel over bottom of mold to loosen, if necessary). Serve with avocado dressing. Serves 8.

Avocado Dressing

- 1 medium avocado, peeled and pitted
- ½ cup sour cream
- 1 Tablespoon lemon juice
- ½ teaspoon salt
- ¼ teaspoon pepper
- 3-4 drops Tabasco sauce

Put all ingredients into blender container. Blend on high speed until mixture is pureed. Serve with Gazpacho Mold.

"This is one of Tom's favorite lunches on a hot Indian summer day. Served with chilled shrimp, white wine and crusty French bread, it's positively inspiring! Some of his best paintings were done after a meal like this!"

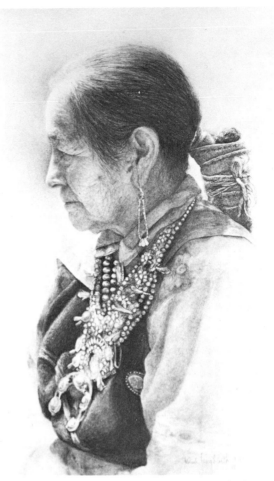

Mimi and Ed Jungbluth
Ruidoso, New Mexico

Mimi Jungbluth is a native of Kansas City, Missouri where she grew up and had her first beginnings in art. In 1968, she and her husband Ed moved to Austin, Texas where she began to devote her efforts toward potraying the Native American Indians as they are today. Mimi and Ed were blessed with some beautiful friendships among many of the North American Indian groups and with their move to Ruidoso, New Mexico, they made even stronger ties with the wonderful Mescalero Apache people whose reservation is only a short distance away. It is a joy for Mimi to work with the tribe in various programs, but she feels especially fortunate to be able to be so close to and in touch with the people she has chosen to paint. It is said that children and old people are the most difficult to paint, but Mimi thrives on expertly painting both. She works mostly in pastels, but also utilizes oil, carbon pencil, gouache, and occasionally, watercolor. Awards have come steadily to Mimi and her work is acclaimed from the East Coast to the Pacific. She has been featured in Southwest Art Magazine *and is a member of the Pastel Society of America.*

Taco Salad Deluxe
- **1 pound ground round steak**
- **⅛-½ teaspoon oregano**
- **1 15-ounce can kidney beans, drained**
- **3 medium tomatoes, chopped**
- **1 medium onion, chopped fine**
- **1 medium head lettuce, shredded**
- **1 medium size bag of small corn chips, crushed**
- **½ pound sharp Cheddar cheese, shredded**
- **1 8-ounce bottle French or Thousand Island dressing**
- **1 8-ounce bottle mild or hot taco sauce**

Brown ground round steak and season with oregano, to taste. Add kidney beans to meat. Set aside. Combine tomatoes, onion and lettuce and set aside. Combine corn chips and cheese. Set aside. Combine dressing and taco sauce and set aside.

In an attractive, *large* bowl, arrange above ingredients in this order: meat and bean mixture; lettuce, tomato and onion mixture; and combined dressing and taco sauce. Just before serving, add shredded cheese and corn chips.

Nothing is really needed with this salad since it provides meat, vegies and a starch in one dish. However, along with freshly brewed iced tea, this salad is beautifully complemented by a light, tart dessert such as lime sherbet or lemon souffle.

"Since I was a Home Ec. major in college, I am especially happy to have the opportunity to express that other part of 'me.' I try, number one, to provide my hubby and myself with a 'Happy Home.' I hate the term 'housewife!' I feel there is a real difference between housewife and *homemaker* — making a home is a joyous art and besides, I'm a wife to my husband not my house! I'm also an artist and while I love to cook and bake, painting is just as pleasing, but not as fattening! I'm lucky to have a husband who encourages and assists me in my endeavors. He is my photographer, freeing me to work with my subjects and he is the best business manager obtainable! After all, promotion is Ed's game since he's Executive Director of the Ruidoso Valley Chamber of Commerce! This explains why he is such a supportive spouse — in every aspect. Not only emotionally, but financially, he is and has always been dependable. He made it possible, in those lean, beginning years, for me to become a STARVING ARTIST!!"

Miriam and Bob Wolf
Laporte, Colorado

"Everything-But-the-Kitchen-Sink" Salad

HM

- ½ large head iceberg lettuce, finely chopped
- ½ large head Romaine lettuce, finely chopped
- 2 medium tomatoes, finely chopped
- 2 cooked chicken breasts, diced (optional)
- 6 strips bacon, crisply fried and crumbled
- 1 large avocado, diced
- 3 eggs, hard boiled and chopped
- 2 Tablespoons fresh chives, chopped
- 3 ounces bleu cheese, crumbled

Arrange lettuce in large salad bowl. Scatter tomatoes, chicken, bacon and avocado in layers over the lettuce. Garnish top with a layer of eggs, chives, and bleu cheese in that order. Just before serving, toss lightly with Dressing I. Makes 6 servings as a salad, 4 servings as a meal.

Dressing I

- ⅔ cup salad oil
- ⅔ cup water
- ⅔ cup red wine vinegar
- 1 teaspoon sugar
- 1 clove garlic, minced
- 1 teaspoon salt
- ½ teaspoon pepper
- 1 teaspoon Dijon mustard
- 1 teaspoon Worcestershire sauce
- 1 teaspoon paprika

Combine all ingredients in a jar; shake well and refrigerate for at least eight hours. Use sparingly on any green salad. Makes three cups.

For a different taste treat, omit chicken and blue cheese; add one large can English peas (drained) and toss with Dressing II:

Dressing II

- 2 Tablespoons green onions, chopped
- 1 clove garlic, minced
- ¼ cup parsley, chopped
- 1 cup mayonnaise
- salt to taste
- 1 Tablespoon lemon juice
- ¼ cup white vinegar
- ¼ cup (2 ounces) blue cheese, crumbled
- ½ cup sour cream or yogurt
- pepper, freshly ground

Combine all ingredients well and refrigerate. Makes 2¼ cups.

"This recipe came in 4th in a local cooking contest featuring 98 entries in the salad division. Everyone *always* has seconds!"

Dixie and George Morse
Western Art Auctioneer
Prairie Village, Kansas

White Shoepeg Corn Salad

- ■ 2 cups white shoepeg corn
- ■ 1 large can English peas
- ■ 1 lage can French-cut green beans
- ■ 1 small jar pimientos, chopped
- ■ ½ green pepper, chopped
- ■ 1 medium onion, chopped
- ■ ¾ cup vinegar
- ■ ¾ cup sugar
- ■ 1 teaspoon celery salt
- ■ salt and pepper to taste

Drain all cans of vegetables. Mix all ingredients together. Let mixture sit overnight. Serve chilled or at room temperature.

"Super for picnics, tailgate parties or camping trips, and so easy!"

HM

Marilyn and Robert K. Abbett
Bridgewater, Connecticut

Woodbine Caesar Salad Dressing

- ■ 1 egg
- ■ ¾ cup salad oil
- ■ ¼ cup lemon juice
- ■ 1 teaspoon salt
- ■ ½ teaspoon pepper
- ■ 1 teaspoon Worcestershire sauce
- ■ ¼ cup Parmesan cheese, grated

Submerge egg in boiling water for 1 minute. Break egg into blender or food processor container and process until fluffy. Continue processing at high speed while *slowly* adding oil. Reduce speed and add remaining ingredients.

Note: We've never had luck doubling this recipe in a blender but it does well in a food processor. Be sure to add the oil *very* slowly or it won't emulsify.

"This is a recipe from Woodbine Cottage at the Harbor in Sunapee, New Hampshire. A favorite of our family for years, it has been served at our table regularly to artists and no complaints yet!"

Vegetables

Cernihaus Beans

- ■ ½ pound bacon, cut into pieces
- ■ 2 16-ounce cans French-cut green wax beans
- ■ 2 cans cream of mushroom soup
- ■ 2 2½-ounce jars mushrooms, sliced and drained
- ■ 1 8-ounce package cashews

Fry bacon in deep cast-iron skillet until done. Pour off fat, leaving a small amount in skillet. Add beans, soup, mushrooms, and cashews. Season to taste. If cashews are salted, go easy on the salt. You can add other seasonings you like, but don't overdo. Cook over medium heat for 10 minutes, then lower heat and simmer for 1½ to 2 hours, until the mixture thickens and cooks down. Check the beans every now and then and give them a stir. This pan-full will serve 8 to 10 people and is pretty darn good served cold or warmed up. It goes well with duck, pheasant or venison, and, if you can afford it, rare roast beef.

"This recipe is from two of my lifelong hunting and social buddies, 'Trapper' McClatchy and Tyack Bennett. They first whomped this up on an antelope

Genevieve and Robert F. Morgan
Helena, Montana

Robert F. Morgan is a native Montanan representing the fourth generation of his family in Montana. His maternal grandfather came to Montana Territory in the summer of 1863 in search of gold and stayed on to raise a family and establish the first irrigated ranch in the area. This heritage has served as a catalyst for Bob's chosen profession as an artist. Early in 1952, Bob was hired as an exhibits designer with the then-newly-housed Montana Historical Society. Montana's history and the aqcuisition of the Mackay collection of C. M. Russell artworks provided the perfect setting and background for nearly two decades of creativity and learning. Bob worked variously as exhibits designer, curator and finally museum chief, with a one-year stint as acting director in between. He is active in the arts and serves on the Board of the Helena Arts Council and has served as President of that group. He is the founder of the Western Rendezvous of Art show and is a co-founder of the Northwest Rendezvous Group. He is the originator of the "Quick Draw" auction which is now so popular with the various art auctions throughout the country and is regarded as an authority on the works of C. M. Russell. Bob and his wife Gen maintain a studio at their home on the southern edge of Helena, Montana.

hunting expedition back in the '50s near an old mining town by the name of Radersburg, Montana. It seems that when 'Trapper' was running a hunting lodge in the Bitterroot Mountains near the Idaho line, he picked up this recipe from one of his guides by the name of Cernihaus. We don't know what he called the resulting product, so we named it in his honor. We all like it so well that we usually have it when we get together. One thing's for sure, it's good!"

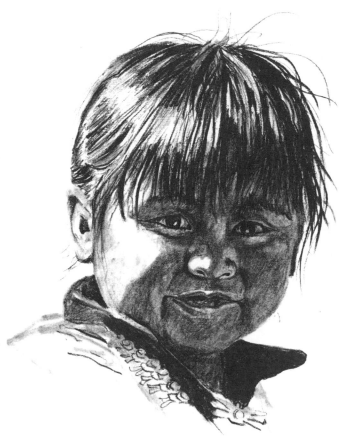

Beverly and Ray Swanson
Prescott, Arizona

Ray Swanson has been a professional artist of American realism for more than 22 years. He is best known for his colorful and accurate paintings, in watercolor and oil, depicting the Navajo Indians of Arizona. He preserves on canvas many of the traditions of the Southwestern tribes that are rapidly changing and disappearing. Ray and his wife Bev were both born and raised on farms in South Dakota. The early years of their marriage were spent managing a curio shop and art gallery in California. Shortly thereafter, they moved to Prescott, Arizona to be nearer the Indian reservations. The whole Swanson clan is involved in the art field as there are four professional artists and a few amateurs in the family. Ray has shown at many prestigious art shows throughout the country and has won numerous awards and honors. He shows annually at the Western Heritage Show in Houston, Texas and is a member of the Northwest Rendezvous Group. The Swansons maintain a busy and hectic schedule. Bev teaches art at a private elementary school in Prescott and both Swansons stay quite involved with the various activities of their children, Pam and Steve.

Cheesy Corn Casserole

- ½ cup butter
- 1 small onion, chopped
- ½ green pepper, chopped
- 1 17-ounce can cream-style corn
- 1 17-ounce can whole kernel corn
- 1 package Jiffy corn muffin mix
- 3 eggs, beaten
- ¼ teaspoon salt
- ¼ teaspoon sugar
- 1 teaspoon pimiento, chopped
- ½ pint sour cream or yogurt
- 1 cup sharp Cheddar cheese, grated

Heat oven to 350 degrees. Saute butter, onion and green pepper lightly. Pour into a 9"x13" casserole pan. Add beaten eggs, cream-style corn, whole kernel corn (do not drain), muffin mix, salt, sugar and pimientos. Drop sour cream or yogurt on top and sprinkle with grated cheese. Bake for 45 minutes. Serves 12.

"This is the most 'asked-for' recipe that I have ever served. It came from my brother and sister-in-law who live on the family farm in South Dakota. It goes well with any kind of meat."

Evalyn Prouty Hickman and Charles P. Hickman
Fort Collins, Colorado

Evalyn Prouty Hickman, a member of the Art Faculty at Colorado State University since 1955, became interested in Southwest Indian art when her family began collecting Zuni jewelry. Since the early 1940s she has exhibited and given lectures on the subject and her current work in embossings, porcelain, etched glass and desert sand paintings, reflects these Indian influences. Each original design represents research, respect, regard and love for Southwest Indian cultures.

Chuck's Cauliflower Supreme

- 1 medium head cauliflower
- 1 can cream of mushroom soup
- 3 Tablespoons soy sauce
- dash of lemon pepper
- 1 8-ounce can water chestnuts, sliced
- 1 4-ounce can mushrooms, sliced
- 1 3-ounce can chow mein noodles
- grated Parmesan cheese

Cut cauliflower into bite-size pieces. Steam or cook until crisp and tender. Drain and set aside. Mix soup, soy sauce and lemon pepper together and set aside. Drain water chestnuts and mushrooms and slice. In a greased 2-quart casserole, layer ⅓ of the chow mein noodles and ½ of the cauliflower, chestnuts and mushrooms. Repeat, ending with layer of noodles. Gently spread soup mix over top and cover with Parmesan cheese to taste. Bake at 325 degrees 30 minutes. Serves 6 to 8.

Nancy Boren
Clifton, Texas

Crunchy Celery Casserole

- 4 cups celery, sliced
- 1 5-ounce can water chestnuts, sliced and drained
- ½ teaspoon basil
- 1 10-ounce can cream of celery soup
- ½ cup pimientos, chopped
- ½ cup soft bread crumbs
- ⅓ cup almonds, slivered and toasted
- 2 Tablespoons margarine, melted

Cook celery in small amount of salted water until crisp and tender; about 8 minutes. Drain well. Combine celery with water chestnuts, basil, soup and pimientos. Spoon into a lightly greased 2-quart casserole. Combine bread crumbs, almonds and margarine. Sprinkle over celery mixture. Bake at 350 degrees for 35 minutes. Makes 6 servings.

Ginger K. and Fred Renner
Paradise Valley, Arizona

Ginger Renner was raised in Silver City, New Mexico and educated at Colorado Woman's College, New Mexico Western University and the University of California. For nine years, she was director/owner of Desert Southwest Art Gallery at Palm Desert, California and Trailside Galleries in Jackson, Wyoming. Since her marriage to Fred Renner, whose dedication to the life and works of Charles M. Russell is legendary, Ginger has also succumbed to the lure of the great Cowboy Artist. She has written several catalogues for one-man and group art exhibitions and has taken part in seminars all the way from the National Cowboy Hall of Fame to the Los Angeles County Art Museum and several museums in between. She is an active member of the Western Art Associates of the Phoenix Art Museum and functions as a touring Docent for that institution.

Silver City Slumgullion (or Hominy, Cheese and Green Chili Casserole!)

- **2 cups boiling water**
- **1 teaspoon salt**
- **½ cup hominy grits**
- **1 14½-ounce can golden hominy, drained (save juice)**
- **2 Tablespoons chives, chopped**
- **1 6-ounce garlic cheese roll, cut up**
- **4 eggs, room temperature, separated**
- **crackers, crushed**
- **paprika**

⋅ Bring two cups water and one teaspoon salt to boil. Slowly add hominy grits, stirring constantly. Turn heat to low, cover and simmer for 20 minutes, stirring constantly. Set aside. (This mixture should be soupy; if it is too thick add some of reserved hominy juice or milk.) Drain can of chilies and wash carefully, discarding seeds. Pat dry with paper towels and chop. *Generously* butter a large casserole. Heat oven to 350 degrees. Transfer hominy grits to large pot (at least 3-quart), place over low heat and stir in the chilies and chives. Add the roll of garlic cheese which has been cut into 8 or more pieces and stir over low heat to melt. Add egg yolks and continue to stir and cook over low heat for 2 to 3 more minutes. Remove from heat. Beat egg whites with ¼ teaspoon cream of tartar on medium speed and when fluffy, turn up speed and beat until quite stiff. Stir the golden hominy into the hominy grits mixture, then fold in the egg whites. Turn into buttered casserole. Sprinkle crushed crackers and paprika on top. Bake for 25 minutes at 350 degrees. This casserole will serve 8 to 10 people. Best served with ham or pork.

"I would not guarantee any dish if Ortega chilies are substituted. They are grown in California, which has yet to produce a decent chili. Use only New Mexco chilies in all your recipes and you will assure your reputation as a good cook. Sometimes I have trouble locating the garlic cheese roll and will substitute a ½ block of Velveeta cheese and add a large clove of finely minced garlic to the chives and chilies. Don't be afraid of substituting or adding things. All really great recipes (except souffles and lemon meringue pie) can stand change."

Ina and Fritz White
Loveland, Colorado

Onion Deluxe
- **onions**
- **butter or cheese**
- **spices**

Peel onions; cut a conical hole and remove center. Fill onions with butter and your favorite spices. They are also good with cheese (except Brie) in place of butter. Wrap in foil and stick onions in coals until tender. Can also bake in 350 degree oven 45 minutes to 1 hour or until done.

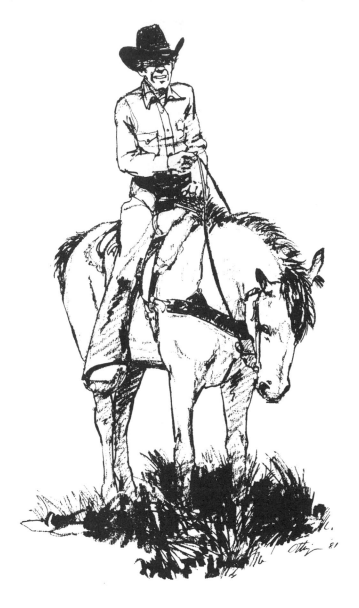

Drawing courtesy of Ken Ottinger

Jo Ellen and Gerald A. Bowie
West Point, Georgia

Gerald Bowie is a highly successful livestock and western art auctioneer. A pioneer in his field, Gerald has, for the past several years, begun the annual Western Heritage Sale Auction of Santa Gerturdis cattle, quarter horses and fine western art in the Grand Ballroom of the Shamrock Hilton Hotel in Houston, Texas. Each year the participation and drama rises steadily, and no doubt next year will be another great sale to tell his grandchildren about some day.

Squash Casserole

- 2-3 cups cooked squash (crookneck or zucchini)
- 1 egg, slightly beaten
- ½ stick margarine, sliced
- ½ cup mayonnaise
- 1 Tablespoon sugar
- 1 cup Cheddar cheese, grated and divided
- 1-1½ cups cracker crumbs, divided
- dash cayenne pepper
- salt and pepper
- herbs, (optional)

Heat oven to 350 degrees. Put well-drained, hot squash in large mixing bowl. Add egg, margarine, mayonnaise, sugar, ½ cup Cheddar cheese and half the cracker crumbs. Season with cayenne pepper, salt, pepper and herbs (oregano is especially good). Put into buttered 1½-quart casserole and top with remaining cheese and cracker crumbs. Bake at 350 degrees for 20 minutes. Makes 6 to 8 servings.

Chapter III
THE MEAT OF THE SUBJECT
(Meats and Main Dishes)

Beef	Seafood
Pork	Poultry
Lamb & Veal	Eggs & Cheese
Wild Game	Dried Beans

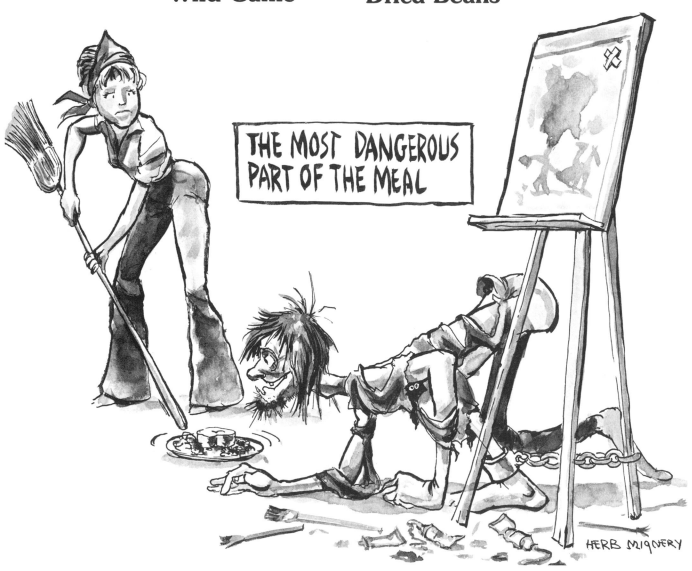

THE MOST DANGEROUS PART OF THE MEAL

HERB MIGNERY

Beef

Carolyn and Michael Wardle
Pleasant Grove, Utah

Michael Wardle has spent much of his life in the West. He received his art training at Brigham Young University, taking a variety of art classes, with his emphasis on painting and sculpture. Michael's interest in the West was kindled by stories of the experiences of his forefathers. "My own great-grandfather pulled a handcart across the Great Plains in 1856. Later, my grandfather had a small freight company that took him over the Teton Pass into Jackson, Wyoming. The Indians, cowboys and settlers of that era were individuals with much strength and courage. Together they wove the fabric of what has become the most exciting era in our country's history. Art has been the center of my life for as long as I can remember, and telling this story of the West through my art gives me a great deal of satisfaction and enjoyment."

Beef Stroganoff

- 1½ pounds round steak
- 4 Tablespoons butter or margarine
- 1 large onion, diced
- ½ pound mushrooms, sliced
- 2 teaspoons dry mustard
- 1½ teaspoons salt
- ¼ teaspoon pepper
- ¼ cup beef broth (optional)
- 1 Tablespoon all-purpose flour
- 2 Tablespoons water
- 1 cup sour cream
- hot rice or noodles

Trim fat from round steak; cut meat across grain into ½-inch slices. Cut each slice into 2"x½" strips. Pat strips dry with paper towels. Cook half of meat in a 10 inch skillet over high heat in 1 Tablespoon butter. Stir constantly, being careful not to burn. When meat is lightly browned (about 1 minute), pour meat and drippings into bowl; set aside. Cook remaining meat in 1 Tablespoon butter; pour into bowl and set aside. Add 2 Tablespoons butter to skillet, then add onion, mushrooms, mustard, salt and pepper. Cook over medium heat, stirring frequently, until vegetables are tender, about 5 minutes. Add reserved meat and drippings to skillet and heat mixture to boiling. Reduce heat to low; cover and simmer 35 to 45 minutes or until meat is fork-tender. Stir occasionally. Add ¼ cup beef broth or water if mixture gets too thick. In a small jar, put 1 Tablespoon flour and 2 Tablespoons water. Shake until well-blended. Pour into skillet and cook over medium heat, stirring constantly, until mixture is thickened. Reduce heat to low and stir in sour cream. Heat through, but do not boil. Serve over hot rice or noodles. Makes 6 servings.

"This is our 'celebration' main dish when the check comes in the mail!"

Braciuolini

- 1 breakfast steak or top sirloin steak
- 2 Tablespoons Parmesan cheese, grated
- 1 clove garlic, minced
- 1 teaspoon salt
- black pepper to taste
- 2 Tablespoons olive oil
- 3 Tablespoons, plus 1½ teaspoons onion, minced (⅕ cup)
- 3 ⅛" slices hard Cervelat salami

Sauce

- 1 8-ounce can tomato sauce
- pinch of basil
- pinch of garlic
- 2 Tablespoons olive oil
- 1 cup water

Betty and Roy Lee Ward
Arlington, Texas

For painter Roy Lee Ward, the Old West has never died. The bite of a northern wind or the scalding burn of desert sands come alive in his paintings of the American West. While his technical skills are quite obvious, his concern for recording authentic history is equally evident. His love for the American Indians has led him to spend many hours in libraries and old bookstores across the western states learning as much about them as possible. This additional knowledge has allowed him to portray situations, through his paintings, of true historic significance. Roy is a native Texan and holds degrees from Baylor University and Los Angeles Art Center College of Design. Before becoming a full-time painter 12 years ago, Roy worked as a free lance illustrator for several years, and also did art work for movies, books and national magazines. He was chosen to paint the William Blakeley memorial painting that hangs permanently in the main lobby of the Scottish Rite Hospital. The 8'x12' oil painting is entitled "The Legacy."

Pound meat flat. (Breakfast steaks should be of medium thickness; top sirloin should be ⅛" to ¼" thick.) Combine next 7 ingredients to form a paste. Place large spoonful of mix on steak and roll up and tie with a string. (Should look like a large cigar!) Mix sauce ingredients and put in saucepan. Add steak and cook over low heat for 1½ hours or until tender. Each steak serves one.

"When you're struggling through art school, you learn to make do with what's in the kitchen. Betty and I were broke most of the time, so when weekends came around, she would take our 'bank' (around $3.00) to the store and buy something to make a treat with. She has a marvelous ability to create delicious meals from practically nothing. The name of this dish came from a friend of ours who told us about having it at a very expensive restaurant. Years later, when I graduated, we had the real dish at an excellent restaurant, and I think ours was better — ha, ha!!"

Kris Thorpe
Gallery Select
Seattle, Washington

HM

Braised Oxtail

- 3 pounds oxtail, cut into 1¼" pieces
- salt to taste
- pepper to taste, freshly ground
- 3 Tablespoons olive oil
- 1 cup onion, chopped fine
- 1 teaspoon garlic, chopped fine
- ½ cup dry red wine
- 1 cup beef stock
- 1½ cups whole tomatoes, drained and chopped
- 1 Tablespoon tomato paste
- 4 whole cloves
- 2 cups boiling water
- 1 celery heart, cut into 2"x¼" Julienne strips

Preheat oven to 325 degrees. Season pieces of oxtail with salt and pepper, then roll in flour and shake off excess. Brown 5 or 6 pieces at a time in olive oil over high heat in a 10- to 12-inch skillet. Keep turning until richly browned on all sides. Transfer the oxtail pieces to a large (3- to 4-quart) casserole. Discard most of fat from skillet, leaving only a thin layer. Add onion and garlic to skillet and cook over medium heat, stirring frequently, until tender (about 8 to 10 minutes). Add wine and boil mixture over high heat, stirring constantly. When the wine has almost cooked away, stir in beef stock, cook for 1 to 2 minutes, then pour mixture over oxtails. Add drained and chopped tomatoes, tomato paste and cloves. Bring casserole to oil over high heat, cover and place on middle oven shelf. Regulate 350 degree heat if necessary to keep the casserole at a slow simmer. Let simmer for about 3½ hours. Meanwhile, cook the celery strips in 2 cups boiling water for 5 minutes. Drain and set aside. When the oxtail has cooked for 3½ hours, add blanched celery; cover and cook for 30 more minutes. If time allows, cool casserole completely; skim off fat and discard, re-heat and serve directly from casserole.

"Contrary to popular belief, oxtails do not come from oxen, but are skinned steer tails."

60

Beverly Hutton and Staff
West Palm Beach, Florida

Art Voices magazine originated in 1978 as Art Voices/South. *It was published, along with* Art Craft *magazine, by J. James Akston, well-known artist and patron of the arts. His original idea was to give relatively-unknown, talented artists in a 26-state area, the exposure to the public that they deserved. Under the management of Mr. Akston and the direction of Beverly Hutton,* Art Voices/South *eventually grew in quality and popularity with artists and interested observers of the arts. In January of 1981,* Art Voices/South *merged with* Art Craft *to form* Art Voices *magazine. This move expanded the editorial scope of the magazine and allowed it to extend coverage to the fine arts and encompass the entire United States with a wider variety of fine art forms.*

Chili Tortillas

- **1 pound hamburger, cooked and drained**
- **1 large can red kidney beans**
- **1 can condensed tomato soup**
- **1 large can tomato sauce**
- **1 small can tomato paste**
- **1 bay leaf**
- **1 teaspoon chili powder**
- **1 teaspoon sage**
- **1 teaspoon chili powder**
- **1 teaspoon sage**
- **1 teaspoon pepper**
- **1 teaspoon salt**
- **1 pound sharp Cheddar cheese, grated**
- **10 stone-ground corn tortillas**

Throw everything but the cheese and tortillas into a large kettle and bring to a boil. Simmer, covered for 2 hours. Store in refrigerator for at least 24 hours. After chili has "aged," slowly simmer over low heat until hot throughout. Fill each tortilla with chili, place in a 1½-quart casserole and sprinkle with half of cheese. Pour in enough chili to cover tortillas and sprinkle remaining cheese on top. Bake at 350 degrees for 30 minutes. Serves 2 to 5 artists depending on how hungry they are! This recipe will leave enough chili to store or freeze for a quick meal later.

"This recipe was concocted when hamburger was cheap. It was served without the cheese — which wasn't cheap!! It has, like most inexpensive foods, remained a favorite and a real boon to the budget as well as the palate."

phil prentice

Phil Prentice
Los Angeles, California

Phil Prentice was born in Muncie, Indiana. His love of art was passed on to him by his artist father. At the age of 12, he was offered a scholarship to the Dayton Art Institute, which he attended after regular school classes. After high school, Phil enrolled at the Pratt Institute in Brooklyn, New York. Following a stint in the Air Force, the better part of which was spent in Japan, he settled in Los Angeles to pursue his career in art. After attending the Art Center School of Los Angeles, Phil began to sell his seascapes, desert scenes, portraits and animal studies. He eventually found animals to be his forte and spent hundreds of hours researching into the animal world and with painstaking efforts, slowly achieving recognition as a fine wildlife artist. Big cats remain his favorite subjects. His works have been reproduced in five countries and he is now recognized by the U.S. Information Agency as one of America's leading international wildlife artists.

Curried Beef and Macaroni

- ■ ½ pound ground beef
- ■ 5 large mushrooms, sliced
- ■ ¼ teaspoon curry powder
- ■ ½ cup cream sherry
- ■ 1 Tablespoon Worcestershire sauce
- ■ 1 pinch rosemary
- ■ ½-1 pound elbow macaroni
- ■ Swiss cheese, sliced thin
- ■ sharp Cheddar cheese, sliced thin

Lightly mix ground beef, mushrooms, curry powder, cream sherry, Worcestershire sauce and rosemary and saute in a sauce pan until just done. Meanwhile, cook macaroni according to package directions. When beef and macaroni are done, place a thin layer of macaroni in a 1½-quart casseole; sprinkle ground beef over it, then layer beef with a mixture of sliced cheeses. Continue alternating layers, ending with cheeses on topo. Cover casserole and bake in 350 degree oven for 30 minutes or until cheese is melted and bubbly. Serves 4 to 5.

"For anyone who has a need for preparing a meal in advance, or who never knows when someone will be home for dinner — this recipe is for you. It will keep for hours on "low" in the oven. It also refrigerates well and makes a great snack. Take cold leftovers and saute in pan with butter. It can be served with a salad, vegetable or by itself."

Barbara and Ken Ottinger
Marion, Montana

Born in Greenville, South Carolina, Western sculptor Ken Ottinger spent his first ten years in St. Louis, Missouri, then moved to Los Angeles where, in 1968, he earned his Bachelor of Fine Arts degree from the Art Center College of Design. Soon thereafter, Ottinger became a successful freelance illustrator and was admitted to membership in the Society of Illustrators. During that time, he also taught figure drawing at the Art Center and later, in 1975, was invited to spend a year as artist in residence at the University of South Dakota. Of special significance to Ken, were the Brule Sioux Indians who were among his students there. Since his boyhood, he has had a consuming interest in all things Indian. Today, he has a library of rare books, many dating back to the days of the Old West, a museum-worthy collection of Plains Indian beadwork and weaponry, fine old saddles and spurs, Kachinas and pre-1900 Southwest pottery. Many of these items have served as inspirations for his sculptures and have become integral components of his bronzes. Ken enjoys riding trail with his daughter Victoria and his bride Barbara.

"Shut Up and Eat It!" Chili

- **2½ pounds lean ground beef**
- **2 packages Schilling Taco seasoning mix**
- **2 green bell peppers, diced**
- **Tabasco sauce to taste**
- **Picante sauce to taste**
- **1 zucchini, unpeeled and diced**
- **2 cans Stagg Laredo chili**
- **2 pounds Cheddar cheese, grated**
- **2 medium-size bags Frito corn chips**
- **3 large tomatoes, diced**
- **1 red bell pepper, chopped**

Brown ground beef and add taco seasoning according to package directions. Stir well and add green peppers. Add tabasco and picante sauce to your taste. (Be careful, they're hot!) Add diced zucchini and two cans of chili. Stir well. Simmer on low heat until nice and hot. Meanwhile, grab a couple handfuls of corn chips and throw in each individual serving bowl. Add ¼ cup Cheddar cheese on top of chips. Put diced tomatoes in chili and stir. Carefully pour hot chili over the chips and cheese. Add more cheese and top off with chopped red peppers. Serve the extra corn chips on the side. Makes 6 servings. Enjoy!

"Not being experienced in the world of cooking, I have been known to place a few crazy concoctions in front of Ken at dinner time. Being an understanding sort of guy, he makes an honest effort at eating most of them. One day I got really creative, (Ken, being tired of the "same old, same old") and after an hour or so in the kitchen, I came up with this special chili. Very proudly, I placed the final product in front of him. His reaction was sort of blank. Then raising one eyebrow, he looked up at me and asked, "What is this?" The proud smile quickly disappeared from my face and my only comeback was, 'Shut up and eat it!' Thus, the name of this special recipe was born. Needless to say, he loved it!"

Ethel and Newman Myrah
Portland, Oregon

Newman Myrah is a thoroughly-trained artist, having studied at the Art Institute of Pittsburgh with additional courses at the University of Nebraska, Reed College and Portland Art Museum. For over two decades, he worked as an illustrator, layout man and art director for advertising agencies in Montana, Chicago and Portland. Working in oil and watercolor, Newman reflects, with understanding and affection, contemporary remnants of a fast-disappearing West. His recent project of thirty large oils depicting salmon fishing in the southeast Alaskan waters might well have the same nostalgia in the not-too-distant future.

Elsie's Tater Tot Casserole

- 1½ pounds ground beef
- 1 8-ounce package Tater Tots
- 1 can cream of mushroom soup
- 1 can cream of celery soup

Spread uncooked ground beef evenly in a 1½-quart casserole. Add frozen tater tots on top of meat. Mix the two soups together and pour over the top. Bake uncovered for one hour at 350 degrees. Serves 6 people.

"This is a simple recipe for an amateur cook, a gourmet chef or a starving artist. Since the ingredients are easily obtained and the directions very simple — the results are nearly guaranteed. This tasty treat was handed down from my mother Elsie, to my wife Ethel, to me."

Bonnie and Bert D. Seabourn
Oklahoma City, Oklahoma

Bert D. Seabourn's paintings are windows to the Indian soul. His transparent watercolors touch the spirit and loosen the imagination, making each viewer a storyteller, free to find his own vision in the timeless faces and ancient totems which typify the Seabourn style. Bert has won major awards throughout the U.S. and his drawings have illustrated several books. He is also the subject of a hardback book, Cherokee Artist Bert D. Seabourn *by Dick Frontain. Born in Iraan, Texas of English, Irish, Dutch and Cherokee ancestry, he joined the Navy after high school and was a Navy artist until his discharge, when he entered Oklahoma City University and received his degree in art. His paintings are found in collections from the Vatican to the White House and in 1975, his Indian art was displayed in Berlin, Germany at the Overseas Export Fair, "Partners for Progress." It was the first time for a Native American artist to show his art at a fair in Germany. In 1976, he was selected to a special master's category by the Five Civilized Tribes Museum. He is listed in* Who's Who in American Indian Art, Who's Who in the South and Southwest, Who's Who in America, Who's Who in American Art, Dictionary of International Biography *and the* Encyclopedia of American Indians.

Enchilada Casserole

- 1 pound ground beef
- 1 medium onion, diced
- 1 cup cream of mushroom soup
- 1 cup cream of chicken soup
- 1 cup milk
- 1 can enchilada sauce
- 1 small can green chili peppers
- ½ pound Velveeta cheese, grated
- 1 package tortillas

Fry ground beef and onion until done. Drain. In separate pan, mix soups, milk, enchilada sauce and green peppers. Add ground beef mixture to soup mixture and mix well. Alternate layers of beef/soup mixture, tortillas and cheese in large, greased casserole. End with cheese. Bake at 350 degrees for 25-30 minutes.

"This famous old Indian recipe should be served with "Pow Wow" Kool Aid!"

Doris and Mel Gerhold
Whitney, Nebraska

Mel Gerhold's father was of German descent and his mother was born in Germany, thus Mel's taste for German food is authentic. He graduated from the Maryland Institute of Art in Baltimore, Maryland and has been painting ever since. He and his wife Doris have a small ranch at Whitney, Nebraska where they raise cows and horses while Mel pursues his art career. His favorite medium is oil, but Mel enjoys working in all media and has recently begun sculpting in bronze. He primarily depicts the West of yesterday: mountain men, cowboys, Indians and soldiers, but occasionally paints the contemporary cowboy and ranch life of today.

German Beef Roulade

- **1-4 pound round steak, sliced very thin**
- **salt and pepper to taste**
- **mustard**
- **4-5 dill pickles, chopped**
- **3 medium onions, diced**
- **½ pound bacon, chopped**
- **3 Tablespoons oil**
- **water**
- **flour**
- **3 Tablespoons sour cream**

Cut round steak into serving pieces; sprinkle with salt and pepper and then lightly spread with mustard. Place a small amount of chopped pickles, onions and bacon on each slice of steak. Roll up and fasten with toothpicks, then roll in flour. Brown rolls on all sides in hot oil. Reserve drippings. Put rolls in large roaster; add water and drippings. Cover and bake for 1½ hours or until fork-tender. Check occasionally and add water if necessary. At the end of cooking period add small amount of flour to thicken gravy, then add sour cream to gravy. Makes 6 servings.

Hamburger Surprise

"Buy 5 pounds of lean hamburger meat. Pull off half-pound chunks and make 10 "sorta thin" patties out of them. Rummage through the vegetable bin, refrigerator shelves and cupboards to come up with fillers, like mushrooms, cheese, chopped onions, green pepper slices, etc. Take 1 of those items and fold the meat patty over it . . . take the next one and do the same, and so on. You wind up with 10 folded patties, each holding its own mysterious ingredients. The secret now is to do a "shell game shuffle" so you can't remember what filler is where. Wrap 'em all in foil and freeze them for future use. You never know what's coming up next for 10 days of HAMBURGER SURPRISES! A bachelor's life in an art studio ain't great, but maybe Hamburger Surprise will help! Another tip . . . if you hate the stuff you stuffed it with, wait until it's cooled off from the broiler heat, pick it up, toss it in the wastebasket and make yourself a peanut butter sandwich!

"Starving artists sometimes are starving alone! Before I sold Jessica the bill of goods, I was stuck with feeding myself. Times weren't desperate, so there was enough . . . but TV dinners wear thin, so . . . Hamburger Surprise was born!"

Jack Hines and Jessica Zemsky
Big Timber, Montana

The historic West is a special commodity to Jack Hines . . . a place, a time, a state of mind. He sees the era of trans-Mississippi exploration and settlement as a textbook of human strengths, weaknesses, foibles and motivations encapsulated in a brief span of dramatic time. There are lessons for everyone in such an instructive tome. In his art, Jack endeavors to highlight what he feels to be the important messages of this dramatic set of events. Born on the eastern edge of Sioux country, along the Platte River in Nebraska, he was educated in Nebraska, California and New York and has, for the past 12 years, lived and painted in south-central Montana, submerged entirely in the history of the West that is his subject. He is a founding member of the Northwest Rendezvous Group and his work has been widely published in book and print form. Jack and his wife, Jessica Zemsky present the Zemsky-Hines Pro-Art Workshop annually, teaching a one week seminar in art which has attracted students from all over the U.S.

Mary and Bruce Wynne
Wellpinit, Washington

Bruce Wynne was born in Wellpinit, Washington and received degrees from the Institute of American Indian Arts, Santa Fe, New Mexico and the University of Colorado. While Bruce was Exhibits Designer at the Heard Museum, he began to paint and sculpt under the tutelage of Allan Houser, highly respected as the Dean of American Indian Art. Bruce has won numerous awards and has had many one-man shows throughout the U.S. He is totally immersed in stone carving. "I knew what I wanted to do and the time had come to simply do it," he explains. Working in pink Colorado Alabaster, Soap Stone and African Wonder Stone, his work is in great demand for public and private collections. His heritage is Indian; it permeates his outlook on life and is the inspiration for his art.

Indian Tacos

- ■ 2 cups all-purpose flour
- ■ 1½ teaspoons salt
- ■ 5 Tablespoons baking powder
- ■ 1½ cups warm water
- ■ 2 cups oil

Combine first 4 ingredients; cover and set aside while preparing meat mixture. While meat mixture is simmering, heat the 2 cups of oil in a large, heavy kettle until hot. Knead dough on floured board for several minutes. Divide into 6 parts. Roll each part into a round shape and fry until brown on 1 side, turn and brown other side. Remove, drain and keep warm. Makes 6 servings.

Meat Mixture

- ■ 2 pounds lean ground beef
- ■ ¼ cup onion, minced
- ■ salt to taste
- ■ 2 cloves garlic, minced
- ■ ½ teaspoon green chilies, minced
- ■ 2 Tablespoons green pepper, minced
- ■ 1½ cups small red beans
- ■ 1 15-ounce can tomato sauce
- ■ 1 8-ounce can tomato sauce with mushrooms

Brown beef, onion and garlic in large, heavy kettle. Drain fat. Add all other ingredients. Simmer 30 minutes while preparing fry bread. Divide into 6 parts. To serve: Place fry bread on warm plate, smother with meat mixture. Top with shredded lettuce, cheese and taco sauce if you wish.

"Bruce really enjoys this dish, he calls it an Indian dish with a Mexican influence. The fry bread is a recipe that my grandmother taught me when I was young. Several people have requested the recipe, but I have never given it out until now. I hope everyone enjoys it!"

Joe Morris
Tacoma, Washington

Joe Morris was born in Clovis, New Mexico and later moved to Tacoma, Washington where he lives today. At an early age, he displayed a creative talent for drawing and painting and knew, even then, that his life would center around art. He graduated from the Burnley School of Professional Art in Seattle. After working as a graphic designer, illustrator and art director, he decided to devote his full energy and talent to fine art as a career. His love for the Indian people and the Pacific Northwest is reflected in his stylized Indian portraits, marine and western landscapes and rural scenes. He has received numerous awards and has had work shown at the Frye Art Museum in Seattle and the Rocky Mountain National Watermedia Exhibition in Colorado. He is a member of the Northwest Watercolor Society and is a founding member of the American Artists of the Rockies Association.

Joe's Chili

- 2 pounds lean ground beef
- 2 cloves garlic, minced
- 2 cans chili or kidney beans
- 1 can water
- 1 can tomato paste
- 1 large onion, chopped
- 2 teaspoons salt
- 1 package Lipton onion soup
- 3 Tablespoons chili powder, or to taste
- sharp Cheddar cheese, grated
- green onion, chopped

Brown beef and garlic. Drain fat. Add next 7 ingredients and simmer for 1 hour. Serve with sharp Cheddar cheese and green onions on top. Corn chips are a good addition on top, too!

"This is an old favorite family recipe. It's easy and delicious — a real man-pleaser — and easy for a bachelor to cook. It impresses everyone with his cooking skills!"

69

Betty and Roy Kerswill
Jackson, Wyoming

*"If there is a better, more beautiful place to live, I've yet to find it."
These are the words of a man who has roamed the world and now
makes America his home — the Southwest in the winter and
Jackson in the summer. Born and educated in Devon, England, and
heading for New Zealand in 1947, Roy Kerswill decided to see
America first. The beauty of the Rocky Mountains put an end to his
travels. That his work is loved and appreciated is evident by the
collectors and art lovers from all over the world who have sought out
and purchased his paintings. Card and calendar companies have
reproduced his work in abundance and he has won awards too
numerous to detail. Roy says of his work, "I paint with the same
need as I eat. I paint because it is an adventure into something
strange and beautiful. I paint because it is pleasureable; like smelling
the rain, touching a child, loving a woman, singing to the wind or
listening to the hushed roar of wind in the forest. As I strive to reach
and understand this thing that I but barely sense, I become attuned
or embued with something very beautiful, and it is this exciting
sensation which drives me on. I suppose I'm addicted to painting, to
this inner urge to create and communicate."*

Kerswill's
Cornish Pasties

- ■ 1 recipe plain pastry (lard may be used in place
 of part or all of the shortening, if desired)
- ■ 1 cup beef (or pork), cut into small pieces
- ■ 1 cup potatoes, cubed
- ■ ½ cup onions, sliced
- ■ 1 cup white turnips or rutabagas, cubed
- ■ ½ cup gravy
- ■ salt and pepper to taste

Roll pastry ⅛" thick and cut out circles, 6 inches
across. Combine remaining ingredients and drop 2
spoonfuls on each circle. Fold circle in half and bring
edges together. Pinch to seal edges and place on cookie
sheet. Puncture top side of crusts with fork. Bake in 425
degree oven for 15 minutes. Reduce heat to 350
degrees and bake for 1 hour or until done. Makes 3
servings. Increase ingredients according to need.

"Cornish pasties have been used by tin miners,
farmers and fishermen for several hundred years. When
miners came to the U.S., they brought the pasty with
them. It has remained a popular meal in such mining
communities as Butte, Montana and Leadville,
Colorado and has recently received more nation-wide
notoriety as a nourishing 'all-in-one' meal."

Sharon and Ron Stewart
Scottsdale, Arizona

Ron Stewart was born in Brooklyn, New York and raised in California. After a move to Arizona, he studied with Austin Deuel and began painting with watercolors. He has refined his artistic abilities in watercolor and oils to a fine degree. The hallmark of a Stewart painting is the representation of a mood and atmosphere appropriate to his subject. The quality of Ron's work has not gone unnoticed by serious western art collectors. His work is represented in many private collections and he has won many awards. He, his wife Sharon and their four children live in Scottsdale where they raise Arabian horses.

Lasagna

- ¼ cup salad oil
- ¼ cup onion, minced
- 1 clove garlic, minced
- 2 pounds lean ground beef
- 5¾ cups stewed tomatoes
- 2 6-ounce cans tomato paste
- 2 teaspoons salt
- 2 teaspoons oregano
- ½ teaspoon pepper
- 1 package jumbo lasagna
- 2 cups creamed cottage cheese
- 1 pound Mozzarella cheese, sliced thin
- ½ cup Parmesan cheese, shredded

Cook onions, garlic and ground beef in salad oil until beef is lightly browned. Add tomatoes, tomato paste, salt, oregano and pepper. Cook covered over low heat for 1 hour, stirring occasionally. Cook lasagna according to package directions and drain. Arrange layers of meat sauce, lasagna and Mozzarella cheese in lightly-greased, shallow baking dish. End with Mozzarella cheese and sprinkle Parmesan cheese over top. Bake in 350 degree oven for 30 minutes or until cheese is melted. Makes 6 to 8 servings.

"This recipe was given to us 20 years ago (the first year we were married) by a very good friend. We usually serve it with a tossed salad, garlic toast and wine. It's excellent for company!"

Grace and Robert L. Knox
Carlsbad, New Mexico

Grace Knox grew up on a ranch at the foot of Saddleback Mountain in Colorado. When painting, she draws upon experiences for the portrayal of the West she loves. When viewing her western paintings, her understanding of her subjects is obvious. Grace's honors are many and her one-woman shows numerous. She is also represented on Leanin' Tree Greeting Cards and had the pleasure of doing a cover for Paint Horse Journal *magazine and has been featured in* Southwest Art Magazine. *Her portrayals of today's working cowboy, western landscapes, wildlife and Indians show her love, belief and emotions. Those that have a Grace Knox painting feel they are indeed fortunate to share the emotions of this gifted artist.*

Mexican Beef Casserole

- ■ **2 pounds lean ground beef**
- ■ **1 medium onion, chopped**
- ■ **½ teaspoon salt**
- ■ **1 teaspoon pepper**
- ■ **¾ teaspoon garlic powder**
- ■ **1 14-ounce can red chili sauce**
- ■ **2 cans cream of mushroom soup**
- ■ **1½ cans water**
- ■ **1 4-ounce can chopped green chilies**
- ■ **12 corn tortillas**
- ■ **¾ pound Cheddar and/or Longhorn cheese, grated**

Cook ground beef, onions, salt, pepper and garlic powder until meat is lightly browned. Add chili sauce and cook until onions are tender. In a separate pan, heat cream of mushroom soups (diluted with water) and green chilies. Line a large, greased casserole with 5 to 6 tortillas. Spread a 1-inch layer of meat mixture over tortillas. Sprinkle part of grated cheese over meat mixture. Cover with one cup of mushroom soup mixture. Repeat layers until casserole is filled. End with layer of cheese. Cover and refrigerate overnight. Bake at 350 degrees for 1 hour.

"This was the main dish at a surprise birthday party that my art students gave me once. I have used it many times when I have guests coming. You can make it the day before and then just pop it in the oven and serve with a tossed or guacamole salad. My husband Bob says he gets tired of everything in the house smelling like turpentine (oil painters never notice this!), but this recipe is strong enough to hold its own!"

Dayna and Gerry Metz
Scottsdale, Arizona

Gerry (pronounced Jerry) Metz was born in Chicago, Illinois. He received his formal art training there and credits as necessary and valuable discipline the five years he spent in commercial art and the additional five years as director of the Village Art School. Shortly thereafter, he began his pilgrimage to the West and eventually settled in scenic Scottsdale, Arizona where he now resides with his wife Dayna and their four sons. Gerry travels extensively throughout the West to gather background material for his paintings, and holds a special fondness for the Tetons in Wyoming and the desert areas of Arizona. Consequently, these areas often provide dramatic settings for his realistic portrayals of mountain men, Indians and cowboys. He works in a variety of media, but his personal favorite is opaque watercolor because he feels it adapts to his controlled yet spontaneous nature. Gerry has won many art awards and is listed in Who's Who in American Art *and* Who's Who in the West.

Mountain Man Beef Skillet

- 1 pound lean ground beef
- ¾ cup onion, chopped
- 1½ teaspoons chili powder
- ½ teaspoon salt
- ½ teaspoon garlic salt
- 1 16-ounce can whole tomatoes, cut up
- 1 15½-ounce can kidney beans
- ¾ cup rice (uncooked)
- ¾ cup water
- 3 Tablespoons green pepper, chopped
- Cheddar cheese, shredded
- corn chips

Cook ground beef and onion in large skillet until beef is browned and onion is tender. Drain fat and discard. Add chili powder, salt and garlic salt to meat mixture. Stir in undrained tomatoes and beans, raw rice, water and green pepper. Cover and simmer, stirring occasionally, for 20 minutes. Top with cheese and chips if desired.

"This is a fast, easy and delicious dinner for those hungry mountain men of yours. The little critters love it, too!"

Ruth and Fred Sweney
Issaquah, Washington

Fred Sweney began his art career during the big Depression. After two years at the Cleveland School of Art, more years in studios, at a big newspaper and free-lancing, he tried his luck as a wildlife artist, which is what he always wanted to be. After 30 years of painting a national wildlife calendar, teaching at Ringling School of Art, writing and illustrating three books on wildlife as well as many magazine articles, photographing a hunting safari in Kenya, painting special commissions, and creating limited edition prints for Wild Wings and the American Western Collection, Fred has recently completed writing and illustrating a new book, Painting Animals and Birds *for Prentice-Hall, Inc. This book includes comparative anatomy and was published this year. Listings in* Who's Who in the South and Southwest, Contemporary Authors, Who's Who in American Art *and* Personalities of the South *as well as several awards have made Fred feel that his 50 years in art was a worthwhile choice.*

Oven Barbecue Beef

■ **2 pounds beef (stew meat)**
■ **1 large onion, sliced**
■ **salt and pepper to taste**
■ **1 cup smoky-flavored barbecue sauce**
■ **1 large can mushroom bits and pieces, drained**

Put beef (as is) in large roaster. Spread onion slices over top. Cover beef and onion with barbecue sauce. Season with salt and pepper. Cover and bake at 350 degrees for 2 hours. Add mushroom bits and pieces, cover and bake for 30 more minutes. Makes 6 servings.

Note: The beef will absorb the liquid from the barbecue sauce which acts as a tenderizer. We like this dish served with buttered noodles and a fresh spinach salad.

"This recipe was conceived out of desperation. We socialized with a bunch of well-known artists and their wives and it finally became a real challenge to think of something different to serve. We dreamed up this oven barbecue dish because it was easy to make for a crowd, and were surprised to have the "gourmet" in the crowd rave about it. It promptly became an 'Old Family Secret Recipe' of course, until now!! Actually, my most successful cooking attempt was broiled lamb chops, baked potatoes and a simple salad. I invited a girl named Ruth to dinner, asked what dress she would be wearing and had pink roses as a centerpiece. I got a little help from some of the fellows' wives at the Cleveland Press as to how to fix the food. Ruth was so impressed, she has been Mrs. Fred Sweney for 47 years now! How's that for a method? In all seriousness though, I am really best at fried eggs!!"

74

Sandra and Harry Antis
Ann Arbor, Michigan

To Harry Antis, living and working as a wildlife artist is not just a profession, but rather a dedication. Bird and animals, mountains, forests and fields with all of their wonder and excitement, are a constant source of inspiration for him. Harry has been painting wildlife and western art on a full-time basis for over 12 years. More than 35 of his paintings have been reproduced as fine art prints. Using light, Harry has been able to add a depth and feel to his paintings that literally mesmerizes the viewer. He, his wife Sandi and their four children live in Ann Arbor, Michigan.

Porcupines in a Cabbage Patch

- 2 cans cream of tomato soup
- 1 pound lean ground beef
- 1 medium onion, diced
- 1 egg
- 1 cup Minute rice
- ¼ teaspoon garlic salt
- ¼ teaspoon onion salt
- ⅛ teaspoon salt
- ⅛ teaspoon pepper
- 2 cups water
- ½ head cabbage, shredded

In a bowl, mix together ½ can tomato soup, the onion, egg, rice and seasonings. Put remaining 1½ cans of soup in a large skillet and add 2 cups water. Stir. Form meat mixture into balls and place in skillet. Lay shredded cabbage leaves over the meatballs, cover and cook on medium heat for one hour.

"This is really a recipe for cabbage rolls; one day, I really ran short on time and took this shortcut. I thought the meatballs with the rice sticking out reminded me of porcupines, thus the name of the recipe was born. Harry loved the new creation and especially the name. We usually serve it with corn on the cob, applesauce and hot rolls."

Helori M. and Robert F. Graff
Art West Magazine
Bozeman, Montana

Founded in Kalispell, Montana in 1977, Art West Magazine moved to Bozeman in 1980. The magazine has been produced, since its inception, by Artcraft, Inc. owned by Bob and Helori Graff. In September, 1980, Helori became editor of the magazine and president of the publishing company, Art West, Inc. The magazine's emphasis continues on the western genre and strives toward excellence in all areas of the publication with great success. Vivian A. Paladin, editor emeritus of Montana *plays a very active role in the magazine and ably oversees the editorial process. Art West is a project which Bob and Helori and the staff share a deep dedication to. Top quality as well as contagious excitement about the future are always featured in its pages.*

Riley's Roast Beef, Western Style

- ■ **1 standing rib roast (not less than 5 pounds) with a moderate covering of tallow**
- ■ **10 pounds rock salt (or sufficient to cover roast; allow 1 pound salt per one pound of roast)**
- ■ **Worcestershire sauce (to taste)**
- ■ **½ cup water**

Put a one-inch layer of rock salt in the bottom of a large roasting pan. (Roasting pan should be large enough to be able to completely cover the roast with rock salt.) Apply Worcestershire sauce to the entire outer surface of meat and rub in well. Place meat in center of roaster, tallow side up, and completely cover with a one- to two-inch layer of rock salt. Sprinkle very lightly with ½ cup water. Bake in preheated oven at 500 degrees for 12 minutes per pound of roast for medium rare roast. For medium well roast, leave roast in oven an additional 15 minutes. Remove from oven and break away the salt. Slice into choice, delicious, mouth-watering style beef!

"This is Bob's recipe. It is a great favorite of ours and of our friends. Since the recipe was given to us by a friend, it has become our traditional Christmas dinner. It is delicious served with Yorkshire pudding and plenty of au jus. Enjoy!"

Jean and Howard Forsberg
Rio Rancho, New Mexico

Howard Forsberg was born in Milwaukee, Wisconsin. His mother and grandfather were artists and encouraged his early attempts at drawing. He studied art at the Layton School of Art in Milwaukee before moving to Chicago, Illinois and working as an apprentice at a large art studio there. It was not long before Howard became a very successful illustrator, completing assignments for such clients as Reader's Digest, Colliers, Woman's Home Companion, Budweiser, and Coca Cola, to name a few. Furthering a career necessitated several moves between Connecticut, Arizona and California. While in California, he owned and managed a large art studio. In 1976, he decided to forego his commercial work and become a fine western painter. He was anxious to return to the West, so he and his wife Jean moved to Rio Rancho, New Mexico and completed a house which they enjoy very much. Howard is a member of the Artists Guild of Chicago, the Art Directors Club of Los Angeles, the Society of Illustrators and has written and illustrated a book entitled An Approach to Figure Painting for Beginners, *published in 1979.*

HM

Sauerbraten

- 1 cup red wine vinegar
- ½ cup cider vinegar
- 1 cup Burgundy wine
- 2 onions, sliced
- 1 carrot, sliced
- 1 celery stalk, chopped
- 2-3 sprigs parsley
- 1 bay leaf
- 2 whole allspice
- 4 whole cloves
- 1 Tablespoon salt
- 1 Tablespoon pepper
- 4 pounds chuck (pot) roast
- ⅓ cup shortening or oil
- 6 Tablespoons flour
- 1 Tablespoon sugar
- ½ cup gingersnaps, crushed

In large glass or ceramic bowl (*not* metal), combine vinegars, Burgundy, onion, carrot, celery, parsley, bay leaf, allspice, cloves, salt and pepper. Wipe roast with a damp cloth and add meat to marinade. Refrigerate, covered, for 3 days, turning several times to marinate evenly. After 3 days, remove roast from marinade and wipe dry. Heat marinade in small saucepan. Meanwhile, heat shortening in large Dutch oven or heavy kettle very slowly. Dredge meat in 2 Tablespoons of the flour and brown on all sides in hot fat. Pour in marinade and simmer covered for 2½ to 3 hours, or until tender. Strain liquid from meat into a 1-quart bowl. Skim fat from surface and measure 3½ cups of the liquid back into saucepan; heat. Make a paste of ½ cup cold water, 4 Tablespoons flour and sugar in small bowl. Stir into hot liquid and bring to a boil, stirring constantly. Add gingersnaps and pour over meat. Simmer, covered for 20 minutes. Remove roast to heated platter, slice thin and pour gravy over it. Serve with more gravy and mashed potatoes or potato dumplings. Makes 6 to 8 servings.

"Although this recipe calls for beef, it would be equally tasty with venison or bear meat. The marinating for 3 days breaks down the fibers in even the toughest meat and will tenderize it. The aroma of this dish cooking is the greatest smell in the world and always brings back the days of my childhood when my mother used to make it. It has and always will be my favorite meal. It makes great leftovers — gravy, and meat over thick slices of homemade bread!"

Dennis Silvertooth
Corpus Christi, Texas

Dennis Silvertooth was born in Killeen, Texas and began his illustrious sculpting career at the age of 16. By the age of 21 he had participated in numerous one-man and group art exhibitions throughout the nation. "When I first began sculpting, all I was interested in was making something with my hands," says Dennis. "Then I became acquainted with Harry Jackson and was totally awed by details and realism." A sensitive, unassuming young man, Dennis has spent the last several years totally dedicated to the creation of his sculptures. The resulting works have taken awards at every juried competition into which they have been entered. Art collectors, appraisers and critics have been impressed by his strong and steady development as well as his singular technique of effectively blending realism, impressionism and heritage (his is Cheyenne/Cherokee). By combining natural talent and hard work, Dennis has produced in his art a distinctive, refreshing interpretation of the Native American Indian that is readily recognized by art appreciators everywhere.

Silvertooth Spaghetti
and Rich, Thick Tomato Sauce

- olive oil or shortening
- 1 clove garlic, minced
- 1 large onion, chopped
- 2 pounds lean ground beef
- 1-2 pounds lean ground pork
- salt and pepper to taste
- 2 29-ounce cans tomato sauce
- 1 12-ounce can tomato paste
- Italian seasoning to taste
- 2 carrots, grated
- 4 large tomatoes, diced
- 1 20-ounce can pitted black olives, sliced
- 1 Tablespoon sugar or honey
- spaghetti, cooked 'al dente'
- Parmesan or Romano cheese, grated

Heat oil in large kettle; add garlic and onion; cook over medium-low heat until brown and soft. Add meat and cook until lightly browned (no pink showing). Season mixture with salt and pepper to taste. Add tomato sauce and paste and simmer, covered, over low heat for at least 1 hour. The longer you can allow for the simmering process, the better. I usually let the pot simmer all afternoon. All day is even better. But remember to cook on very *low* heat — tomato sauce burns easily. While the sauce simmers, clean and cut your vegetables. Check your sauce regularly, stirring frequently and adding your favorite spices or Italian seasoning (you can make your own by mixing 1 teaspoon oregano, 1 teaspoon basil, 1 bay leaf — crushed, a dash of marjoram, thyme and red pepper).

Add sugar or honey about 45 minutes before serving time. Add tomatoes, carrots, olives and mushrooms toward the end of the cooking time to avoid shrinkage. During the last 15 minutes of cooking time, prepare your spaghetti according to package directions. Slip spaghetti into a warm, buttered serving dish and call your guests. It's time to eat. Garnish with grated cheese. Makes about 16 servings. Sauce freezes well and is good for late night "Hunger Panic!"

"Most of my recipes are the result of trial and error. As in my art, I have had no formal training, but have been fortunate enough to be around kind folks with the patience to pass on tips to me which have helped me survive. Generally, I forget to eat, but once in the kitchen, I really enjoy cooking and love eating the results. Most of what I cook is for myself when I'm alone at odd hours. Therefore, I always keep on hand the very basic staples: eggs, milk, butter, flour tortillas and Picante sauce. These will see any artist through many a long and cold night of studio work. Cans of chili and mushroom soup help too! When I left the 'nest' several years ago, my mom and sister gave me some advice: If you get lonely, you can generally find really nice ladies to meet at laundry mats and grocery stores; (I'm still not much for laundry mats, but I've had some great times shopping for groceries!) and when cooking spaghetti, 'al dente' (to the tooth) test by throwing it at the stove. If it sticks, it's done . . . ready for the tooth. I pass both tips on to you and hope they prove as worthy to you as they have to me!"

78

Ellie and Robert J. Weakley
Fort Collins, Colorado

Ellie Weakley's artistry puts color and light to life. One of Colorado's own, Ellie was born in Denver and raised in Nebraska and Colorado. She graduated from the University of Colorado in 1961 and began painting seriously in 1974. Strong support from two daughters and her dentist husband, Bob, has enabled her to paint and collect the works of western artists. Best known for her watercolors, Ellie paints florals, landscapes and people with equal liveliness, freedom and softness. Study with such artists as Ned Jacob, Charles Reid, Ramon Kelly and Lowell Ellsworth Smith allowed Ellie to develop a soft brushwork style that renders her subjects sensitively and warmly. As a family, the Weakleys enjoy traveling, skiing and fishing in the Colorado mountains not far from their home in Fort Collins.

Painter's (or Skier's) Stew

- 2 pounds beef (stew meat)
- 4 carrots, chopped
- 4 potatoes, quartered
- 2 onions
- 1 slice whole wheat bread, torn into pieces
- 2 Tablespoons Tapioca (optional)

- 1 Tablespoon sugar
- 1 16-ounce can whole tomatoes
- 1 16-ounce can water
- 2 teaspoons salt
- ½ teaspoon garlic salt
- ¼ teaspoon allspice

Combine all ingredients in a large roasting pan, cover and bake for five hours at 250 degrees. (You can also put in a medium crock pot and cook all day, if you prefer.)

"This stew came to me through the Fort Collins medical wives and is a wonderful meal to prepare as you leave to go painting (or skiing!) for the day."

Ilse and Harvey W. Johnson
Santa Fe, New Mexico

Born in New York City to a noted sculptor father and popular landscape artist mother, Harvey Johnson joined the Army near the completion of his senior year in high school, served two years in Europe and also managed to earn his high school diploma. Following his discharge, he enrolled in the Art Students' League in New York, just as his mother and father had before him. For almost 19 years, Harvey was instructor at the Famous Artists School in Westport, Connecticut while also producing hundreds of illustrations for men's pulp magazines. Although the subjects varied widely, the majority of the manuscripts were westerns. Eventually, totally dedicated to western painting, he moved to New Mexico. Harvey and his wife Ilse, the parents of three grown children, live in a charming adobe home overlooking the Santa Fe Trail. He is a charter member of the Cowboy Artists of America and has served the organization as vice-president and president; he has also received silver medals for his oils at two of their annual shows. Harvey has been the subject of many magazine articles and his paintings have been included in several books, including Western Painting Today *by Royal B. Hassrick. He is also listed in* Who's Who in American Art.*"*

"Spanish" Rice!

- 1½ pounds round steak, chopped
- 1 egg
- ⅓ medium red onion, chopped
- 1 teaspoon Italian seasoning
- 1 32-ounce jar Ragu Thick & Zesty spaghetti sauce
- 2 cups Quick brown rice

Mix first 5 ingredients in large bowl. Brown meat mixture in large skillet (I use a Silverstone pan and no oil) until meat is nicely browned. Add sauce and stir until mixed. Let meat simmer while you cook rice according to package directions. When rice is done, fluff and add to meat mixture. Makes 8 servings.

"This has been Harvey's favorite dish since I first made it, 'lo these many years ago. As you can see, there is nothing 'Spanish' about it! We serve this quite often at parties. I like to serve it with cole slaw to which carrot curls and sliced green onions have been added."

80

Sue and Grant Speed
Lindon, Utah

Grant Speed was breaking horses by the time he was twelve, working on neighbors' ranches. After years of riding the rodeo circuit, he got a bachelor's degree, taught school and began to sculpt in his free time. By the early '70s, he was creating bronzes full time. Grant's sculptures can be reflective as well as action-packed, but they are always characterized by their authenticity and sensitivity. He knows the West and he knows people. And into an area that takes steers and cowboys as its usual subjects, Grant has introduced women. His sensual portrait, The Half-Breed, won a gold medal at the 1976 Cowboy Artists of America exhibition. Grant is also the subject of the book From Broncs to Bronzes *by Don Hedgpeth and published by Northland Press. It contains 38 duotones of the work of one of the CAA's most accomplished sculptors and analyzes Grant's development as an artist and documents his career. He has cast many of his bronzes himself and a section of the book is devoted to the "Lost Wax Bronze Casting" method.*

Steak Stroganoff

- ½ cup onion, chopped
- 1 clove garlic, minced
- 2 Tablespoons oil
- 1 pound round steak, cubed
- ¼ cup flour
- 1 6-ounce can mushrooms
- 1 cup sour cream
- 1 can cream of mushroom soup, condensed
- 1 Tablespoon Worcestershire sauce
- ½ teaspoon salt
- ⅛ teaspoon pepper
- 2 Tablespoons cooking Sherry

In a large electric frying pan, saute onions and garlic in oil. Roll meat in flour, add to skillet and brown. Mix remaining ingredients together and add meat to mixture. Cover and simmer, stirring occasionally, for 1 hour or until tender. You may need to add a little more water while it's cooking, but not too much, as you need a thick gravy.

"We were invited to dinner at a friend's home, back in 1962 (I always date recipes I receive) and she served this Stroganoff. Grant and I liked it so much that we have it often. Whenever I serve it to guests, they always want the recipe, it is so well-liked. I usually serve it with a tossed salad, vegetable, homemade rolls and a light dessert. I also usually double the recipe, so we can have leftovers the next day. It is just as good. Hope you like it."

Vivian A. and Jack R. Paladin
Art West Magazine
Helena, Montana

A native of eastern Montana, Vivian Paladin began her distinguished writing career by working in a small printing plant in her hometown of Glasgow while she was still in high school. She eventually became a journeyman Linotype operator and attended the School of Journalism at the University of Montana at the same time. Later, she worked at several Montana newspapers, setting type and gradually working into writing and editing. In 1956, she began reading proof on Montana Magazine *and became associate editor and then editor of that illustrious magazine until her retirement in 1978. She is currently the consulting editor of* Art West *magazine and has had the great pleasure of writing and editing the Northwest Rendezvous Group's annual* Western Rendezvous of Art *catalogs and through those endeavors has come to know, love and appreciate the fine artists involved.*

HM

Stuffed Green Editor (Peppers)

- 1 egg, slightly beaten
- ⅔ cup milk
- 2-3 slices bread, cubed
- 1½ pounds lean ground beef
- ⅓ cup onion, chopped fine
- ⅓ cup celery, chopped fine

- 1 teaspoon salt
- ⅛ teaspoon pepper
- ⅓ cup catsup
- 1 teaspoon Worcestershire sauce
- 3-5 green bell peppers, halved

Preheat oven to 375 degrees. Combine egg, milk and bread. Allow bread to soak through. Mix in remaining ingredients except green peppers. Boil bell pepper halves (number depends on size) in water to cover for 10 minutes. Drain. Fill peppers with meat mixture. Place in shallow baking dish, pour 1-inch water into dish and bake peppers, uncovered, for 1 hour. Makes 4 to 5 servings.

"This was discovered by Jack, who often pinch-hits for me in the kitchen when I'm overwhelmed with editing, reading proof-copy, or doing laundry! It was originally a meat loaf recipe, but one day he harvested some extraordinary bell peppers in his greenhouse, brought them into the kitchen and stuffed them with the mixture he was about to shape into a loaf. It turned out great and we have it often."

Pamela and George Carlson
Elizabeth, Colorado

George Carlson was born in Elmhurst, Illinois and studied at the American Academy of Art and the Art Institute in Chicago and at the University of Arizona in Tucson. He has exhibited in many group and one-man shows at several museums including the Denver Natural History Museum, the Indianapolis Museum of Fine Arts, the Smithsonian Natural History Museum in Washington, D.C. and was honored with a one-man retrospective at the Phoenix Fine Arts Museum in Arizona. The National Academy of Western Art has honored his fine sculpting abilities with three gold medals, two silver medals and the Prix de West award at their annual shows held at the Cowboy Hall of Fame in Oklahoma City. His works are in private and public collections and he has been featured in several books, including The American Sculptors of the West *and* Treasures of the American West, *both by Patricia Broder and is the author of* The Tatahumara. *He also was featured in the 1981 Ken Meyer/Bill Kerr film production of* Profiles in American Art. *He and his wife Pamela live in the beautiful Colorado countryside of Elizabeth, Colorado.*

Swedish Meatballs

- 1½ cups soft bread crumbs
- 1 cup light cream
- ½ cup onion, chopped
- 3 Tablespoons butter
- 1 pound lean ground beef
- ¼ pound ground pork sausage
- 1 egg
- ¼ cup parsley, chopped fine

- 1½ teaspoons salt
- ¼ teaspoon ginger
- dash of pepper
- dash of nutmeg
- 2 Tablespoons flour
- 1 cup beef broth
- ½ teaspoon instant coffee

Soak bread crumbs in cream. Saute onion in 1 Tablespoon butter until tender. Combine meats, crumb mixture, onion, egg, parsley and seasonings. Beat vigorously until fluffy. Form mixture into 1-inch balls (mixture will be soft). Brown in 2 Tablespoons butter, removing meatballs as they brown. Drain. When all meatballs are browned, stir flour into drippings in skillet and add beef broth and coffee. Stir over low heat until gravy thickens. Return meatballs to skillet; cover and cook slowly over low heat for about 30 minutes, basting occasionally. Makes 4 dozen meatballs.

"This is a traditional Swedish dish — served either as a main course — or smorgasbord style. Both Pamela and I are of Swedish origin and, having been raised with the Swedish meatball, felt it would be an appropriate recipe for the cookbook. Enjoy."

Laura and Renne Hughes
Fort Worth, Texas

Renne Hughes, a soft-spoken Fort Worth artist, enjoys his work and receives great satisfaction out of knowing that the people who collect his works find enjoyment in them. He demonstrates a wide versatility by painting with oils and dry brush watercolors as well as sculpting in bronze. Renne's art has been published in several fine art magazines and has been featured on the cover of Cattleman *magazine and the* Paint Horse Journal. *His paintings are represented in many permanent collections, including the Favell Museum of Western Art in Klamath Falls, Oregon and the Diamond M Foundations Museum, Snyder, Texas. He has received several awards and participates in annual invitational art shows throughout the country.*

Texas Poverty Pot

- 1 pound round steak, cut into ½-inch cubes
- water
- 4 carrots, sliced thin (too many tastes too strong)
- 1 bell pepper, chopped
- 4 celery stalks, sliced thin
- 1 handful dried pinto beans, cooked
- 1 medium sweet onion, chopped
- 1 28 oz. can stewed tomatoes
- salt and pepper to taste
- 5 medium new potatoes, cut into 1-inch cubes
- 1 package Lipton Onion-Mushroom soup
- 1 can Blue Lake green beans (or Italian flat beans)
- 1 handful Rotini Curly-Roni noodles (too many spoils taste)

Brown steak in skillet. Fill 8-quart pot ⅔ full of water. Add all ingredients except green beans and noodles. Cook, covered, over low to medium heat about one hour or until vegetables are tender. Add dry noodles and green beans and continue cooking about 20 minutes or until noodles are tender. Add more water, if necessary. Feeds 15 people for a day or 2 people for a week, depending on the outcome of the last art show!

"This 'cowtown country concoction' originated out of necessity. When starting my career 13 years ago, I would go to the grocery store and buy all the makin's for five bucks. One pot would do us for a week, depending on how much water we added! Times are much better now, but this stew still tastes just as good now as it did then."

Pork

Joanne Hennes

Joanne and Wayne Hennes
Jackson, Wyoming

Joanne Hennes is a strong realist, finding her greatest inspiration in towering mountains. She has studied in Illinois, where she was born, and in Paris. Beginning her painting in the Alps, she has traveled extensively from the deserts of Egypt to the jagged volcanic peaks of Hawaii capturing the varieties of nature on canvas. Joanne finds the Grand Tetons in Wyoming to be a fresh and continuing challenge, and it is here that she and her husband Wayne have made their home. Joanne captures the magic of those mountains in oil. The varying textures that she creates with a palette knife give her paintings an unusual sense of depth. Her work has been exhibited in art centers throughout the West including the Montana Historical Society in Helena, Montana and the Buffalo Bill Historical Center in Cody, Wyoming, as well as several one-women shows at leading galleries. Joanne has chosen to paint subjects realistically because she believes that in this way her thoughts can most readily be shared with others.

Carnitas

- 1 pork butt
- salt and pepper to taste
- garlic powder to taste
- ⅔ small bunch cilantro (Chinese parsley)
- ½ head cabbage
- 6-8 radishes
- 1 small white onion
- 4 green onions
- 2 large ripe avocados
- 1 green tomato
- 4 green onions
- ⅓ small bunch cilantro
- juice of ½ lemon or lime
- dash hot sauce
- 1 teaspoon garlic powder
- dash cumin seed
- salt to taste
- 1 package corn tortillas

Coat pork butt with salt, pepper and garlic powder. Bake, covered, at 275-300 degrees for 4½ hours. When done, remove fat and shred meat with fork. Place in serving dish and keep warm. Finely chop the next 5 ingredients. (You may use a food processor if you wish.) Place in separate serving dish and keep cool. Make guacamole topping by mashing the avocados with a fork. Finely chop tomato, green onions and cilantro by hand. Add spices, lemon juice and hot sauce and let stand for a while to allow flavors to blend. Place in separate serving dish. Heat tortillas in oven, wrapped in foil, until hot and flexible. Place on warm platter with hot, damp towel over them. To serve: Allow each guest to fill his tortillas with the pork, vegetables and guacamole. Roll up filled tortillas and serve with your favorite salsa. To complete meal, serve with refried beans and Spanish rice. Makes 8 servings.

Ina and Fritz White
Loveland, Colorado

City Chicken

- 1 pound pork (or turkey)
- 1 pound veal
- 1 recipe of your favorite chicken batter
- bacon grease

Cut meat into 1½-inch cubes. Put on wooden skewers. (You can get these from your butcher.) Roll in chicken batter and chicken-fry in bacon grease. When done, just pick up sticks and eat! Enjoy!

Avis and John S. Wilson
Watertown, South Dakota

Country-Style Barbecued Spare Ribs

- ■ 3-4 pounds spare ribs, cut in pieces
- ■ 1 lemon, sliced
- ■ 1 large onion, sliced
- ■ 1 cup catsup
- ■ ⅓ cup Worcestershire sauce
- ■ 1 teaspoon chili powder
- ■ 1 teaspoon salt
- ■ 2 dashes Tabasco sauce
- ■ 2 cups water

John Wilson was born and raised in Sisseton, South Dakota, where he spent his boyhood days hunting and fishing. He still enjoys these activities which help him gather the necessary research material for his paintings. Following an eight-year stint in the Air Force, John attended the State School of Science in Wapeton, North Dakota and completed a year of architectural drafting. In order to more fully enjoy his strong interest in the out-of-doors, he started sketching and painting for his own pleasure. After 24 years as a designer and artist for a sign company, John is a relative newcomer to wildlife art, but his accomplishments over the past few years have been noteworthy. In 1979, and again in 1981, he won the South Dakota Pheasant Restoration Stamp contest and was one of two winners in a contest sponsored by the Council of Outdoor Art to promote South Dakota artists. He was further recognized as the 1981 Federal Duck Stamp competition winner. By nature, John is a concerned, soft-spoken and sincere person with a realistic outlook on his career as a wildlife artist. "I realize there is a lot of luck involved in any contest, and winning the Federal Duck Stamp Design doesn't automatically make you a wildlife artist. My goal now is to keep working at it and try hard to produce paintings people will like."

Place ribs in shallow baking pan, meaty side up. Place a slice of unpeeled lemon and a slice of onion on each piece. Roast in 450 degree oven for 30 minutes. Combine remaining ingredients and pour over ribs. Continue baking, lowering oven temperature to 350 degrees, for 1 hour or until tender. Baste ribs with sauce every 15 minutes. If sauce gets too thick, add a little more water. Makes 4 servings.

"Good with anything!"

Patricia and Mike Scarano
Port Angeles, Washington

The paintings of Patricia Scarano display a warmth, understanding and dignity that can only come from the artist herself. Whether it be a landscape, a contemporary Indian, or children, each painting shows a tenderness and sensitivity in dealing with these very special subjects. Although partially self-taught, she has studied with Leslie B. DeMille, David Barkley and John Pogany as well as attending the University of Washington. Her paintings are enjoyed and sold at many galleries across the nation and three of her paintings are in the permanent collection of the Favell Museum of Western Art in Klamath Falls, Oregon.

Easter Pie

- ■ 1 recipe of plain bread dough
- ■ 3 pounds fresh Italian sausage
- ■ 3 pounds ham, diced
- ■ 1½ pounds salami, diced
- ■ 1½ pounds sharp Cheddar cheese
- ■ 1 pound American cheese, diced
- ■ 1 dozen raw eggs
- ■ 1 dozen hard boiled eggs, diced

Roll bread dough out and place it in a 12"x18" baking dish, to make a crust. Fry sausage and drain off fat. Mix all ingredients together well and put into large baking dish. Bake at 350 degrees for 1½ hours or until set. Different cheeses may be used to suit the taste of the cook.

"This is an old recipe given to us by Mike's Italian aunt and is the traditional Easter Pie. It makes a very large pie which freezes well. It can be heated or eaten cold and makes a perfect meal with a tossed salad."

Lois and Terrill Knaack
Beaver Dam, Wisconsin

Terrill Knaack is a native of the Horicon Marsh area of Wisconsin where he grew up among the vast variety of bird life that inhabits those beautiful marshlands. Interested in drawing at an early age, he later studied art, photography and wildlife ecology at the University of Wisconsin. After receiving his degree, he devoted his full time to painting, in oil, the wildlife in its natural habitat. He credits his friendship and informal study with wildlife artist Owen Gromme as the greatest help in developing his painting skills. Terrill's North American bird and animal subjects are often painted in natural settings showing Wisconsin's woodlands, lakes, wetlands and prairies. His strong interest in hunting, canoeing and camping aid in generating new ideas for his paintings. His original oils are in collections throughout the country and he has several limited edition prints of his work displayed and sold in galleries in the U.S.

T.A.K.

Ham, Cheese and Kraut Packets

- 1 package Pillsbury crescent rolls
- 4 slices Swiss cheese
- 4 slices ham
- 1 16-ounce can sauerkraut, drained
- caraway seed
- 4 slices Cheddar cheese
- 1 egg, beaten

Press together the perforations between 2 crescent roll triangles. Roll out to form a 4"x8" rectangle. On one-half of the dough place 1 slice of Swiss cheese, 1 slice of ham, ¼ cup of sauerkraut, a pinch of caraway seed and 1 slice of Cheddar cheese. Fold other half of dough over and seal edges to form a 4"x4" packet. Brush top with beaten egg. Bake on ungreased cookie sheet at 400 degrees for 15 minutes or until golden. Recipe makes 4 servings.

"This is an easy, hearty meal to make ahead of time before a hunt, hike or cross country ski outing. Just make packets and store in 'fridge until ready to bake."

Frederic G. and Ginger Renner
Paradise Valley, Arizona

Frederic G. Renner holds a B.S.F. degree from the University of Washington and an M.S. from Oregon State University. He has published more than a hundred articles in the field of range management and five books about C. M. Russell including: Paper Talk: Illustrated Letters of Charles M. Russell *and* Charles M. Russell: Paintings, Drawings, and Sculpture in the Amon Carter Collection; *and compiled with Karl Yost* A Bibliography of the Published Works of Charles M. Russell. *Mr. Renner is a consultant to museums and art dealers and is considered the eminent authority on the life and works of the famed western artist. The always-gracious gentleman, Fred and his talented and western art enthusiast wife Ginger live in Paradise Valley, Arizona.*

HM

Ham Hocks and Lima Beans

- 1 16-ounce package large dried lima beans
- 1 ham hock (or the ham bone left from a roast)
- 1 teaspoon salt, or to taste
- butter

Wash beans well, cover with cold water and let soak overnight. Add ham hock to beans, add water to cover. Cook, covered, over low heat for 2 to 3 hours. When you think it is done, stir and taste . . . add more salt if needed and a chunk of butter, cover and cook a little longer.

"Don't add onions . . . that would spoil it! When the beans are tender (i.e., falling apart!) butter a thick slice of homemade whole wheat bread, pour yourself a tall glass of cold milk, spoon beans into a warm bowl with some of the ham meat and enjoy!"

Jim Daly

Carole and Jim Daly
Eugene, Oregon

Jim Daly was born in Oklahoma of Osage and Cherokee Indian parentage, and as a child, displayed such a talent for drawing that some of his illustrations won prizes from juried exhibits. His artistic talent continued to develop and after a three-year stint in the Army, he enrolled at the Art Center College of Design in Los Angeles, learning to master oils and acrylics, having already acquired expertise in charcoal and opaque watercolor. Jim is a highly dedicated artist who spends a great deal of time researching and studying rural America, the frontier and their artifacts. He especially likes to work with live models, using original props and costumes he has collected. For all their authenticity and studied excellence, Jim's paintings always reveal real people with honest, human emotions that touch the soul. He, his lovely wife Carole and their sons reside in beautiful, lush Eugene, Oregon. He is a member of the Northwest Rendezvous Group and consistently wins awards at their annual shows.

Lasagna

- 3 Tablespoons olive oil
- 3-4 cloves garlic, minced
- 1 medium onion, chopped
- 1 20-ounce can whole tomatoes, cut up
- 1 6-ounce can tomato paste
- 1 cup red wine
- 1 Tablespoon sweet basil
- 1 teaspoon salt
- 1 teaspoon freshly ground pepper
- ¾ pound Mozzarella cheese, sliced thin
- ¾ pound Ricotta cheese
- ½ cup Parmesan cheese, grated
- 1½ pounds sweet Italian sausage (or ¾ pounds ground beef and ¾ pounds sausage)
- ¾ pound lasagna noodles

In large skillet saute onion and garlic in olive oil until tender. Add cut up tomatoes, tomato paste, wine and spices. Simmer on low heat for at least 2 hours. When sauce is done, cook lasagna noodles according to package directions. Drain and place on paper towels to absorb moisture. Set aside.

Line a large, well-greased baking dish with strips of lasagna. Alternate layers of meat, sauce, Mozzarella, Ricotta, Parmesan cheese and lasagna noodles until all ingredients are used. Top with sauce and sprinkle liberally with Parmesan cheese. Bake in 350 degree oven for 20-25 minutes or until hot throughout. Makes 6 to 8 servings.

"This lasagna recipe is especially good and a favorite when guests come for dinner. We served this to Tom Browning, Don Prechtel and families the first time they came to dinner. The sauce also makes an excellent spaghetti sauce!"

Ann and R. Brownell McGrew
Quemado, New Mexico

R. Brownell McGrew has been a Westerner since leaving his birthplace, Columbus, Ohio, in childhood. After completing four years of study on full scholarships at Otis Art Institute in Los Angeles, he painted portraits, religious subjects, and did some matte shot and scenic work for motion picture studios. Winning the John F. and Anna Lee Stacey Scholarship in 1947 enabled him to devote many months to intensive study of landscape, particularly the California Sierra. He later focused his attention on the desert, whose harsh, demanding subtleties led him to a life-long fascination with the Southwest and its peoples. Dazzling colors of Navajo and Hopi apparel, shimmering contrasts of heat and coolness, and loving representations of the dignity of man and the grandeur of nature are magnificently portrayed in the incomparable art of the man known to his friends as "Brownie." He and his charming wife Ann have three daughters. He is one of the founding members of the National Academy of Western Art and holds honorary membership in many other professional art organizations. His book R. Brownell McGrew, published by Lowell Press and personally supervised by the artist, received the Publishing Industries of America's 1979-80 Best of Category in Trade Books Award as well as a Best Book Jacket Award.

Parsonage Sausage and Rice Casserole

- ½ pound pork sausage
- 1 cup raw rice
- ¼ cup onion, chopped (or to taste)
- 1 can chicken gumbo soup
- 1 can water

Brown sausage and drain. Place sausage in casserole and add remaining ingredients. Bake, covered, at 350 degrees for 30 minutes. Remove cover and bake for 30 more minutes or until top is browned. Add more water if necessary. Try these variations:

Chinese Missionary Rice

Add small cans of sliced water chestnuts and button mushrooms. Garnish with chopped almonds and green onions.

South of the Border Rice

Add small can of chopped green chilies. Top with grated Cheddar cheese during last 15 minutes of baking time.

Hawaiian Rice

Add small can of chunk pineapple and sprinkle top with chopped almonds and shredded coconut.

"This recipe can't be beat, because I got it from a minister's wife who said she could not have kept house without it, what with missionaries dropping in and all. It has endless possibilities. For one thing, if your artist is painting and forgets to eat, it can stay on warm for hours and not suffer too much. If another hungry artist or missionary drops in, you can add another can of soup and some more raw rice and carry on. If you sell a painting, you double the meat, of course!"

93

JoniFALK ©1979

Joni and Robert E. Falk
Phoenix, Arizona

Joni Falk's paintings have a luminous and captivating quality. Her extensive collection of Indian artifacts provides her with excellent subject matter and she incorporates them into her work with breathtaking detail. Joni's dedication to her art has resulted in much acclaim and recognition. She has won numerous awards and her work is not only in major art galleries and private collections, but also is in the permanent collection of the Favell Museum of Western Art, Klamath Falls, Oregon and the First National Bank of Arizona. Her work has been featured in Art West magazine and she has completed several offset lithographs and a stone lithograph available throughout the U.S. She and her artist husband Bob live in Phoenix, Arizona.

Pork Chop Barbecue

- ½ cup water
- ¼ cup vinegar
- 2 Tablespoons sugar
- 1 Tablespoon mustard
- 1½ teaspoons salt
- ½ teaspoon pepper, scant
- ¼ teaspoon cayenne pepper
- 1 slice lemon
- 1 medium onion, sliced
- ½ cup catsup
- 2 Tablespoons Worcestershire sauce
- 2 Tablespoons Liquid Smoke
- 6 pork chops, ½-inch thick

Mix water, vinegar, sugar, mustard, salt and peppers. Add lemon and onion. Simmer on low heat for 20 minutes. Add catsup, Worcestershire sauce and Liquid Smoke; bring to a boil. Place pork chops in shallow baking dish. Pour sauce over chops and bake, uncovered, at 350 degrees for 1½ hours, turning chops over once during middle of cooking period.

"Don't let the long list of ingredients throw you . . . it's worth the effort! I usually quadruple the recipe and freeze what I don't use. It's been a family favorite for over 20 years."

Linda and Gregory I. McHuron
Moose, Wyoming

Raised in Colorado, Wyoming, Alaska and California, Greg McHuron grew up surrounded by the West's varied and changing scenes. The desire to record these settings came early and continues to intensify. Schooled in fine arts as well as forestry, fisheries and wildlife at Oregon State University, Greg has been living and painting in the Tetons since 1973. His work in watercolor and oil, of the mountains and wildlife in the Jackson Hole area, are the realization of his desire to rcord moments in time which he has experienced. Annually, Greg visits Okanagan Game Farm in Penticton, B.C. to paint with other artists, with an emphasis on anatomical studies. He and his wife Linda live at the foot of the Tetons in Moose, Wyoming.

Sweet 'n Sour Pork
- 1 pound boneless pork (or chicken)
- 1 Tablespoon Sherry
- 2 Tablespoons light soy sauce
- 3 Tablespoons cider vinegar
- 4 Tablespoons sugar
- 5 Tablespoons water

Cut meat into large cubes. Place in saucepan or wok over high heat. Add rest of ingredients. Bring to a boil. Reduce heat to low, cover and simmer for 40 minutes. Uncover, turn heat to high and cook meat, stirring constantly, until liquid evaporates. Makes four servings.

Loretta and Joe Taylor
Cypress, Texas

Loretta Taylor has a sincere dedication and sensitivity toward her art which produces an appreciative response from collectors who enjoy paintings that have a true feel of the West. Loretta was born and raised on a ranch and studied at Hardin Simmins University, McMurray College and North Texas State University. Her hard work, studies and perseverance has paid off with a successful career in the world of western art. Loretta gives a lot of credit to well-known western artist, Lajos Markos, with whom she has had informal art training. Her subtle treatment of natural tones and interesting lighting contrasts in watercolor has won her numerous awards and she is represented by several fine galleries throughout the U.S.

Taylor House Specialty

- 1 pound pork pan sausage
- 1½ cups hash brown potatoes (can use frozen)
- 2 green onions and tops, minced
- ½ pound mushrooms (or 1 small can) sliced
- 1 large tomato, chopped
- 1 dozen eggs
- 1 avocado, chopped
- 2 jalapenos (canned), chopped
- salt and pepper to taste
- 12 flour tortillas
- 2 cups Longhorn or Monterey Jack cheese, grated
- sour cream

Crumble sausage in large skillet and lightly brown. Drain off fat. Add potatoes and onions to skillet. When potatoes are about half done, add mushrooms and tomato. Cover skillet and continue cooking while you beat the eggs until well-mixed. When tomatoes in skillet are soft, add eggs, avocado and jalapenos. Stir constantly until eggs are done. Cover half of a warm flour tortilla with egg mixture. Sprinkle grated cheese on top and fold over. Dollop with sour cream and serve. Makes 12 servings.

"Our friends always request this concoction for Sunday brunch. The best part about this recipe is that you can add, omit, or substitute all ingredients except the eggs. Just be sure to keep about the same proportions for whatever you choose to use and feel free to express your artistic freedom! We always serve these with plenty of extra jalapenos and Bloody Marys — never heard a complaint yet!"

96

Lamb & Veal

Mimi and Ed Jungbluth
Ruidoso, New Mexico

Momma's Lamb with Special Mint Marinade

- 1 leg of lamb (or shoulder roast) (5 to 7 pounds)
- 1 medium onion, chopped
- 1 lemon, cut in small wedges
- 2 teaspoons salt
- ⅛ teaspoon freshly ground pepper
- ½ teaspoon whole cloves
- ½ teaspoon garlic powder
- 2-3 parsley sprigs (or 1 teaspoon parsley flakes)
- 1 dash thyme
- 8-10 fresh mint leaves (or 1 Tablespoon dried mint)
- ¼ cup Worcestershire sauce

Rinse lamb and pat dry. Place in large roaster, mix remaining ingredients and allow lamb to marinate for 2 to 3 hours, turning several times. Then roast in 300 degree oven for 2½-3½ hours. Momma always stressed that lamb was best if cooked *slowly* on low heat . . . and that the lamb should still be pink inside . . . not rare, but not medium either — somewhere in between! (If you have a meat thermometer, remove lamb from oven when thermometer reaches 150 degrees for medium-rare meat.) When lamb is done, strain marinade sauce and serve as au jus.

"Thanks to Momma's special secrets (not always measured!) I have had the pleasure of following in her footsteps and leading many non-lamb-lovers to becoming 'dyed in the wool' appreciators of this feast!"

98

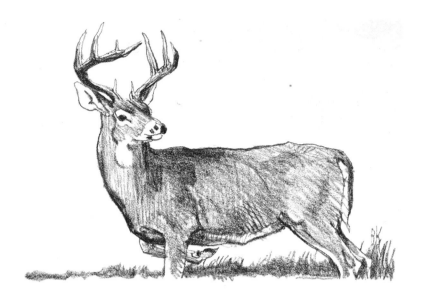

Veal and Dumplings Casserole

- ½ cup flour
- 1 teaspoon paprika
- 2 pounds veal, cubed (beef or venison can be used)
- ¼ cup oil
- 1 16-ounce can small onions
- 2 cans cream of chicken soup
- 2 cups Bisquick
- ⅔ cup milk
- 1 teaspoon poultry seasoning
- 1 teaspoon celery seed
- 1 teaspoon dried onion flakes
- 1 Tablespoon poppy seed (optional)
- ¼ cup butter
- 1 cup cracker crumbs
- 1 cup sour cream

Libby and Bob Kuhn
Roxbury, Connecticut

Bob Kuhn studied art at the Pratt Institute in Brooklyn, New York. He began his successful art career by illustrating books, calendars and magazines, until 1941 when he paused for time in the maritime service, then resumed his career painting for such magazines as Reader's Digest, True, Argosy, Outdoor Life and Field & Stream. In 1970, he began his fine art career and has had two books written about him, The Animal Art of Bob Kuhn and The Big Five both by Tony Dyer. He has several limited edition prints of African subjects on the market and his work is in the permanent collections of the Genesee County Museum, Rochester, New York; Wildlife World Museum, Monument, Colorado, and the National Cowboy Hall of Fame in Oklahoma City. Numerous trips to Africa, Alaska and Canada give him a wealth of subject matter to research and paint. His expertise has earned him a gold and silver medal at the National Academy of Western Art shows and the prestigious Purchase Award at the Wildlife Art Show at the National Cowboy Hall of Fame as well as several awards from the Society of Animal Artists of which he is a member.

Mix flour and paprika together and pound into veal. Cut into 2-inch cubes and brown in oil. Transfer to a 13"x9"x2" pan; add can of onions, 1 can of soup, 1 can of water and bring to a boil. Bake in 350 degree oven for 45 minutes or until meat is tender. To make dumplings; mix Bisquick with milk and seasonings. Drop by tablespoonsful into mixture of the butter and cracker crumbs. Roll to coat with crumbs. Top veal mixture with 15 dumplings, raise oven temperature to 425 degrees and bake for 20-25 minutes or until dumplings are brown. To make sauce; mix 1 can soup with the sour cream, heat just to boiling. Serve over meat. Makes 8 servings.

Wild Game

Robert H. Blair
Mountain Ranch, California

Bob Blair was born and raised in California and later left the Los Angeles area to live and work in the foothills of the Sierra Nevada, close to nature and the West he loves. Through his watercolors, and, occasionally, oils, the pages of American history have a new life. Art collectors and historians seek his empathetic portrayals of the people and times of the fur-trade era. From his research and imaginationn Bob composes scenes from the past, using authentic clothing, weapons and accoutrements to sing the praises of unsung heroes whose names and deeds were neither recorded or remembered in history booksm He has won several awards, is listed in Who's Who in California *and his paintings are in collections in Czechoslovakia, Saudi Arabia, West Germany and Canada as well as in the U.S.*

Blair's Trapline Chili

- 1 large onion, chopped
- butter
- 1 pound buffalo burger
- 1 pound ground sausage
- garlic salt to taste
- pepper to taste
- 2 large cans kidney beans
- 2 16 oz. cans tomato sauce
- 1 small can tomato paste
- 1½ cups brown sugar
- dried bell pepper flakes to taste
- chili powder to taste

Saute onion in butter. Brown meat in large skillet; season with garlic salt and pepper. Throw in onions and rest of ingredients and cook through.

"If it don't taste right, throw in some gun powder!"

Kathy and George Hallmark
Kopperl, Texas

Born and raised in the Cleburne area of north central Texas, George did not begin his formal art training until college. Like many of the successful artists of today, he has paid his dues through several years of commercial art and architectural design. His sincere appreciation and love for the West begins with his grandfather's ranch in Brady, Texas and continues today with George being not just an observer but an active participant in everyday ranch life. George is a versatile artist, working in several media including mixed media and charcoal. His sensitive portrayals of the people and animals of the West have a special quality that has gained the attention of collectors and critics who foresee a bright and shining future in the world of western art for this gifted artist. George, his wife Kathy and their daughter reside on a ranch in Kopperl, Texas.

Dead Armadillo Chili

- ◼ 3 pounds armadillo meat (or round steak)
- ◼ 1 large yellow onion, chopped
- ◼ 2 jalapeno peppers, sliced
- ◼ ½ clove garlic, chopped
- ◼ 2 10-ounce cans Ro-Tel tomatoes and green chilies
- ◼ 1 3-ounce can green chilies, chopped
- ◼ 2½ Tablespoons cumin (comino)
- ◼ 2 Tablespoons paprika
- ◼ 1 Tablespoon oregano
- ◼ ½ Tablespoon sage
- ◼ ½ Tablespoon black pepper
- ◼ 1 Tablespoon salt
- ◼ 1 Tablespoon red ant heads (optional)
- ◼ 3 Tablespoons margarine
- ◼ 1 shot glass Tequila
- ◼ water as needed

Place meat, salt and black pepper in large pot and sear. Puree Ro-Tel tomatoes in blender. Add tomatoes and rest of ingredients to pot. Bring to a boil, reduce to low heat and cook for two hours or until tender. Serve with grated cheese, Lone Star beer and fire extinguisher. Makes six to eight servings.

"This chili recipe has sustained me through many hard times and even some not so hard. It can be frozen for eating later or for removal of paint. Also, armadillo meat does not have to be used, any good meat found alongside the road can take its place. Of course, I've added my own touches to this recipe; however, the original recipe was copied off the men's room wall at Filthy McNasty's, a honky-tonk on Fort Worth's north side. Bon Appetit!"

Jessica Zemsky

Jessica Zemsky and Jack Hines
Big Timber, Montana

Born in New York City, Jessica Zemsky graduated from Pratt Institute and took so many art lectures and classes at the Art Student's League and various museums that the guards thought she was a staff member. She loves art and has never gotten enough of traveling, studying and painting her way to and through Europe and the West. The West's history, first hand encounters with the land, the seasons and people engaged in making their lives happen are Jessica's "meat," painting the now — with its new cast of characters — people bringing a new enthusiasm to life — a pride — and alone in concert with the place where they live and work. Jessica is a member of the Northwest Rendezvous Group, and with her talented artist husband Jack conducts the annual Zemsky/Hines Pro Art Workshops in Montana every August.

Elk Thing

- ■ **1 elk roast (whatever size someone gives you!)**
- ■ **2 onions, chopped**
- ■ **½ cup water**
- ■ **2 tomatoes, quartered**
- ■ **1-2 large cans tomato sauce**
- ■ **salt and pepper to taste**
- ■ **garlic and oregano to taste**
- ■ **lemon juice**
- ■ **1 package large noodles**
- ■ **butter**
- ■ **carrots, cut in chunks**
- ■ **broccoli, cut up**
- ■ **Parmesan cheese, grated**
- ■ **Mozzarella cheese, grated**

First, thank your friends for the roast! Brown meat and onions in large, heavy pot. Add ½ cup water and cook for ½ hour. Add tomatoes and 1 or more cans of tomato sauce and cook for 1 hour. (It's getting delicious now!) Add salt, freshly ground pepper, garlic, oregano and lemon juice to taste. Cook for 1 hour. Add carrots and broccoli pieces and cook for 1 more hour or until meat and vegetables are tender. Cook noodles according to package directions; drain. Coat large casserole with butter, add noodles, then meat. Sprinkle top generously with Parmesan and Mozzarella cheese. Bake at 350 degrees for 20-25 minutes or until hot and bubbly. Enjoy!

"This is one of those recipes that just happened — and so it was a happy and delicious surprise, and there is no tension about how it will turn out. It's fool-proof, no matter what fool puts it together — and it doesn't have to be served at a precise moment — which makes it nice for an artist-cook who gets involved in painting and forgets what's cooking. My only serving suggestion is to present it with wine — which smooths out all cooking problems. And, serve it to Jack, who thinks game meats are the best, and I agree!"

Ingrid and Howard Rees
Auburn, California

Growing up in Utah, Howard Rees has had a life-long interest in art, as well as a strong feeling for the West. He received his formal training at the Art Center College of Design in Los Angeles and after his graduation, he worked as a designer for Ford Motor Company's line of Mustang cars and at Mattel Toy Company as a concept designer/artist. Now, as a full time artist, working mainly in transparent watercolor, he is totally dedicated to his art. His paintings focus on the soft use of light to enhance a sense of tranquility evident in each of his reflections of things remembered and observed. He, his wife Ingrid and son Ryan live in a beautiful area of northern California where Howard's long time dream of having a studio has become a reality.

Foot Warmer Stew

- 2 pounds bear meat, cut into 2" cubes (may use beef stew meat)
- 2 Tablespoons shortening
- 2 medium onions, sliced
- 2¼ cups water
- 2 whole cloves garlic
- 3 bay leaves
- 1-3 teaspoons chili powder (depending on how hot you want your feet!)
- 1 Tablespoon salt
- ½ teaspoon pepper
- 1 6-ounce can tomato paste
- 1 16-ounce can small white onions
- 2 15-ounce cans red kidney beans
- 1 cup green pepper, sliced
- 8 carrots, quartered
- 3 Tablespoons flour
- ⅓ cup cold water

Place meat, shortening and 1 of the sliced onions in a large dutch oven. Season with salt and pepper and brown thoroughly. Add 2¼ cups water, the other onion and the next 8 ingredients. Cover and let simmer for an hour and 15 minutes or until meat is fairly tender. If you can, find the garlic cloves and remove them. (If you can't, someone will, while you're eating!) Add green pepper and carrots, cover, and continue cooking for 30-40 minutes or until carrots are tender. If stew needs thickening, slowly blend flour with cold water and add to stew, a little at a time; stir until thickened. Makes 1 serving for a mountain man or 6 to 8 servings for "regular" people. Goes good with big chunks of fresh bread and a side of slaw.

"This recipe started out as a typical 'Good Ol' American' stew, but in the Rees house, it became a little less typical by taking on more of a chili-stew flavor. I've been known to add paprika and Tabasco sauce to the mixture, but then I've been known to do a lot of things!"

105

Patsy and Gene Zesch
Mason, Texas

Gene Zesch was born and raised on a ranch in Mason County in the Texas Hill Country where he still lives. He learned early in life about the problems that plague the modern cowboy. During his years as an Army pilot, Gene started carving; after many years of self-training, he turned to carving as a profession. He treats the hardships encountered by today's rancher with humor and affection. His characters do not bring to mind the weekend cowboy of today or the Hollywood wrangler of yesterday; instead, his figures represent the cowboy who still exists today, but just barely. They drive 1948 Jeeps held together with bailing wire. They patch irreparable fences with scrap tin and sticks, and Bull Durham sacks dangle from their shirt pockets. Gene believes that wood is an excellent medium for caricature. He concentrates on facial expressions using bold knife cuts to create his timeless faces. Gene's unique and special art form expresses the tragicomic life of the modern rancher in terms of humor rather than pathos and his work is collected throughout the country.

"WE'RE THE ONLY PEOPLE THAT STARVING ARTISTS CAN LOOK DOWN ON!"

Jerky

- ■ **venison (or beef)**
- ■ **salt and pepper**
- ■ **red pepper**
- ■ **brown sugar**

Make jerky in cool, dry weather Cut strips of venison about ¼-inch thick, 2 inches wide and 8 inches long. Salt and pepper to taste. Rub a small amount of red pepper and brown sugar over all. Thread on a piece of string. Smoke briefly for flavor. Do not cook. Hang to dry for 2 to 3 days depending on weather conditions.

"Good for snacks."

Carol and Skip Seaver
C. M. Russell Auction
Great Falls, Montana

The C. M. Russell Auction of Original Western Art held its fifteenth show at the Heritage Inn in Great Falls, Montana in March of 1983. The grand-daddy of all the annual invitational western art shows, the Russell show is noted for its quality art and exciting activities. There are two evening auctions, both preceeded by Quick Draws, a reception at the C. M. Russell Museum, a Chuckwagon brunch, "Best-of-Show" juried and public awards, 96 exhibit rooms, seminars of unusual interest and special honored guests as well as lots of fun. Artists and collectors agree, it is one of the finest and most hospitable shows around the country today.

Moose Mozzarella

- ■ 1 4-pound chunk of moose meat cut into 8 round steaks
- ■ ¾ cup flour
- ■ 6 Tablespoons shortening
- ■ 1 Tablespoon salt
- ■ ¼ teaspoon pepper
- ■ ½ teaspoon savory seasoning
- ■ 2 cups water
- ■ 1 cup celery, chopped
- ■ 1 cup green peppers, chopped
- ■ 2 16-ounce cans stewed tomatoes
- ■ ½ pound Mozzarella cheese, sliced thin

Dredge steaks in ½ cup of the flour and brown in shortening. Transfer from skillet to large roasting pan. Blend remaining ¼ cup of flour with hot drippings in skillet. Add seasonings, gradually blend in water and then add vegetables. Cook, stirring constantly, until slightly thickened. Pour mixture over meat and bake, uncovered, at 350 degrees for 3 hours or until meat is fork tender. Just before serving, top with Mozzarella cheese and heat just until cheese melts.

"Skip hunts a lot here in Montana and we regularly eat deer, antelope, elk and moose. We have come to prefer it to beef and even birds and trout. Many of our frequent dinner guests don't know what meat they are eating until they ask for seconds. Properly hunted and prepared, it is a wonderful treat. Bon Appetit!"

Marian and Ron Jenkins
Missoula, Montana

Ron Jenkins was born in Pawtucket, Rhode Island and, like so many artists, is primarily self-taught. He attended the Philadelphia Museum School of Art and has illustrated and written short stories for numerous publications. The list of his credits is long and includes winning the coveted Duck Stamp award in 1965 and being selected for his prints by the National Wildlife Art Exchange. Ron, his wife Marian and their five sons frequently explore the deep woods and fish the brawling creeks in their beloved western Montana mountains. He is a dedicated fisherman and ardent birdwatcher, and it is this intense interest and personal feeling for his subjects that comes through in his accurate and finely detailed wildlife paintings.

Papa Celeste's Mess

- **4 medium-sized venison round steaks, cut into 1½-inch cubes**
- **6 eggs**
- **1 package saltines (12-15 crackers)**
- **butter-flavored salt**
- **lemon pepper seasoning**
- **mushrooms (optional)**
- **green peppers (optional)**
- **onions (optional)**

Place meat and all remaining ingredients in a large skillet and cook on medium-high heat, constantly stirring and turning. Add or omit any seasonings and vegetables, to taste. The entire mess will be ready to eat when the meat is cooked the way you like it. Makes 4 to 5 servings.

"This recipe is the brainchild of Lloyd Jackson, a friend who lived near us in Arlee, Montana. He likes to experiment and probably developed this dish out of necessity when the pantry was nearly empty. It's quite delicious and filling."

Margaret and Joe Halko
Cascade, Montana

Joe Halko was born and raised in the Great Falls, Montana area. He graduated from the College of Great Falls, served two years in the Army and worked as a taxidermist for 17 years before pursuing an art career. His favorite subject matter as a sculptor is wildlife, but enjoys creating historical subjects as well. Joe also enjoys hunting, fishing and camping. He has made several trips to Alaska to study and research his favorite subjects. He is a member of the Society of Animal Artists and the Northwest Rendezvous Group, has received numerous awards and has a bronze in the permanent collection of the Leigh Yawkey Woodson Art Museum in Wausau, Wisconsin. Joe, his wife Margaret and their two daughters live in Cascade, Montana.

Pheasant

- 2 pheasants
- bacon grease
- 2 cups water
- salt and pepper
- 2 cans golden mushroom soup

Season birds generously with salt and pepper. Brown whole birds in bacon grease. Add water, cover and simmer for 1 hour or until meat is tender. Add the soup and cook for 30 more minutes. Use the soup mixture as gravy if desired. Serve immediately. Makes 4 servings.

"This recipe came from a tired, hungry hunter-chef-friend of ours from Alaska. It's easy to prepare and leaves plenty of time to tell old and new hunting stories. We usually serve it with rice, tossed salad and a good bottle of wine."

Sandy Scott
El Paso, Texas

Scott's Moose Chili

- 6 big chili pods (or 6 Tablespoons chili powder)
- 1 pound beef suet
- 5 pounds lean moose meat (ground coarse for chili)
- 1 large onion, chopped fine

- ½ cup chili powder
- salt to taste
- 1 Tablespoon oregano
- 2 Tablespoons cumin (comino)
- 6 small jalapeno peppers

Soak chili pods in hot water for 15 minutes. Remove seeds and run through food processor. Put suet in large, heavy kettle and render. Strain fat and return to kettle. Add moose meat and brown while stirring. Add onion, prepared chili pods, ½ cup chili powder, salt, oregano and comino. Run jalapeno peppers through food processor and add. Cover with water, mix well and simmer on low heat 2 hours or until it gets thick.

"I don't consider myself a good cook, but my mother, sister and many of my friends are. I did do the cooking for the two years that I lived with my father on the farm. We would go to Canada during the spring and fall, as we have done for years, and bring back fish (walleyed pike), grouse and moose meat. I hope you like my moose chili. You can serve it plain or with Mexican red beans or spaghetti on the side.

Vel and Warren Miller
Atascadero, California

Vel Miller, born in Wisconsin and a California resident since childhood, has lived in a ranching and farming environment most of her life. She has a love and keen knowledge of the animals, people and the big sky country of the West. Actively involved in the arts since her school days, Vel studied under Max Turner and Hal Reed at the Art League in Los Angeles with whom she later taught for three years. She also received valuable advice and instruction from her good friend, the late Jo De Yong. Vel concentrates mainly on western American subjects, but as Vel says, "I am interested in painting the West from a woman's point of view. There is a tender and loving side of life and that is what I want to portray." Her paintings have a serene and gentle quality, a romantic realism that is universally appealing. She is listed in Who's Who in American Art *and* Who's Who in the West.

Vel's Buffalo Lasagna
(a.k.a. Irish Lasagna)

- 1 pound buffalo meat (or lean ground beef)
- ½ pound pork sausage
- olive oil
- 1 large onion, chopped
- 2 cloves garlic, minced
- 2 28-ounce cans tomato sauce
- 2 Tablespoons parsley flakes
- 3 Tablespoons Spice Island spaghetti seasoning
- 2 teaspoons sugar
- 1 teaspoon fennel seed
- ½ pound fresh mushrooms, sliced
- 1 8-ounce package cream cheese
- 1 pint sour cream
- 1 pound Jack cheese
- 1 large bunch green onions, chopped
- 1 package lasagna noodles
- Parmesan cheese

In large, heavy skillet, brown meat in oil. Add onions and garlic and saute until tender. Add sauce, seasonings and mushrooms; simmer on low heat for 1 to 2 hours or until sauce is thick. Cook noodles according to package directions. Cream together the cream cheese and sour cream. In a large, well-greased, shallow pan layer noodles with Jack cheese, tomato sauce and cream cheese mixture, repeating until all is used. End with sauce. Sprinkle liberally with Parmesan cheese. Bake at 350 degrees for 35-40 minutes or until hot and bubbly.

"I'm used to cooking for a crowd, so I always make large batches of things like spaghetti sauce. This recipe is easy to double or triple. It freezes well and I usually make enough for two or three meals and freeze what we don't need at the time. (Freeze before you bake and bake an extra ½ hour.) It's a great recipe for a party. Serve with a crisp green salad and crusty bread."

Mel Dobson
Jackson, Wyoming

When he was growing up on his father's ranch in the foothills of Utah, Mel Dobson became very fond of the wild country that surrounded him and the numerous varieties of wildlife he discovered there. He also liked to draw. After 18 years as a draftsman for the Washington State Game Department, Mel chucked it all one day to pursue an art career. Mel now works with scratchboard; a heavy, clay-coated paper covered with a thin layer of black ink. He sometimes spends days creating the tiny details evident in every sketch, by scratching away the ink with a sharp knife. This reverse method of drawing requires that he think in terms of sheen and highlight, rather than shadows. At first, Mel worked only in black and white. In recent years, he has perfected a full-color technique and added a new dimension to the realism he achieves in his beautiful drawings.

Venison and Gravy Old Fashioned Style

- venison steaks, sliced very thin
- salt and pepper to taste
- bacon grease
- ¼ cup flour
- ½ cup onions, chopped
- 1 clove garlic, chopped (optional)
- hot water

Sprinkle thinly sliced venison with salt and pepper, and lightly dust with flour. Fry in bacon grease until browned well, remove from skillet. Saute onions and garlic in the grease; stir in ¼ cup flour, salt and pepper to taste. Slowly add enough hot water to make a medium-thin gravy. Stir well. Add venison, reduce heat to low and simmer until meat is tender. Serve with hot homemade bread and butter.

"I was raised on a ranch in west central Utah near the town of Holden and was the youngest of eight boys. Our winter meat was venison as there were many mule deer in and around our mountains. My best memories are of breakfast venison steaks, browned with homemade bread on top, steamed in the fry pan."

112

Jean and Sam Senkow
Bordurant, Wyoming

Venison Piddaha

- 1½ cups all-purpose flour
- 1½ cups whole wheat flour
- 1 teaspoon salt
- ½ cup plain or vanilla yogurt
- ½ cup sour cream
- 2 eggs
- 5-6 large potatoes, peeled
- ¾ cup cooked spinach, chopped
- 1 cup cooked venison, finely chopped
- 1¼ cup Cheddar cheese, grated
- butter for frying

Boil potatoes in 1 inch of lightly salted water for 30-40 minutes or until tender. Drain and mash. Add spinach, meat and cheese; mix well. Set aside. To make dough, mix the flours and salt. Set aside. Stir yogurt until creamy, add sour cream and eggs; mix well. Stir yogurt mixture into flour. Knead. Dough should be slightly sticky. Divide dough into pieces the size of baseballs and roll as thin as possible on a floured board. Cut each piece in half and place ¼-½ cup of venison mixture in center of each. Fold dough in half and seal edges by pressing with a fork. Bring a pot of salted water to a boil and boil each piddaha until it floats. They can be served at this point, or lightly fried in butter and served with a dab of sour cream.

"The Ukrainian Piddaha is a meat, vegetable and starch (even dessert) enclosed in a delicious pastry. We live above 7000 feet and are outdoors a lot. We have found that you can snowshoe a far piece with a few of these resting in your belly!"

Temple and Tom Beecham
Saugerties, New York

Venison Steak with Milk Gravy

- 1 venison steak, ½"-¾" thick
- ice water
- salt and flour
- hot fat
- 1 heaping Tablespoon flour
- milk

Dip steak into ice water or cold stream. Quickly shake off excess water. Dust liberally with flour and salt. Fry in ¼" of hot fat in large cast iron skillet until golden brown. Remove steak and loosen crusty bits from skillet and keep warm. Add heaping tablespoon of flour to bits and fat; stir. Add milk in small amounts, stirring constantly until skillet is about ⅓ full. Continue stirring and cooking until thick, but do not boil.

"Here it is, folks! Tom Beecham's all-time favorite! Serve this up with hot, buttered biscuits. This method of cooking really enhances the flavor of venison better than any other. Too many recipes try to cover it up with some dang sauce!!"

Elaine and Loren Fry
Benton Harbor, Michigan

Loren Fry's paintings convey the excitement and realism of modern-day ranching. Through his artistic talents, Loren hopes to involve those who are unable to experience ranch life in the back country, where the cowhand and his work horse are partners. Much of his inspiration comes from time spent at the Fear Ranches in Big Piney, Wyoming where he is active in all phases of ranching from timbering to fence mending. Loren's superb work has appeared in Southwest Art, Western Horseman and the Quarter Horse Journal and 12 of his paintings were reproduced as a calendar by the Acme Boot Company. He, his wife Elaine and son Lance live and work on their Michigan farm.

Venison in Wine

- 1 pound round steak from a young buck, cut into 1-inch cubes (remove fat and gristle)
- 1 large onion, coarsely chopped
- 1 clove garlic, coarsely chopped
- red wine vinegar
- ½ green pepper, diced
- 4 Tablespoons margarine
- flour
- salt and pepper to taste
- 1 cup dry, red wine
- 1 bay leaf
- ½ small head cabbage, chopped
- 1 cup milk
- 1 teaspoon dry mustard

Place meat, onions and garlic in earthenware bowl; pour red wine vinegar over all to cover. Let stand, covered, in refrigerator for 24 hours. Pour yourself a glass of wine. Remove meat from marinade and strain out onions and garlic. Set aside. Save marinade. In large skillet, saute marinated onions and garlic with green peppers in margarine. Shake meat in paper bag with flour (add salt and pepper to taste if you wish). Brown gently with onion mixture. Try another sip of wine. If it is judged good, add wine and bay leaf to meat mixture. Bake, tightly covered, in a 325 degree oven for 1 hour or until meat is tender. Add chopped cabbage to leftover marinade and bake in separate covered container in oven along with meat. When venison is tender, add cabbage mixture to it; stir. Add milk, dry mustard and enough flour to thicken. Simmer for 5 minutes, stirring constantly. This recipe is best served over dumplings. Makes 4 to 6 servings.

"If you're a real wine lover, using wine for cooking may hurt a little!"

115

Elaine and Loren Fry
Benton Harbor, Michigan

Wild Rabbit in Mustard with Dumplings

- 1 wild rabbit, cut up
- flour
- 8 Tablespoons margarine
- 2 Tablespoons oil
- Dijon mustard
- 1 small onion, diced
- 1 cup mushrooms, chopped
- 3 Tablespoons flour
- 2 cups cream
- ½ teaspoon salt
- ½ teaspoon pepper
- 2 eggs
- ½ cup milk
- 2 cups flour
- 2 teaspoons baking powder
- 1 teaspoon salt
- 2 slices bread, diced

Dredge rabbit pieces in flour and brown with 5 tablespoons margarine and 2 tablespoons oil. Remove to hot platter and brush with Dijon mustard; set aside. Add 3 tablespoons margarine to same skillet and saute onions and mushrooms. Stir in 3 tablespoons flour and the cream. Cook, over low heat, stirring constantly, until slightly thickened. Arrange rabbit pieces in casserole, sprinkle with ½ teaspoon each salt and pepper. Pour sauce over top. Bake, covered, in a 300 degree oven for 1-1¼ hours. To make dumplings, whip eggs, then add milk and mix with dry ingredients. Divide in half and shape like bread loaves, using plenty of flour on hands to prevent sticking. Place in large pot of boiling water. Float on each side for 10 minutes. Drain. Slice like bread and serve hot. Delicious! (Works well with chicken, too.)

"Part of my year is spent on the ranches of the West and part in my studio in Michigan. Even at home, I'm rarely more than 50 yards from horses. I ride 'em, feed 'em and care for 'em when they're sick. In the West, I feel what it's like to perform a working function with a horse and what a remarkable athlete he can be. The excitement of working cattle under all conditions and in all terrains is almost overwhelming to me. It's always an adventure to ride the barren high country, the cottonwood bottoms and all that lies between. Even the sharp clicking of shoes on rocks as you ride across sage flats and the bawling of calves are sounds I can hear as I sit at my easel. Hopefully, all this filters down to my paintings and to you."

Seafood

A. Mickelson

Arlene Mickelson
Issaquah, Washington

Arlene Mickelson was born in the Pacific Northwest and raised on the beaches of Puget Sound. She attended the University of Washington where she majored in ceramic art. Working primarily as a sculptress, she also enjoys working with embossings and pottery. She portrays her deep interest in Indian art with an emphasis on Northwest Coastal Tribes. Developing her style around the culture of these Indians, Arlene brings to life the warm earth tones and intricate detail of an art form typical of Washington, Alaska and British Columbia. Her knowledge of the customs and mythology of the Pacific Northwest is evident throughout her work. Long hours are spent researching patterns and meanings behind each creation. Her work has been shown in galleries from Seattle to New York and she is a member of the American Artists of the Rockies.

Barbecued Salmon

- **salmon filets**
- **hickory-smoked salt**
- **½ cup butter**
- **Juice of 1 lemon**
- **2 Tablespoons white wine**
- **Parmesan cheese**

Place salmon filets, skin side down, directly on rack or grill over hot coals. Sprinkle with hickory-smoked salt. Mix remaining ingredients and baste salmon with sauce. Cover loosely with aluminum foil. Cook approximately 15 minutes per inch thickness of filets, basting every 5 minutes until salmon is cooked through but not cooked dry. Remove from grill and sprinkle with Parmesan cheese, if so desired, and serve with lemon. (The secret to this recipe is the hickory-smoked salt.)

"The Indians tell us that the Salmon People lived in five different villages in the sea. In early spring, they changed from human form into salmon form and started their long journey across the ocean and up the rivers of the Pacific Northwest Coast. The spring Chinook came first alerting the other villages of sockeye, humpback, chum and coho. The salmon were and still are, to a certain degree, an important food resource to the peoples of the Pacific Northwest. The Indian legends tell us how they were brought to the sea, rivers and lakes. The recipe above is one way it can be brought to your table for a typical Pacific Northwest treat."

Alderson Magee
Sharon, Connecticut

After a 15-year career in the field of aviation, Alderson Magee began to pursue his career in art, concentrating on the unique medium of scratchboard engraving. He learned this fascinating technique in Europe and has spent many years seeking to master this century-old art form. Striving for extremely fine detail and brilliant contrasting effects, he uses engraving tools to cut through a dense black India ink surface to a pure white under layer of China clay. His skillful handling of this medium is well-suited to wildlife and his accomplishments in that field include the 1976-77 Federal Duck Stamp Award. He has received nationwide recognition and is listed in Who's Who in American Art.

HM

Poor Man's Pasta

- fettucini
- smoked Scotch salmon, chopped
- whipped Jersey cream
- Parmesan cheese, grated
- caviar
- white truffles
- scallions, minced (optional)

Cook freshly-made fettucini in salted water, drain and mix in the chopped salmon (¼ bulk of the pasta). Mix a few tablespoons Jersey cream with Parmesan cheese and caviar (be careful not to break the eggs). Add to pasta mixture. Shave white truffles over pasta with a vegetable peeler or truffle slicer. Sprinkle top with minced scallions (white and green parts) if so desired. Now you know that the "poor man" refers to your financial state *after* preparing this pasta!

"This recipe was created one early, cold, fall morning while Mark Taverniti (president of the American Western Collection, Bozeman, Montana) and I were sitting in a duck blind. The birds were not flying and with no breakfast, our thoughts turned to food. I love fine cuisine involving seafood and Mark loves his pasta — thus the combination."

Darlene and Melvin Johansen
Merlin, Oregon

Melvin Johansen has had a lifelong interest in wildlife and has devoted his life to its various aspects. A native of the Bay area, he began his career as a taxidermist with the Oakland Natural Science Museum. He also became well-known as a wildlife photographer and his work appeared in many national magazines and in motion picturesm Mel left the museum as senior curator several years ago to devote his talents to sculpting big game animals. His years in taxidermy and in museum work gave him a great insight into animal anatomy. This consciousness combined with looseness and freedom of style has made his bronzes highly appealing and sought after by collectors here, in Africa and in Europe.

Salmon Souffle

- 1 7-ounce can salmon, drained and boned
- freshly ground pepper to taste
- 1 Tablespoon lemon juice
- ½ teaspoon lemon rind
- ½ cup soft bread crumbs
- ½ cup light cream or Half & Half
- 3 egg yolks, beaten
- 3 egg whites, stiffly beaten
- ¾ cup green peas, cooked
- ½ cup carrots, cooked
- ¼ cup canned mushrooms, sliced
- 1 cup creamy mashed potatoes
- ½ teaspoon parsley flakes

Flake salmon with a fork. Add the next 5 ingredients and mix well. Fold in egg whites. Pour mixture into buttered casserole. Top with peas, carrots and mushrooms. Dot vegetables with butter and season with salt if so desired. Lightly spread mashed potatoes over top. Sprinkle with parsley flakes. Bake in a 350 degree oven for 20-25 minutes or until golden brown. Serve with tartar sauce and lemon wedges. (You can omit vegetables entirely, if you wish.)

"This salmon souffle came out of a "Cookbook for Two" we used after two hungry, teenage boys grew up and left the nest. Reducing menus needed a little re-thinking at first and this light, tasty and inexpensive dish came in handy. (Actually it can serve 2 to 4, depending on appetites.)"

Flavia and John Scott
Ridgefield, Connecticut

John Scott's art career began in earnest while he was a combat artist/correspondent for Yank Magazine during World War II. He followed this with three decades of covers, articles and illustrations for Sports Afield. His "Garcia Series," paiintings commissioned by the tackle company to immortalize the best fishing areas, made him world famous. Another series of ten paintings illustrating the early days in Texas and Oklahoma oil fields is on exhibition at the Oil Museum in Midland, Texas. His largest works, 12'x32' murals commissioned by the Mormon Church are in Salt Lake City and Washington, D.C. For the last several years, John has worked almost exclusively recreating the early West and its people. He recently began a series of limited edition prints for Millpond Press and is a founding member of the Northwest Rendezvous Group. He and his wife Flavia maintain a home and studio in Fairfield County, Connecticut.

Shrimp in Sour Cream

- 1½ pounds shrimp, shelled and deveined
- 2 shallots, minced
- ½ pound mushrooms, sliced
- ½ cup butter
- 2 Tablespoons flour
- 1 teaspoon salt
- freshly ground black pepper
- 2 cups sour cream
- ¼ cup Sherry

Saute shrimp and shallots in butter until shrimp are pink. Add mushrooms and cook 5 more minutes. Blend in flour, salt and pepper, stirring constantly. Add sour cream and continue stirring over low heat, until thick. Remove from heat and stir in Sherry. Makes 6 servings.

"The drawing is of our home and John's studio. The shrimp dish is one of John's favorites.

122

Flavia and John Scott
Ridgefield, Connecticut

Shrimp Jambalaya

- ¼ cup onion, chopped
- 1 clove garlic, minced
- 2 Tablespoons butter
- 2 Tablespoons flour
- 1 teaspoon salt
- ½ teaspoon chili powder
- ½ teaspoon thyme
- dash ground cloves
- dash red pepper
- 2 Tablespoons parsley, chopped
- 2 bay leaves, crushed
- 1 quart fish stock
- 1 quart chicken bouillon
- 1 16-ounce can tomatoes
- ¾ cup raw rice
- 1½ pounds shrimp, shelled and deveined

Saute onion and garlic in butter in large kettle until tender. Stir in flour, herbs and spices. Gradually stir in stock and bouillon. Add tomatoes. Bring to a boil. Add rice and shrimp. Simmer, covered, over low heat for 30 minutes or until rice is tender. Makes 6 servings.

Helori and Robert F. Graff
Art West Magazine
Bozeman, Montana

Shrimp Curry

- ⅓ cup butter
- ½ cup onions, chopped
- ¼-½ cup green pepper, chopped
- 2 cloves garlic, minced
- 2 cups sour cream
- 2 Tablespoons lemon juice
- 2 teaspoons curry powder
- ¾ teaspoon salt
- ½ teaspoon ginger
- dash chili powder
- dash pepper
- 3 cups cooked shrimp, shelled and deveined

Saute onion, garlic and green pepper in butter until tender. Add sour cream, lemon juice and spices. Mix well. Add shrimp and stir until hot throughout. Do not boil. Serve over rice or in puff pastry shells. Green beans and a delicate salad are all you need when you serve this entree. Makes 6 servings.

"This recipe has become a standby at the Graff home and has been served to many of our artist friends. For many years, it was a traditional Sunday evening meal for us, but with the rising cost of seafood and our move to a cattle ranch, it is now served as a "company best" meal.

123

Dante V. de Florio
Upper Montclair, New Jersey

Dante V. de Florio began sculpting in his native Italy, where he studied at the Academia delle Belle Arti in Naples, and where his interest in the American West as a subject developed after seeing many Hollywood Westerns and becoming acquainted, through books and printed reproductions, with the works of Frederic Remington and Charles M. Russell. He came to the U.S. in 1947 and soon after became an American citizen. He continued art studies at the Newark School of Fine and Industrial Art in New Jersey. He has exhibited his sculptures in his native country, Albania, Germany and Yugoslavia as well as the U.S. Dante finds the American West artistically stimulating as a subject for his fine bronzes and dedicates many hours to the recreation of one of the most colorful eras in American history.

Spaghetti au Caviar

- ■ **1 pound flat spaghetti**
- ■ **1 stick of butter, lightly salted**
- ■ **3 eggs**
- ■ **1 4-ounce jar black Romanoff caviar**
- ■ **1 teaspoon fresh coarsely ground black pepper**

Cook spaghetti according to package directions, but do not add salt to water. While spaghetti is cooking, place half of the stick of butter in a 12-inch frying pan and set aside. Also open jar of caviar and set aside. One minute before spaghetti is fully cooked, place frying pan over medium heat and melt butter. When butter begins to sizzle (about 30 seconds), place eggs in pan "sunny side up." Sprinkle pepper over eggs and turn heat off. Drain spaghetti and place in same frying pan. Add rest of butter and mix well. Add caviar, mix again and serve immediately. Makes 6 servings.

"This recipe was born when, by mistake, a jar of opened caviar fell into some cooked spaghetti. I looked at it, added the butter and ate it — and have been doing it ever since. The addition of eggs came later. The eggs should not fry too long, so that the yolks and whites will mix well with the spaghetti. I prefer whole wheat or spinach spaghetti, but any good spaghetti will do. I usually serve this with a glass of dryn white wine and a green salad. Sometimes on the weekends, it will be served with a glass of American champagne or a very cold, dry martini. The ingredients for this recipe cost about $5.00 and are very nourishing."

POULTRY

Chicken & Turkey

HM

Charolette and Donald J. Polland
Prescott, Arizona

Don Polland's remarkably detailed and technically accurate miniature sculptures feature an amazing spectrum of subject matter from working cowboys to wild animals to Indians of the past and present. Don has mastered all phases of the art of sculpting and his thorough knowledge of the medium is apparent in his work. Most of his pieces feature his favorite subject, the horse, and are cast in bronze, silver, gold and pewter. Don is a founding organizer of the annual George Phippen Memorial Art Show in Prescott, Arizona. He and his lovely wife Char maintain a studio, home and foundry in Prescott.

Baked Chicken and Corned Beef

- ¼ pound roasted corned beef, sliced ¼-inch thick
- 6 boneless chicken breasts or thighs (or mixture of both)
- 6 soft cooked bacon strips
- 1 can cream of mushroom soup
- 1 cup sour cream
- paprika

Place slices of cooked corned beef on bottom of lightly greased casserole. Wrap each piece of chicken with one strip of limp bacon and place on top of beef. Mix soup and sour cream and pour over meat mixture. Sprinkle with paprika. Bake, uncovered, 3 hours at 275 degrees. (You may substitute canned corned beef or a 1- to 2½-ounce jar of sliced dried beef, soaked in cold water and then drained.)

"This is a simple, delicious dish to prepare. It is my version of Mrs. John W. White's main dish recipe published in the *Fine Arts Cookbook II*, Museum of Fine Arts, Boston, Massachusetts."

Marilyn and Robert K. Abbett
Bridgewater, Connecticut

Chicken Cutlets with Raisins and Almonds

- 3 Tablespoons raisins
- 3 Tablespoons light or dark rum
- ¼ cup butter or margarine
- ¼ cup slivered almonds
- 4 whole chicken breasts, skinned and boned
- 1 teaspoon salt
- ¼ teaspoon pepper
- ½ teaspoon meat paste or extract
- ¾ cup chicken broth
- 3 Tablespoons cornstarch
- ½ cup light cream or Half & Half

Put raisins in small cup, add rum and soak while preparing recipe. In large skillet, toast almonds in butter until nicely browned. Remove with slotted spoon and set aside. Season chicken breasts with the salt and pepper and add to skillet. Cook over medium heat, turning often for 10 minutes. Remove to a platter and keep warm. Add meat paste or extract and chicken broth to skillet and bring to a boil. Mix cornstarch and cream in small bowl and add to boiling liquid, stirring constantly. Reduce heat and simmer for 3 minutes. Stir in rum/raisin mixture and season with more salt and pepper, if necessary. Return chicken cutlets to skillet and reheat gently in the sauce. Arrange in heated serving dish, spoon sauce over all and garnish with almonds and watercress, if you wish. Serve with rice. Makes 6 to 8 servings.

"Tastes even better if made the night before and reheated. One of our favorites."

Shari and Gerald Farm
Farmington, New Mexico

Gerald Farm was born in Grand Island, Nebraska and graduated from Nebraska State College in Kearney. He spent four years in the Navy and spent part of that time as an illustrator at the Art and Animation Department of the Naval Photographic Center in Washingtonn D.C. He taught art and was an art director for the Colorado Division of Hewlett-Packard Company for several years before beginning his fine art career in 1968. Gerald has traveled extensively through Europe studying the works of the Old Masters and has applied this knowledge to his realistic depictions of life in the West. His work is featured on Leanin' Tree Publishing Company greeting cards and he has several limited edition prints available through Mill Pond Press and Texas Art Press. He has been featured in Southwest Art Magazine *and is listed in* Who's Who in American Art, Dictionary of International Biography, American Artists of Renown, *and* Men of Achievement.

Chicken Enchilada Casserole

- 1 large stewing chicken
- 1 large onion, chopped
- ½ pound sharp Cheddar cheese, grated
- ½ pound Monterey Jack cheese, grated
- ½ pound Longhorn cheese, grated
- 1 can cream of chicken soup
- 1 can cream of celery soup
- 1 cup chicken broth
- 1 7-ounce can chopped green chilies
- 1 package corn tortillas
- oil
- sour cream

Stew chicken. (A crock pot works well for this.) Bone and set aside. Reserve 1 cup of chicken broth. Have onions and cheeses ready; set aside. Mix soups, chicken broth and green chilies in saucepan and heat through. Fry tortillas in hot oil just until flexible. Remove from pan and drain by placing each between paper towels. Next, the fun of assembling begins! Spread a small amount of soup mixture on bottom of 8"x13" casserole. Over a sheet of waxed paper (to salvage spills) place a tortilla. Put some chicken, onions and cheese in each tortilla, roll and place seam side down in casserole. Continue until all tortillas are used. Pour soup mixture over all and bake at 350 degrees for 30 minutes. Serve with sour cream. Makes 6 servings.

"This is an easy recipe to double. We have great fun putting these together. We usually just serve this with a tossed salad."

Carol and Donald Theroux
Bellflower, California

Carol Theroux was born in Cardwell, Missouri; raised and educated in California. She was awarded a scholarship to the Art Center of Design in Los Angeles while in high school. She has studied with leading artists throughout her career, received her Life Teaching Credential in Art in 1976 and served for five years on the Board of Directors of Women Artists of the American West. It was there that she came to realize the obstacles women must overcome in their search for recognitionm Carol is of German-Indian heritage and directs her talents toward the contemporary Indian. She frequently travels across the country to collect "scrape" (information) for her subjects. Though proficient in oils, pen and ink, pastel, watercolor, scratchboard and acrylics, she particularly likes and specializes in acrylics and drawings. Carol has won several awards and is represented in numerous western art shows and galleries throughout the West. Her art has been featured in Southwest Art, Art West, The American West *and* Artists of the Rockies *magazines and she is a contributing artist to the monthly Indian publication,* Moccasin Tracks.

Chicken and Broccoli

(Microwave Method)

- ■ 3 large chicken thighs
- ■ ½ cup water
- ■ 2 bunches fresh broccoli, cut and sliced vertically
- ■ 1 cup instant rice
- ■ 1 teaspoon onion minced
- ■ salt and pepper to taste
- ■ 1 can cream of mushroom soup (or your favorite cream soup)
- ■ ½ cup slivered almonds

In a 3-quart ceramic casserole, cook chicken thighs and water on full power for 15 minutes, or until chicken falls off bones easily. Remove chicken from casserole; cool and bone. Cut chicken into coarse pieces and return to casserole of water. Place broccoli pieces over top and add rice, seasonings, and then soupm Sprinkle almonds over top. Bake on "roast," uncovered for 30 minutes. Makes 2 servings.

"My children are grown and gone and the hardest thing to learn was to cook for two when they left! Until my microwave was presented to me by my husband, the crock pot was used for just about everything. When I'm painting in the studio, I completely forget about everything else — so I really like this recipe because it is easy to prepare and freezes well. It's a complete meal and is delicious with sliced pineapple on the side."

Lillian and Thomas Thiery
Onsted, Michigan

Thomas Thiery is a native of Indiana and now resides in Onstead, Michigan. He is a charter member of the Rocky Mountain Watermedia Society and his work has been featured on the Watercolor page of American Artist *magazine. Tom studied at the Art Institute of Chicago, worked as an illustrator and drew inspiration from his artist father. His vibrant and jewel-like watercolors have proven to be quite popular and he continues to produce paintings which are fresh, fluid and controlled. The influence of his environment is evident in his work. He has a collection of covered wagons and chuck wagons and also raises Belgian draft horses used for recreation and farming. His art is in numerous private and public collections and his paintings were included in the Michigan Bicentennial Exhibit at the governor's residence in Lansing.*

Chicken and Rice

- ■ 1⅔ cups carrot strips
- ■ ¼ cup butter
- ■ ¼ cup onion, chopped
- ■ 1 cup orange juice
- ■ 1 cup water
- ■ 2 Tablespoons sugar
- ■ 1 teaspoon salt
- ■ 1 teaspoon orange peel, grated (optional)
- ■ ½ teaspoon poultry seasoning
- ■ ⅛ teaspoon pepper
- ■ 1½ cups cooked chicken, diced
- ■ 1⅓ cups Minute rice

Saute carrot strips in butter, turning frequently, until crisp-tender. Add onions and brown. Add next 7 ingredients and mix well. Add chicken and rice; cover and cook on low heat for 8 minutes or until rice is tender. Makes 4 servings.

"This is best served with cranberry sauce. The original recipe came from a long-lost and forgotten magazine, but has been changed considerably by trial and error!"

Pat and Bob Tommey
Carthage, Missouri

Bob Tommey, now residing in Carthage, Missouri, is a painter and sculptor of western and wildlife subjects. He loves horses, dogs and most women (probably in that order). He is a self-taught artist who has little patience with his teacher and less discipline with himself. Bob is married, the father of four children and a friend to all.

BOB TOMMEY

Chicken Spaghetti

- 1 3-pound hen
- 2 quarts salted water
- 4 medium onions, diced
- 1 clove garlic, minced
- 1 bunch celery, diced
- 4 medium bell peppers, diced
- ¼ cup vegetable oil
- 1 46-ounce can tomato juice
- 1 10-ounce can tomato sauce
- 1 teaspoon salt
- 3 Tablespoons chili powder
- 1 teaspoon paprika
- 1 teaspoon black pepper
- 1 teaspoon red pepper
- 1 Tablespoon sugar
- 2 Tablespoons vinegar
- 1½ pounds spaghetti
- 1 recipe cream of mushroom sauce
- Cheddar cheese, grated

Stew chicken in salted water until tender. Skin, bone and cut up. Reserve broth. Saute onions, garlic, celery and peppers in oil just until they glisten. Do not overcook. Combine next 9 ingredients and cook in separate pot over low heat for 30 minutes. Cook spaghetti according to package directions, but omit salt and cook in reserved chicken broth. Do not overcook. Drain. Combine chicken and spaghetti with onion and tomato mixtures in large roaster. Simmer until liquid is absorbed. Do not overcook. Top with your favorite cream of mushroom sauce and sprinkle a generous amount of Cheddar cheese over all. Place in 350 degree oven for 15-20 minutes or until cheese is melted. Serves 40 starving artists. Note: May be frozen in quart or pint size containers for a great, quick meal when you're short on time or money.

"This recipe was given to me by one of my students, Lucy Bellows, and it has been a popular dish around the Tommey household ever since."

133

Laney
Dubois, Wyoming

Born in Denver, Colorado, Laney received her B.A. degree in 1964 and became a staff artist for the Biological Sciences Curriculum Study in Boulder. Later she became a free lance illustrator and did the artwork for two biology textbooks. In 1970, she moved to Dubois as the regional representative for the Sierra Club in the areas of Wyoming, Montana, Nebraska, North and South Dakota. In 1977, she began to devote her full time to fine art. Laney has won several awards for her watercolor and acrylic paintings of wildlife and ranch scenes and has had several one-person shows throughout the West. She participated in the sixth annual Leigh Yawkey Woodson Museum Bird Art Exhibit, the National Audubon Convention and the Rocky Mountain National Watermedia Exhibit.

Chicken Supper in a Pot

- ◼ 1 chicken, cut up (or whole)
- ◼ garlic powder and salt to taste
- ◼ 2 Tablespoons magarine
- ◼ 1 can beef bouillon
- ◼ 1 can tomato soup
- ◼ ½ cup water mixed with ¼ cup chicken broth
- ◼ 1 teaspoon oregano
- ◼ ½ teaspoon salt
- ◼ dash pepper
- ◼ 1 cup Uncle Ben's rice
- ◼ 1 can English peas

Brown chicken with garlic powder and/or salt in dutch oven or large pot with margarine. Reserve ½ cup chicken broth. Add next 6 ingredients and simmer, covered, for 20 minutes. Add rice and peas and cook 25 more minutes or until well done (most of moisture is absorbed). Stir occasionally. Let stand 10 minutes and serve.

study. "New Strength For the Herd"
©1981- Frank D. Miller

Sharlene and Frank D. Miller
De Borgia, Montana

Born in Burley, Idaho, Frank Miller was always surrounded with art and its influence made an early impression on him. He always knew he would be an artist and he absorbed and studied every book on the subject he could find. With his artist father's encouragement, he pursued his goal. Frank paid his dues by being a commercial artist and doing carpentry work until he was able to achieve his dream and become a full-time painter in 1978. He has won several Best-of-Show awards and is represented by many fine galleries throughout the West. Frank and Sharlene's home and studio are nestled in scenic DeBorgian Montana.

Chicken with Homemade Noodles

- 3 pound stewing chicken
- 2 quarts salted water
- ⅛ teaspoon pepper
- ⅛ teaspoon garlic powder
- ⅛ teaspoon curry powder
- 1 bay leaf

Noodles:

- 1 cup all-purpose flour
- 2 eggs
- 1 teaspoon salt
- ⅛-¼ cup water

Stew whole chicken in salted water until tender. Skin, bone and cut into small pieces. Skim fat from broth. Return chicken to pot and add pepper, garlic powder, curry powder and bay leaf. Set aside. Make noodles. Measure flour into bowl. Make a well in the center, add eggs and salt. With hands, thoroughly mix, then add water 1 tablespoon at a time, mixing thoroughly after each addition. Add only enough water to form a firm ball the consistency of pie dough. Turn dough onto well-floured board and knead for 10 minutes or until smooth and elastic. Let rest 10 minutes. Divide dough into 2 equal parts. Roll dough, 1 part at a time, into rectangles, keeping remaining dough covered until used. Roll rectangle around rolling pin, then carefully slip dough out. Cut dough into strips, crosswise. Make ⅛" strips for narrow noodles, ¼" strips for wide. Shake out strips and place on towel to dry for two hours. When dry, break into smaller pieces. Heat chicken mixture to boiling. Add noodles. Reduce heat to low and simmer for 10 to 20 minutes or until noodles are tender. Makes 6 to 8 servings.

"This is a recipe my grandmother, then my mother, always used to make at Thanksgiving time. It has always been one of my favorites and now and then I talk Sharlene into making it, even if it isn't Thanksgiving. I tell you, it is so good that I think it *is* Thanksgiving every time I dip a spoon down into a large bowl of these noodles!"

135

Elaine and Dan May
Scottsdale, Arizona and Jackson, Wyoming

Elaine and Dan May are the gracious hosts of the May Galleries in Scottsdale in winter and Jackson in summer. They present artworks of quality, authenticity and value in comfortable, relaxed and homelike settings and are always on hand to greet clients and artists alike with equal cordiality. If you have the opportunity, stop by and enjoy, firsthand, the efforts of their wonderful artists and a personally-guided "cook's tour" of their galleries.

Chicken Virtuoso

- 6 ounces medium size noodles
- ¼ pound fresh mushrooms, sliced
- butter
- slivered almonds
- 4-5 cups cooked chicken, diced
- 2 cans cream of mushroom soup, condensed
- 1 8-ounce can chopped green chilies

- 1 cup sour cream
- ¼ teaspoon salt
- ¼ teaspoon pepper
- ½ cup black olives, sliced
- 2 cups Monterey Jack cheese, shredded
- black olives, sliced
- fresh parsley, chopped

Cook noodles according to package directions. Drain and place in large bowl. Saute mushrooms in butter and add to bowl. Toast almonds in same pan and set aside. Add next 7 ingredients to bowl and mix well. Spread mixture in 9"x13" buttered, shallow baking dish and bake at 375 degrees for 20 minutes. Remove from oven and sprinkle cheese on top. Garnish with olives, parsley and almonds. Return to oven and bake an additional 15-20 minutes or until cheese is hot and bubbly. Makes 6 to 8 servings.

"I got this recipe from my mom. It can be prepared ahead of time, which I like! A lot of 'starving' artists I've known have really enjoyed it!"

136

Nellie and Roland L. Lee
St. George, Utah

Living in St. George, Utah, a town settled by his pioneer ancestors, Roland Lee draws much inspiration from the weathered barns, crumbling adobes and other historic relics which abound there. His exquisite watercolors have found an appreciative audience, being represented in many private and public collections throughout America, including the permanent collection of the Zion Natural History Association at the museum in Zion National Park. He has exhibited in various competitions and won several outstanding awards. A dedicated family man, Roland enjoys spending time with his wife Nellie and five children at the family cabin near Zion National Park and exploring the southwest deserts. His current pursuit of fine arts continues a ten-year career in the arts, which has found him at various times in positions as illustrator, graphic designer, writer, advertising agency executive and college art teacher. He feels all these experiences have helped him to develop discipline and fine tune his own special style of expression.

Gourmet Chicken

- ¼ cup butter
- ¼ cup lemon juice
- ¼ cup catsup
- 2 Tablespoons Worcestershire sauce
- 1 package chicken legs and thighs
- rice

Boil first 4 ingredients in saucepan for 1 minute. Place chicken in small casserole and pour sauce over top. Cover and bake at 350 degrees for one hour and 15 minutes. Remove lid and continue baking for 15 more minutes to brown. Serve over rice.

137

Olga and Paul Calle
Stamford, Connecuticut

Herbed Chicken Marsala

- 8 boneless chicken breasts
- 2 cups flour
- 4 teaspoons salt
- ¼ teaspoon pepper
- 3 Tablespoons oil
- 7 Tablespoons butter
- 3 Tablespoons onion, minced
- ½ teaspoon garlic, minced
- 1½ pounds mushrooms
- ½ cup water
- ¾ cup dry Marsala
- ¼ cup fresh parsley, minced
- 1¼ teaspoons tarragon
- dash cayenne pepper

HM

Combine flour, salt and pepper; roll chicken breasts in flour mixture. Heat oil and 3 Tablespoons of the butter in large skillet. Brown chicken, a few pieces at a time; remove and set aside. Add remaining butter to skillet; saute onion, garlic and mushrooms for 8 minutes. Return chicken to skillet; add water, Marsala, parsley and tarragon. Bring to a boil, stirring constantly, then reduce heat to low and simmer, covered, for 15 minutes or until chicken is fork-tender. Add dash of cayenne pepper. Makes 12 servings. Serve with salad, peas, rice and rolls. Because it can be made ahead, it's great for buffets.

"A glance at my favorite artist will prove that not all creative people are starving! Special loving care in the feeding of talented artists is needed to provide sustenance for long hours in the studio!"

Sherry and Truman Bolinger
Scottsdale, Arizona

Truman Bolinger was born in Sheridan, Wyoming and lived for 22 years at his parents' ranch in Ucross. It was there that he gained an intimate knowledge of and feeling for the West. His sincere love for the land, animals and people inspired him to devote his life to creating, in bronze, sculptures depicting scenes from the old and new West. Truman studied at the Colorado Institute of Art and at the Art Student's League in New York City. His work has appeared in Artists of the Rockies, Art Voices *and* Southwest Art *magazines and he is listed in* Who's Who in American Art."

Old Fashioned Chicken and Dumplings

- 1 3-pound fryer chicken, cut in pieces
- 1 Tablespoon salt
- ½ teaspoon pepper
- 1 can chicken bouillon
- 2 chicken bouillon cubes
- 3 cups all-purpose flour
- 3 teaspoons baking powder
- 1 cup reserved chicken broth, cooled
- ½ cup cold water
- 1½ teaspoons salt

Place chicken pieces in large kettle, cover with water and add salt, pepper and bouillon. Cover and bring to a boil. Reduce heat and simmer for 45 minutes or until chicken is tender. Remove pieces from broth and set aside. Remove 1 cup of broth and place in refrigerator to use for dumplings. Remove chicken from bones in *large* pieces. Place on platter and keep warm. Mix last 5 ingredients together. Stir until dough forms a ball and leaves side of bowl. Turn onto a floured board and roll dough to a ¼" thickness. Cut into ¼"x3" strips. Bring chicken broth to a boil and drop dumplings in, one at a time. Cover, reduce heat and simmer for 15 minutes. Add chicken pieces and cook 5 more minutes.

"This is my favorite Southern recipe."

MAN WITH LUNCH IN HAND

George W. Lundeen
Loveland, Colorado

Born and raised in a small town in the plains of Nebraska, George Lundeen brings to his sculptures the same honesty and strength for which that part of the country is known. Much of his success as a sculptor is attributed to his ability to capture, in bronze, the spirit and vitality of the human experience. George received his B.A. degree from Hastings College in Nebraska, his Master of Fine Arts degree from the University of Illinois and was awarded a Fulbright-Hays Grant by the Italian and U.S. governments. Since casting his first bronze in 1967, he has exhibited his work throughout the U.S. and abroad. He has received numerous awards and was honored when one of his bronzes was accepted for permanent display in the People's Republic of China.

Peking Fowl Eleganza — The Easy Way

- 1 cut-up bird (chicken works pretty good!)
- garlic salt
- pepper
- paprika
- 1 can cream of mushroom soup
- 1 cup cream
- fresh parsley, chopped

First, make sure the bird is fresh (most fowl found on the highway are not edible); then spread pieces out on a newspaper so as not to get any clay or plaster on meat. Now, pump a bunch of garlic salt, pepper and paprika over the bird parts and put pieces in a shallow baking pan — make sure the pan does not have any plastalina clay or foundry wax stuck to the bottom, as it makes a lot of smoke in the house. Mix mushroom soup and cream together and pour over chicken. Toss parsley over top and bake in 350 degree oven for 1½ hours.

"This recipe has been passed down from generation to generation. Fritz White says it is equally good when cooking pigeons and, of course, Veryl Goodnight likes it with rabbit. Personally, I am partial to the recipe when eating crow. Other variations can be obtained by writing Glenna Goodacre, who is world renowned for cooking your goose!"

Darlene and Melvin Johansen
Merlin, Oregon

Phoney Abalone

- chicken breasts, skinned and boned
- 1-2 bottles clam juice
- 2-3 garlic cloves, crushed
- seafood coating mix

Pound chicken breasts lightly to flatten. Place in shallow baking dish and add clam juice to cover. Add crushed garlic cloves and refrigerate, covered, a *minimum* of 30 hours. Drain chicken pieces, dredge in your favorite seafood coating mix and saute in frying pan until golden brown. Serve with tartar sauce and lemon wedges. Note: Save the leftover clam juice to make your own clam chowder.

"Phoney Abalone came via "Reggie the Butcher" of Petaluma, California who claims it was used in a well-known Bay-area restaurant. It's simple and delicious and a great substitute for abalone which is so expensive and scarce these days. Also a good way to disguise chicken when you can't think of any other way to serve it."

Skillet Chicken

- 1 2½-pound fryer, cut up
- ¼ cup oil
- 1 cup onions, slied
- 1 clove garlic, minced
- 1¾ cup chicken broth
- 2½ teaspoons salt
- ¼ teaspoon pepper
- 1 teaspoon tarragon
- ⅛ teaspoon thyme
- ⅛ teaspoon marjoram
- 1 cup raw rice
- 1 12-ounce package frozen green beans
- ¼ cup slivered almonds, toasted

In large skillet brown chicken in oil. Remove from skillet. Saute onions and garlic for five minutes. Add broth and seasonings and stir. Return chicken to skillet, add rice and green beans and simmer, covered, for 45 minutes or until chicken and rice are tender. Add a little water, during simmering, if necessary. Sprinkle with almonds and serve. Makes 6 servings.

Burdetta and James Ralph Johnson
Santa Fe, New Mexico

A native Southerner, James Ralph Johnson has lived in Santa Fe since 1964. He has drawn and painted all his life and studied art for four years with Alida Townes as well a shorter courses with other artists. Always an avid outdoorsman, he spent 22 years in the Marines where his sketch pad was seldom beyond reach. His illustrations appeared in numerous western and wildlife books published over the last two decades. Before beginning full time painting several years ago, James and his wife Burdetta (pen name B. F. Beebe) wrote 44 books on Western and wildlife subjects, while researching habitats from Alaska to Africa. Three of their books were filmed by Walt Disney Productions and three were Junior Literary Guild selections. A number have been reprinted in Europe. James now loves to paint the clean, sunny scenes of the Southwest and is represented by many fine galleries in the U.S.

141

Juan Dell

Santa Fe, New Mexico

Juan Dell is an artist of enormous versatility whose reflective nature strives endlessly to create significant impressions of her western roots. Her powerful bronzes depicting characters of the Old West have touched the hearts of all who view them. A West Texan by birth, Juan Dell became one of the first women to devote full time to sculpting historical subjects. Her work is represented in many major museums and important collections throughout the country. A biography of Juan Dell and her work, containing a systematic catalogue of over 75 bronzes, entitled The First Lady of Bronze *was published in 1982.*

HM

Stuffed Cornish Game Hens

- ■ ½ cup ham, chopped
- ■ ⅓ cup of equal parts cream and Swiss cheese, shredded
- ■ ¼ teaspoon thyme
- ■ ¼ teaspoon marjoram
- ■ ¼ teaspoon garlic powder
- ■ ½ teaspoon onion powder
- ■ 1 Tablespoon butter or margarine
- ■ 1 Cornish game hen
- ■ 3 strips bacon

Mix first 7 ingredients together in bowl. Have a beer. Wash hen, remove giblets and drain. Stuff with mixed ingredients and wrap with bacon, securing with toothpicks. Place on rack in shallow baking pan and bake at 350 degrees for 1¼ hours or until hen turns golden brown. Recipe is for 1 person. Increase ingredients according to number of guests. Have another beer while hen is cooking.

"This one originated at an art dealer's house while consuming a few beers and dealing for a bronze. Being truly inspired by the "fowlness" of the situation and somewhat hungry, this recipe was born. Hens taste best with either a fine vintage white wine or a quality brand of beer. Nice served on a bed of wild rice with a side dish of asparagus and Hollandaise sauce."

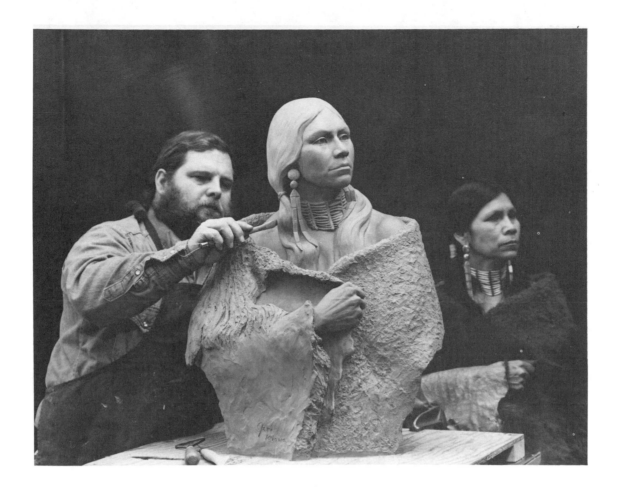

Jeri and Richard V. Greeves
Fort Washakie, Wyoming

Richard V. Greeves comes from a background of Italian artisans which gave him a strong foundation on which to build his career as one of the foremost sculptors in the U.S. today. He is a man with artistic talent, a keen mind and more than thirty years of firsthand experience living with the North American Plains Indians as well as a deep and abiding interest in and comprehension of the Indian race. Although his subject matter is primarily that of the Indian, his work has a universal appeal that is intrinsic to fine art. Richard is a member of the National Academy of Western Art and he has won 2 Gold Medals, 1 Silver Medal and the coveted Prix de West Award at their shows. He lives with his Kiowa wife Jeri and their 2 daughters on the Wind River Indian Reservation in Wyoming.

Tijuana Chicken

- ½ cup buttermilk
- ½ cup chili sauce
- ¾ cup all-purpose flour
- 1 teaspoon salt
- ¼ teaspoon pepper
- 1 3-pound fryer, quartered
- 6 Tablespoons butter

Preheat oven to 375 degrees. In a shallow pan stir together the buttermilk and chili sauce. Combine flour, salt and pepper. Dip chicken pieces in buttermilk mixture, then dredge in flour. Reserve and set aside remaining buttermilk mixture. Melt butter in shallow baking pan and place chicken, skin side down, in butter. Bake at 375 degrees for 30 minutes. Turn chicken over and spread top with remaining buttermilk mixture. Bake 30-40 more minutes or until chicken is tender. Makes 4 servings.

Delphie and David Hagerbaumer
LaConner, Washington

David Hagerbaumeris recognized as one of our premier water-colorists in the wildlife field. Born in Quincy, Illinois, he grew up on a farm overlooking the Mississippi River. His years of hunting, trapping, fishing and studying wildlife gave him his lifetime interest and field knowledge of ornithology. In addition to his painting, his first book, Selected American Game Birds *is in its third printing and he and his wife Delphie are working on two new books. He has done ceramic game bird models and carves in wood — choosing to gun over his own hand carved decoys. Recently, he has done his first etchings which are receiving critical acclaim. His bronze edition of "The Old Decoy" was very well received and his works have been a part of private collections for many years, both here and abroad. He is an avid supporter of several wildlife conservation groups and has been a generous contributor to Ducks Unlimited since 1953, donating yearly his original works as well as prints. In 1981 he was honored by both the Wild Turkey Federation and Ruffed Grouse Society as the artist for their prestigious fund raising efforts. Since he started painting with a specific direction some thirty-four years ago, David continues to hold uppermost in his works the authenticity of habitat, anatomy and accuracy. While his unique style is emulated by some, his technique will always remain identifiable as his own.*

Turkey Enchiladas with Sour Cream

- 3 4-ounce cans chopped green chilies
- 2 cups onions, chopped
- 1 large clove garlic, minced
- 2 Tablespoons oil
- 2 16-ounce cans whole tomatoes, chopped (or 2 pounds ripe tomatoes)
- 1 teaspoon salt
- ¼ teaspoon ground black pepper
- ½ teaspoon oregano
- 2 teaspoons chili powder
- 1 cup white wine
- 3 cups (or more) turkey, cubed
- 2 cups sour cream
- ½ pound Cheddar cheese, shredded
- ⅓ cup oil
- 2 dozen corn tortillas

Saute green chilies with onions and garlic in 2 tablespoons oil. Add chopped tomatoes and next 5 ingredients. Simmer on low heat, covered, for one hour or until thickened. (If you like hotter sauce add Tabasco sauce, Jalapeno peppers, or small, but mighty, red chilies — or all!) Mix together the turkey, sour cream and Cheddar cheese. Set aside. Heat ⅜ cup oil and fry corn tortillas on each side lightly, keeping them flexible. Fill with turkey mixture and roll. Place seam side down in shallow baking pan. Pour sauce over all, cover and bake in 350 degree oven for 20-30 minutes or until hot throughout. Makes approximately 18-24 enchiladas. Serve with refried beans, green salad and beer.

"Many years ago, my paternal grandfather was on a Mexican Cerveza raid south of the border, when he was captured by Pancho Villa. He was interned for some time and prior to his execution he was asked what choice of food would he like for his last meal and he said he would like to have the "specialty of the house." This recipe for Sour Cream Enchiladas was served. It tickled his taste buds to such an extent, that he asked Mr. Villa for the recipe. This would obviously do him little good since he was to face a firing squad at dawn. Pancho, however, being in a conciliatory mood, offered to mail the recipe to Grandma. So today, it rests in my safe possession and I pass it along, at this time, to all you Cerveza lovers."

Mary Ann and Dick Duffy
Montana Arts Council
Helena, Montana

Co-chairman of the Helena Arts Council along with artist Bob Morgan, Dick Duffy's untiring efforts and dedication to the Northwest Rendezvous Group's annual Western Rendezvous of Art shows have made possible a show which ranks among the top art exhibitions in the western region. He and his wife Mary Ann own and operate the Montana Gallery and Book Shop at the Colonial Inn in Helena.

Val's Chicken Casserole

- 4 whole chicken breasts, skinned and boned
- 4 slices Swiss cheese
- 1 can cream of chicken soup
- ¼ cup dry white wine
- 2 cups dry, seasoned croutons or stuffing mix, coarsely crushed
- ⅓ cup butter, melted

Arrange chicken breasts in lightly greased, shallow baking pan. Place 1 slice of Swiss cheese on each piece. Mix soup and wine together; pour over chicken. Spread croutons on top and drizzle butter over all. Bake, uncovered, at 350 degrees for 50-55 minutes. Makes 4 servings.

"This was served to us by our dear California friends, Nat and Val, after a marvelous day visiting the beautifully-dramatic Carmel. It is flavorful and pretty enough to make for company dinner, but easy enough for everyday fare. It is not too expensive and can be dressed up or down to fit any occasion. Serve with love — as it was first served to us."

Carol and Bernard Vetter
El Paso, Texas

Vetter's Chicken Enchilada Casserole

- 2 chickens, boiled, boned and cut into large pieces
- 12 corn tortillas
- 3 cans cream of mushroom soup
- 2 4-ounce cans chopped green chilies
- 1½ pounds Monterey Jack cheese, grated

Born in El Paso, Bernard Vetter has spent all of his life in the west Texas and southern New Mexico areas. His abiding love and respect for the Southwest and its traditions are reflected in his paintings and his transparent watercolors are widely sought by art collectors. Using a dry brush technique, he paints landscapes, still lifes and wildlife scenes with a soft and delicate touch of realism. He has been a professional artist since 1972. A graduate of the University of Texas at El Paso, Bernard taught art and history in the public schools for eight years. His first love has always been art, and although primarily self-taught, he studied art throughout his high school and college years. He, his wife Carol and three sons live in El Paso, but spend a great deal of time in New Mexico.

Generously grease a large casserole. Quarter tortillas and fry them in hot oil until crisp. Drain well between paper towels. Place a layer of chips on bottom of casserole, add layer of chicken, soup, chilies, then cheese, in that order. Continue, ending with chips on top. Bake, uncovered, in 375 degree oven 30 minutes. Makes 6 servings.

"Since living in the Southwest all my life and not being more than a mile from Mexico, it's not unusual that almost all of our meals consist of Mexican food or extracts of it. This recipe has been in Carol's family for years and has *always* been my favorite. I truly believe it will become a favorite of many, because it is reasonably priced, nutritious and easy to prepare. If you want to go 'native' · use hot chilies. Ice cream would be a wise choice for dessert!"

Duck, Goose, Grouse & Quail

Sandy and Herb Booth
Rockport, Texas

Herb Booth combined his two greatest loves — hunting and painting — and became a wildlife artist in 1967 after struggling for several years as a "starving" landscape painter. Today, he ranks high among the premier outdoor artists in the U.S. Herb has had little formal art education and his degree from the University of Colorado

is in economics. He uses nature as his teacher to depict accurate and vivid paintings of life in the outdoors. He started hunting as a boy and moved to Rockport, Texas in 1970. "For a bird hunter, living in south Texas is like going to heaven. It's hard to believe that one section of the country can be jam-packed with so many different kinds of birds: ducks along the coast, geese in the rice fields near Houston, quail everywhere, doves everywhere. It's min boggling!" Herb does most of his painting from February through early August; then he's off hunting with his two sons and three dogs. "I'm gone so much during the hunting season, Sandy hangs out a big "Welcome Home" sign at the end of January!" He is also a conservationist and donates a painting each year to the Houston Ducks Unlimited fund raising campaign and is also active in the Gulf Coast Conservation Association, a group attempting to preserve and strengthen Texas' redfish fishery.

Best Damn Duck I've Ever Eaten!

"For this recipe you need several ingredients: first you need a big storm to screw up a fishing trip like one of the mini-hurricanes we get here on the Gulf Coast each year that are called 'tropical depressions' and never given a name. Then you need a Swedish sculptor who likes smoked fish and whose house happens to be handy to take refuge in when the storm screws up the fishing trip. Kent Ullberg was the sculptor I used. The sculptor should also have a smoker that he has made out of an old refrigerator, electric hot plate and an iron skillet. If he doesn't have these things, take refuge with someone who does, or you won't be able to cook your ducks. Now, to do it right, you should have a whole bunch of ducks that you were planning to cook for all the guys on the screwed-up fishing trip. You also need some fresh carrots, celery and apples. And some salt and pepper and whatever other spices that look good to you. The only other thing you need is a sack of wood chips for the smoker, but wait until the storm gets going real good before you decide you need this, so that the sculptor's wife can get good and wet going out to get it. Now, wash the ducks, taking all the bad stuff out of the body cavity, rub them inside and out with salt and pepper and whatever else appeals to you. Cut apples, celery and carrots into big chunks and stuff them into

ducks. Next, you have to brave the storm to get to Kent's smoker out behind his studio. A few words about the smoker. It is really a simple device. Just an old 'fridge with all-metal insides. Judging from Kent's, being ugly and nasty on the inside from smoking fish counts for something. He had drilled two holes in each side of the ice box for a pair of metal rods which he stuck through to hang things on. For heat, he had a small, one-burner hot plate sitting on the floor and on this he put the worst-looking old, rusty iron skillet that I've ever seen. He filled the skillet full of wood chips and closed the door right on the cord. Kent says it's important to arrange your meat on the metal racks so that the skewers and none of the meat is touching each other. That was the only thing that we did 'carefully' that day, so it must be important — to get all the smoke around each piece, I presume. After you arrange the meat and shut the door, plug in the hot plate cord and make your way through the storm back to the nice, dry house. I'm not sure exactly how long we cooked them, but I'd say that, after two bottles of wine, or two hours (whichever comes first), you ought to check on the ducks. Don't check on them a lot though, because a big 'ice box' shaped chunk of smoke gets away from you each time you open the door. (That smoke is what is cooking the ducks, so you don't want it getting out on you.) Cook them until the joints are loose and the breast meat is red like ham all the way through. Serve with plenty of napkins, because I guarantee that you'll be gnawing the bones before you're finished. I've tried it once without the hurricane, and it was *almost* as good!"

Marilyn and Allen Hughes
Memphis, Tennesee

Allen Hughes is not only a well-respected doctor, specializing in plastic and reconstructive surgery, but is also a professional wildlife artist recognized for his realistic portrayals of waterfowl in paintings and wood carvings. He has won numerous awards in both categories and has had over thirty cover designs on national magazines and publications. He is a life sponsor of Ducks Unlimited and has raised countless dollars for the Tennessee Ducks Unlimited with his generous donations each year. His work has been featured on the cover of Ducks Unlimited magazine and he has a nationally-distributed Ducks Unlimited print. Allen participates in many national wildlife art shows and has had several limited edition prints produced by Swan Graphics.

Duck Marnier

- 3 ducks
- salt
- garlic salt
- pepper
- 3 oranges, quartered
- ¾ of apple, quartered
- ¾ of onion, quartered
- 3 jiggers Grand Marnier
- Lawry's seasoned salt
- 9 slices bacon, uncooked
- 1 cup (or more) orange marmalade
- 4 Tablespoons butter
- dash cinnamon
- dash Worcestershire sauce

Liberally rub duck cavities with salt, garlic salt and pepper. Place each duck on its back on a large piece of Heavy Duty aluminum foil. Place two orange quarters on either side of duck (wedge under legs) to balance it on its back, breast side up. Fill cavities with one orange quarter, one apple quarter, one onion quarter (in that order) and end with 1 more orange quarter. Fill each cavity with ½ jigger Grand Marnier, then baste outside of duck liberally with the remaining Grand Marnier, season with seasoned salt and lay several strips of bacon on top. Wrap tightly in the foil and bake at 250 degrees for 6 hours. Make sauce with remaining ingredients and serve on the side. Makes 4 servings (men generally eat a whole duck, ladies usually ½).

Norma and Shirley Ashby
C. M. Russell Auction of Original Western Art
Great Falls, Montana

Norma Ashby was the 1971 and 1979 Russell Auction chairman and has worked on the auction committee each year since its inception in 1969. She has been an instrumental force in the success of this eagerly-anticipated annual art event.

Roast Duck with Apple Stuffing

- ■ ½ cup celery, chopped
- ■ ½ cup onion, chopped
- ■ 2 medium apples, cubed
- ■ ¼ cup brown sugar
- ■ 1 cup walnuts, chopped
- ■ 2-4 slices bread, cubed
- ■ ¼ cup raisins
- ■ dash pepper
- ■ ⅛ teaspoon marjoram
- ■ dash of sage
- ■ ½ teaspoon salt
- ■ 2 ducks
- ■ 1 bouillon cube
- ■ 1 cup hot water

HM

Mix first 11 ingredients together well. Mix the bouillon cube and water; add ½ cup bouillon to dressing mixture and toss. Stuff duck cavities with dressing and pour remaining bouillon over ducks. Bake, covered, in 325 degree oven 1½-2 hours or until ducks are tender.

"Serve with chokeberry syrup, wild rice, a green salad and vegetable. You will have a meal to delight any duck hunter."

Harvey Rattey and Pamela Harr
Bozeman, Montana

For sculptor Harvey Rattey, a Montana rancher and top rodeo competitor, the West is a way of life, an experience of each day's passing, giving him a fresh style and revealing his deep insight and emotional involvement with his work. Drawing from his Assiniboine ancestry, Harvey depicts Indian life and customs with sensitivity and concern for the history, future and honor of the Indian people. He started sculpting in 1971, learning on his own with help from a few artist friends. Since then, he has sold and exhibited his work throughout the U.S., Canada, Europe and Japan. He and his artist wife Pamela live and work in Bozeman, Montana where they have their own foundry.

Peanut Butter Goose

- ■ 1 12-pound goose
- ■ salt and pepper to taste
- ■ ½ cup peanut butter, crunchy or smooth
- ■ ½ cup honey

Prepare goose as you would turkey. Be sure to cut off excess fat. You may stuff with your favorite dressing if you wish. Mix peanut butter and honey (warming in pan if necessary, to soften). Salt and pepper the goose, then smear with honey/peanut butter mixture. Wrap bird securely in aluminum foil and place on rack in large roasting pan. (Foil will speed cooking and prevent the peanut butter mixture from sticking hard and fast to the pan!) Roast at 350 degrees for 4-4½ hours or until meat thermometer (at thigh) registers 185 degrees. Spoon away fat if needed.

"I concocted this recipe when, as a bachelor, I was trying to think up something to feed two hungry kids at Thanksgiving. It instantly became a favorite."

150

JIM MCREAN.

Ruth and Jim Morgan
Mendon, Utah

Jim Morgan lives in a rural area of Utah and is surrounded by constant inspiration from mountains, marshes and wildlife. He is most interested in portraying his impressions of the endless colors, ever-changing moods, play of light and timeless beauty found in nature, emphasizing the importance of the background in his paintings. Without these natural areas there would be no wildlife for us to enjoy. By preserving them on canvas, he hopes to show others the importance of saving our wildlife and their habitats. He helps in this area as much as possible by donating many of his paintings to various conservation groups such as Ducks Unlimited and Safari International. Jim graduated from Utah State University with a B.A. and has won top awards at many prominent western and wildlife art shows due to his sensitive impressions of the wild that he has experienced first hand.

Roast Canada Goose

- **1 goose**
- **1 onion, sliced**
- **salt, pepper and sage**
- **red wine or butter**

Boil goose in large pan of water with onion and generous amount of salt for ½ hour. Rinse and pat dry. Sprinkle with salt, pepper and sage. Place on rack in shallow roasting pan. Stuff with your favorite stuffing or apples and onions. Roast at 375 degrees for 2 hours or more, until tender. During roasting period, inject meat with red wine or melted butter. Serve with cranberries or black currant jelly.

"Be sure to shoot goose in the head to avoid cracked teeth while eating!"

Margaret and Ted Long
North Platt, Nebraska

Western artist Ted Long has an abundant source of inspiration around him. He lives on the ranch that his great grandfather homesteaded in the 1800s and his studio is a historic, century-old log cabin. The Sioux, Cheyenne and Pawnee Indians followed the great herds of buffalo, and hopeful immigrants walked the Oregon and Mormon trails within sight of his home. Ted enjoys working in oil, pencil, pen and ink and bronze. He has spent a great deal of time at the Pine Ridge Reservation in South Dakota with the Oglala Sioux tribe, observing and gathering research material for his artwork. He was commissioned to paint a medicine man for the Great Plains Regional Medical Library in Omaha and the Nebraska Historical Society commissioned Ted for a life-size bust of Standing Bear, the great Ponca chief, which is in the permanent collection of the Nebraska Hall of Fame in the Nebraska State Capitol. Ted has received numerous awards and participates in a long list of art shows each year including Nebraskaland Days' annual Western and Wildlife Art Show held in North Platte, of which he is chairman, and the Cheyenne Frontier Days Governor's Invitational Western Art Show and Sale in Cheyenne, Wyoming.

Roasted Wild Goose

- 1 wild goose
- salt water brine
- salt and pepper to taste
- apples, quartered
- onions, quartered
- celery, cut in large chunks
- 1 can consomme
- 2 cans water
- 1 cup Madeira wine (or 1 can beer)

Soak goose in cold salt water brine for 4 to 6 hours. Pat dry. Salt and pepper cavity. Stuff with enough apples, onions and celery to fill cavity. Place goose, breast side down, in roaster. Mix consomme, water and wine and pour enough over bird to have breast in liquid. Roast, covered, at 325 degrees for 4 to 6 hours or until tender. It's also delicious stuffed with sage dressing.

"Ted cooks and serves this goose recipe in his goose pit at Lewellen, Nebraska and has had many compliments. He also uses oyster dressing sometimes for a change of taste."

152

Jane and Jack Gellatly
Omaha, Nebraska

Enthusiasm for nature's wildlife came naturally for Jack Gellatly, since much of his childhood was spent along the Republican River in south central Nebraska. He has since combined that interest with a talent for wood carving and painting to produce exquisite waterfowl sculptures that are unique and exciting in appeal and design. He and his lovely wife Jane divide their time between Omaha, Nebraska and Estes Park, Colorado.

Wild Goose

- 1 goose (or 2 ducks)
- 1 large onion, halved
- 2 oranges, quartered
- 2 Tablespoons flour
- ½ cup frozen orange juice concentrate, thawed
- ¼ cup Brandy
- 2 Tablespoons orange marmalade
- ¼ cup orange juice
- 2 Tablespoons Brandy

Place 1 onion half, then 2 orange quarters, in that order, in breast cavity; repeat in hind cavity. Mix 1 tablespoon of the flour, the orange juice concentrate and ¼ cup Brandy together well. Rub some of mixture on goose and pour remainder into 14"x20" clear, cooking bag. Place goose in bag and close with twist tie. Place goose in 9"x13" baking pan. Make 6 ½" slots in top of bag. Insert meat thermometer in center of inside thigh muscle, not touching bone. Roast at 350 degrees until internal temperature registers 180 degrees, about 2 hours, or until tender. Remove bird from bag, reserving cooking liquid. Glaze bird with orange marmalade and keep warm. Pour cooking liquid into skillet, add remaining tablespoon of flour and orange juice, cook, stirring constantly over low heat, until thickened. Add Brandy, blend and serve. Garnish serving platter with oranges, lemons and parsley, if so desired.

Ruth and Jim Morgan
Mendon, Utah

Grouse with Rice Stuffing

- 2 grouse
- salt and pepper to taste
- 2 Tablespoons slivered almonds
- 2 Tablespoons onions, minced
- ⅓ cup raw, long grained rice
- 3 Tablespoons butter
- 1 cup water
- 1 chicken bouillon cube
- 1 teaspoon lemon juice
- ½ teaspoon salt
- ¼ pound fresh mushrooms, sliced
- butter

Rub grouse, inside and out, with salt and pepper. In saucepan, cook almonds, onions and rice in butter for five to ten minutes, stirring often. Add water, bouillon cube, lemon juice, salt and mushrooms. Bring to a boil, stirring to dissolve bouillon cube. Reduce heat, cover, and simmer for 20-25 minutes or until liquid is absorbed and rice is fluffy. Lightly stuff birds with rice mixture. Place, breast side up, on rack in shallow baking pan and brush with melted butter. Roast, covered, at 400 degrees for 1-1½ hours, or until leg joints are loose in sockets. Uncover and brush with melted butter during last 15 minutes of cooking period. Makes 2 servings.

Jo Ellen and Gerald A. Bowie
Western Art Auctioneer
West Point, Georgia

Georgia Smothered Quail

- 12 quail
- 12 Tablespoons butter
- 3 Tablespoons flour
- 2½ cups chicken broth
- ½ cup Sherry
- salt and pepper to taste
- cooked rice

Prepare quail; brown in large heavy skillet with butter. Remove to baking dish (or crock pot). Add flour to butter in skillet and stir well. Slowly add chicken broth, Sherry, salt and pepper. Blend well and pour over quail. Bake, covered, at 350 degrees for 1 hour (5 hours in crock pot). Serve with rice.

Walt Harris
Ponca City, Oklahoma

Walt Harris is an Otoe/Missouri Indian, a former college football player and professional baseball player as well as an outstanding Indian artist. He has won many awards and is represented by fine galleries and museums in the Southwest. He loves the outdoors, hunting and fishing. Walt tries to preserve the Indian way of life as it was — the rituals, the family ties, and the happiness — through his art. Through his colorful work he depicts the Indian as contented and happy in the beautiful world of yesteryear.

Hutah Quail

- **24 Bob White quail**
- **flour**
- **salt and pepper**
- **hot oil**
- **4 small onions, diced**
- **½ cup celery, diced**
- **1 cup white wine**
- **⅓ cup honey**
- **⅔ cup Heinz 57 Sauce**
- **6 slices bacon**

Roll birds in mixture of flour, salt and pepper. Brown in large skillet in hot oil with onions and celery. When done, remove birds and set aside. Remove onions and celery with a slotted spoon and spread on bottom of shallow baking dish. Add ½ cup of the wine. Reserve remaining fat in skillet and set aside. Place birds in 4 rows (6 birds each) in baking dish. Combine honey and Heinz 57 sauce and baste quail. Lay bacon slices over all. Using reserved fat, make your favorite gravy and pour over birds. Bake in 250 degree oven for 2½ hours or until tender, basting occasionally with remaining wine. Serve with fried potatoes, hot biscuits (pour the broth gravy in bottom of baking dish into bowl and serve) and hot coffee. Hutah! (lovely!)

"This is a combination of Walt Harris, Mark Buffalo Hoof and 'Violin Case' Dent's years of research on the tastiest quail dinner ever. Historical background: (an old Indian insight and observation) Be hungry, it's real good! This recipe also gives you plenty of time to sit back and relax with a couple of Canadian Club and 7-Ups while you listen to your brother-in-law tell how he got three birds on a rise four times!"

155

Eggs & Cheese

Miriam and Bob Wolf
Laporte, Colorado

Cheese Enchiladas

Tortillas:
- 1½ cups cold water
- 1 cup all-purpose flour
- ½ cup corn meal
- ¼ teaspoon salt
- 1 egg

Filling:
- 2 cups Monterey Jack cheese, shredded
- 1 medium onion, chopped
- ½ cup sour cream
- 1¼ cups Cheddar cheese, shredded
- 2 Tablespoons parsley, chopped
- 1 teaspoon salt
- ¼ teaspoon pepper
- 1 15-ounce can tomato sauce
- ⅔ cup water
- ⅓ green pepper, chopped
- 1 Tablespoon chili powder
- ½ teaspoon oregano
- ¼ teaspoon cumin
- 2 whole green chilies, chopped (optional)
- 1 clove garlic, minced

Hot Sauce:
- 2 medium tomatoes, chopped fine
- 1-3 jalapeno peppers, chopped fine
- 1 medium onion, chopped fine
- 1 teaspoon salt
- ⅛ clove garlic, crushed

Drawing courtesy of R. C. Gorman

Prepare tortillas: heat 8-inch skillet over medium-low heat just until hot. Lightly grease, if necessary. Beat first 5 ingredients until smooth. Pour scant ¼ cup batter into skillet and *immediately* rotate it around until batter forms very thin tortilla about 6 inches in diameter. Cook until dry around edges, about 2 minutes. Turn and cook other side until golden, about 2 minutes more. Set aside. Makes about 1 dozen. Next, mix Monterey Jack cheese with onion, sour cream, 1 cup of the Cheddar cheese, parsley, salt and pepper. Heat next 8 ingredients to boiling, stirring constantly; reduce heat. Simmer, uncovered, for 5 minutes. Pour sauce into 8- to 9-inch pie plate. Dip each tortilla into sauce to coat both sides. Gently place each tortilla, 1 at a time, on waxed paper and spoon ¼ cup cheese mixture onto tortillas; roll up and place seam side down in a 12"x7½"x2" baking dish which has been sprayed with Pam. Sprinkle top with ¼ cup of the remaining Cheddar cheese and cook, uncovered, in a 350 degree oven for 20 minutes or until cheese is hot and bubbly. While enchiladas are cooking, make hot sauce by mixing last 5 ingredients; cover and refrigerate until serving time. Garnish cooked enchiladas with remaining Cheddar cheese, sour cream and sliced black olives. Serve with hot sauce, a crisp green salad and good Mexican beer. Enjoy! Makes 8-12 servings.

"All I can say about this recipe is that it is *truly* a labor of love, but if prepared properly, worth a gold medal and rave reviews!"

Hank's Best Cracker Omelets

- meat (breakfast stuff or leftovers), chopped
- ¼-½ cup onions, chopped
- ¼ cup green pepper, chopped
- 1 handful Saltine crackers, crushed
- 4-6 eggs
- dash of milk (or better yet: warm, leftover beer)
- cheese, grated

Brown meat in hot, greased skillet. Throw in onions and peppers just before meat is browned good. Stir real well. Whip eggs and add liquid. Add crushed crackers to egg mixture. Pour into meat mixture and cook on low heat until eggs are set. Then, turn them over, toss cheese on top, let melt and serve. Feeds a bunch and is great for hangovers!

"I won first place in a local county cooking contest with this — and they even paid me money for it!!"

Pat and Hank Lawshé
Kalispell, Montana

Hank Lawshe made the move from commercial art to a full time job at the easel in 1975 when he left a supervisory post with the art and production department of a large corporation which decided to move to New York City. Instead of transferring with the company, Hank chose to move to a ranch in the remote area of western Montana where he is surrounded with the land and people he loves to paint. He has won numerous awards and is a member of the Northwest Rendezvous Group.

Dennis Silvertooth
Corpus Christi, Texas

Huevos "Raunchitos"

- 1 can chili with beans
- 2 flour tortillas
- butter
- ¼ cup cheese, shredded
- salt and pepper to taste
- sour cream (optional)
- ½ avocado (optional)

Heat your favorite brand of chili with beans in a saucepan on back burner and keep warm. Heat tortillas, one at a time, in medium size skillet on medium-low heat, turning often until heated through. Remove from pan and place on warm plate. Spoon some hot chili onto tortillas and roll up. Keep warm. Meanwhile, fry eggs, preferably sunny side up. Pour remaining chili on tortillas, slide egg on top, season with salt and pepper and sprinkle with cheese. Serves one. So eat! Also good with sour cream and thinly sliced avocado on top.

Mary-Margaret and Bill Owen

Flagstaff, Arizona

Bill Owen grew up on the ranches of Arizona and his admiration for the people, towering mountains and the animals around him inspired his artistic abilities. After graduation from high school, Bill spent his evenings and weekends pursuing his exceptional talents while working on Arizona ranches. His art was quickly purchased by his neighbors and in 1971, Bill decided to paint full time. His national reputation as an artist has grown rapidly. At the age of 31, he was unanimously voted into the Cowboy Artists of America and has served as its secretary-treasurer, president and on the board of directors. He has won several medals at the CAA shows including one gold medal, three silver medals, the Men's Art Council Award and the CAA Memorial Award. He also won the gold medal for distinguished western art, presented by the Franklin Mint and the Phoenix Art Museum has his oil, The Working Cowboy, on permanent display. He has had works represented in many western and national publications and his paintings and bronzes are collected by art lovers all over the world. Bill is devoted to creating a lasting chronicle of the life and work of the beautiful stockraising country of the Southwest and its people with an in-depth knowledge and sincere affection for his subject matter.

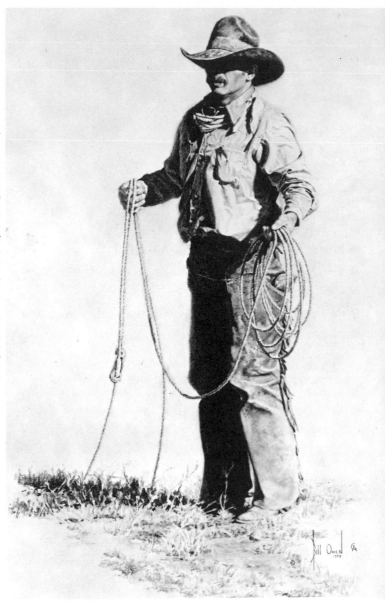

Mexican Trout

- **green chilies (fresh or canned)** *
- **Monterey Jack and Longhorn cheese, cut in pie-shaped wedges**
- **eggs**
- **flour**
- **corn meal**
- **seasoned salt**
- **pepper**
- **corn or safflower oil**

* As far as quantities are concerned, depends on who you're feeding! For a meal, allow men about 8 chilies and the ladies 4. It doesn't take too many eggs, thank goodness, since we are always 2 eggs short in the mornings!

Insert both kinds of cheese into chilies, being careful not to split them. Next, combine eggs, flour, corn meal and seasonings to your liking for a batter. Dip chilies into this concoction, then place in skillet with *very* hot oil. A campfire actually works better than a stove, because not only does the skillet stay a constant temperature, but the smoke does wonders for the flavor! Cook the "trout," turning only once, until the batter is golden and the cheese is melted. Looking at them in the sizzling pan does indeed bring to mind fresh-caught trout — hence the name.

"Our serving suggestion is simple:

Bill Owen's Simple Salsa

(any gunsel can do it)

- **8 ounces tomato sauce**
- **2 cloves garlic, minced**
- **1 teaspoon salt**
- **chili piquin, ground or crushed (also known as dried serrano)**
- **2 Tablespoons fresh cilantro**

Mix all ingredients and serve with Mexican Trout. If you are wondering why there is not a quantity for the chili piquin, it's because most folks could not take the three Tablespoons Bill throws in! Test as you go!"

160

John and Martha Leone
Roxbury, New York

Focusing primarily on action-filled scenes of the past and present American West, John Leone paints with superb detail. Magnificent western scenery usually forms a dramatic backdrop to the action he portrays. Born and raised in New York City, John received his formal art training at the High School of Art and Design, the Art Students' League and Cooper Union. He became a freelance artist, specializing in western and outdoor life illustration. This long and successful career led him to a career in Western art. He and his artist wife Martha and their four children enjoy breeding and training quarter horses and raising seedlings in their greenhouse for their half-acre garden. Each year they make a special point to journey from their home in the Catskills to immerse themselves in the scenery and the history of the West.

Zucchini Omelets

- ■ **5 pounds zucchini, thinly sliced**
- ■ **2-3 large onions, thinly sliced**
- ■ **8-10 red or green sweet peppers, thinly sliced**
- ■ **6 medium potatoes, thinly sliced**
- ■ **1½ pounds Italian sweet sausage**
- ■ **12 eggs**
- ■ **1 Tablespoon oregano**
- ■ **1 Tablespoon basil**
- ■ **2 teaspoons garlic powder**
- ■ **salt and pepper to taste**
- ■ **¼ pound Parmesan cheese, grated**

Saute all vegetables together in large skillet until tender and most of the moisture from the potatoes and zucchini has evaporated. In a separate pan, cook sausage, covered in water until done; drain and thinly slice. Add to cooked vegetables. Beat eggs, add seasonings, stir and pour over vegetables. Mix well. Cook, over medium heat, stirring occasionally, until eggs begin to set. Sprinkle generously with cheese. Stir once more, then press flat with spatula. Sprinkle on remaining cheese and broil until brown and bubbly. Makes 12 servings. Approximate total cooking time: 1 hour.

"Neighborhood covered dish suppers are very popular here and hostesses invariably request that whatever else the Leone clan chooses to bring — would they please bring one of John's omelets. Carries well and is always the first clean tray at a party. If you should be lucky enough to have leftovers, they freeze and re-heat well. This is a good midsummer 'whatever's abundant in the garden' dish."

Patsy and Gene Zesch
Mason, Texas

Prickly Pear Cactus and Eggs

Pick tender, young leaves in the spring when they are 2 to 3 inches in diameter. Slice off the thorns at their base. Parboil prickly pear cactus until tender. Slice in ¼-inch strips, mix with beaten eggs, add salt and pepper. Scramble and serve immediately.

"I learned this recipe from a sheepherder in the hills of Durango, Mexico. It's a little tedious to prepare, but very good and economical."

161

Dried Beans

Mimi and Don Grant

Great Falls, Montana

The West has always been Mimi Grant's home — first in Longmont, Colorado and now in Great Falls, Montana. She finds the subjects of her art from the West, past and present, and from the mountains and rivers found there. The art world has always been a part of her and she began seriously painting in oils in 1967. In 1973, she expanded to the media of pen and ink and charcoal. Her well-known scratchboards became an extension of her pen and ink drawings in 1976. With her husband Don and two children, Mimi frequently hikes and backpacks, with camera and pen in hand, to record nature and wildlife that she hopes will always be.

Baked Beans

- 1 large can Pork 'n Beans
- 1 small can Pork 'n Beans
- ¾ cup sugar
- 1 medium onion, chopped
- ¼ cup catsup
- ¼ cup brown sugar

Mix all ingredients in casserole dish. Bake, covered, for 45 minutes at 450 degrees. Remove cover and bake an additional 45 minutes at 350 degrees.

HM

Kasey and Earl Kuhn
Medicine Lodge, Kansas

Earl Kuhn was born in Plainville, Kansas and began drawing during childhood, his favorite subject being horses. His formal art training began in high school and continued at Fort Hays College where he majored in art and was active in the Rodeo Club. He worked in various media for several years before deciding that pencil and watercolors were the best modes of expression for him. His subject matter is the contemporary cowboy and the West of today. He enjoys painting quarter horses and paint horses, as well as the cowboys who work the ranches in the Medicine Lodge area. His paintings have appeared in several publications and he participates in many national invitational art shows each year. Earl and his wife Kasey have three sons and are co-chairmen of the Indian Summer Days Professional Art Show held each fall in Medicine Lodge.

Beans 'n Noodles

- 1 package of navy beans
- 4 eggs
- 2 cups flour
- 3 teaspoons salt
- milk or water
- 2-3 quarts water
- 4 Tablespoons butter
- 1 slice bread, cubed

Soak beans overnight and cook according to package directions. Mix eggs, flour and 1 teaspoon salt with enough water or milk to make a workable dough. Roll out on floured surface and slice to desired width (¼"-⅛" wide). Let noodles dry thoroughly. Can be left out to dry overnight. Store in air-tight container. To cook, bring at least 2 quarts of water to a boil, add 2 teaspoons salt, drop noodles in and cook until tender. Toast bread cubes in butter. (Or you may omit bread cubes and fry cooked noodles in ¼ cup butter, if you wish.) Place a large helping of beans on top of a plate of noodles and pour croutons and butter over all.

"My father's family ate beans 'n noodles regularly; what with 14 kids, a family needed inexpensive meals — and they are better than any steak I ever ate!"

165

Clarence Tillenius
Winnipeg, Manitoba, Canada

An ardent student of nature since his childhood in the Manitobe Interlake region, Clarence Tillenius has devoted a lifetime to painting all species of Canadian wildlife. One of his prime objectives is to arouse our interest and urge us to preserve wilderness areas which are so essential to the continuing existence of our dwindling wildlife. His subjects, ranging from grizzlies, black and polar bears, timber wolves, mountain lions, musk-oxen, woodland and barren caribou, prong-horned antelope, dall and bighorn sheep, mule and white-tailed deer, seem to come alive on canvas. Despite the loss of his painting hand in a construction accident in 1936, Clarence persevered in his efforts to paint the fascinating world of wildlife. Under the tutelage of a fine artist and great friend, Alexander Musgrove, he mastered the use of his left hand — and went on to complete some of his most ambitious and successful artwork. As well as sketching and painting, Clarence has created impressive dioramas for several museums, including a magnificent 51-foot-long diorama depicting a Red River Buffalo hunt for Manitoba's Museum of Man and Nature in Winnipeg. Clarence Tillenius has arrived at maturity and fame, contributing much to his Canadian heritage and working diligently to preserve the matchless wilderness areas his country is blessed with.

Food for the Trail — Eskimo Style

- 15 pounds white navy beans (double the amount if you wish)
- 5 pounds salt pork, cut in 1" cubes
- 12 large onions, chopped
- 1 cup molasses or brown sugar
- ½ cup mustard
- 10 teaspoons salt
- 5 teaspoons pepper
- water

Wash and parboil the navy beans. Put in a large, 5- to 10-gallon (depending on how many days on the trail) pot. Add remaining ingredients, adding water to cover. Cook on low heat for several hours until whole potful is like thick porridge. Now, spread a sheet of polyethylene plastic (with Eskimo dogs roaming the camp, clean snow is non-existent!) outside on the snow (it is 30 degrees below zero) and ladle out pork and beans, spreading them in a ½-inch thick layer (it will freeze instantly like glass). Take a hammer and break it into 2-inch chunks. Put them into several white cotton bags, pack them on the "komatik" (Eskimo sledge) and all is ready. At night in the Eskimo igloo, light the "kudlik" (stone lamp) or the primus stove (if you are a "Kabloona" [white man] and *have* a primus)! Next, pour the frozen beans into the pot (sounds like hail on the roof!) and, when the pot is hot and bubbling, EAT! For even stronger trail food, brown and then stir in 10 pounds of hamburger with the beans.

"I'm passing along this recipe which my friend Eric Mitchell, who spent 2 years with whalers in the Antarctic, 13 years as first clerk and later northern fur post manager for the Hudson's Bay Company in the Antarctic, introduced to me on a polar bear hunt with Eskimos along the Kokumiak River in northern Southampton Island a few years ago. In the small Eskimo settlement of Coral Harbor, we rented a cabin from the H. B. Company to outfit for the expedition and one of the most important items was what food to carry. Since the temperature was *never* above 30 degrees below (and many times under 50 degrees below!) you *must* have the right food . . . and enough of it! In 40-degree-below Arctic weather, after a day riding the sledge or running behind a team of Eskimo dogs, you will never devour anything more delicious than this Food for the Trail . . . NEVER will you see leftovers on a plate after THIS meal!!"

166

Boo and Robert Summers
Glen Rose, Texas

Robert Summers was born and raised in Glen Rose, Texas where he still resides with his wife Boo and their three sons. Bob grew up with art and by 1964 began a serious painting career. Since that time he has worked in several media including egg tempera, acrylic, oil, dry brush watercolor, pastel and pencil; he also enjoys sculpting in bronze. In 1973, Bob co-organized the Texas Association of Professional Artists and has served as president of the group which holds annual shows each November in Waco, Texas. He is also a member of the Texas Watercolor Society and the American Artists Professional League. His list of achievements, awards and honors is long and varied and his works are found in private and public collections from coast to coast, particularly in the Southwest, the area which he knows and loves so well.

South Fork Ranch Beans

- ■ **2 pounds pinto beans**
- ■ **2 pounds ground beef**
- ■ **2 cups onion, chopped**
- ■ **1 clove garlic, minced**
- ■ **2 teaspoons salt**
- ■ **pinch of oregano**
- ■ **1 dried red pepper**
- ■ **¼ cup bacon grease**
- ■ **salt to taste**

Pick over beans and soak 12 hours in water to cover. Drain; add fresh cold water to cover and bring beans to a slow simmer over low heat. Mix meat, onion, garlic, salt and oregano. Wash pepper, finely crush and add to meat mixture. Fry meat mixture in large skillet with bacon grease until meat is nicely browned. Add to beans and simmer 4 hours, partially covered. Add salt to taste. Makes 8 servings.

"This recipe was found in an old 1918 cookbook belonging to Bob's great aunt, Mrs. Gus Schreiner. The Schreiners owned the famous South Fork Ranch in Kerrville, Texas."

167

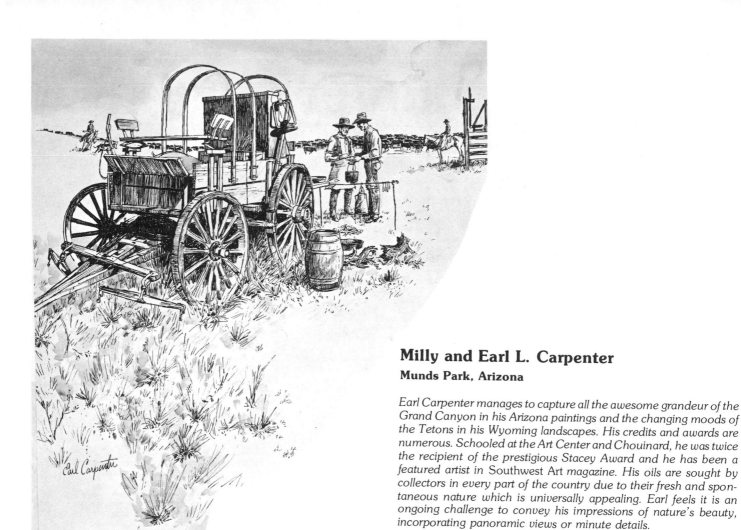

Carl Carpenter

Milly and Earl L. Carpenter
Munds Park, Arizona

Earl Carpenter manages to capture all the awesome grandeur of the Grand Canyon in his Arizona paintings and the changing moods of the Tetons in his Wyoming landscapes. His credits and awards are numerous. Schooled at the Art Center and Chouinard, he was twice the recipient of the prestigious Stacey Award and he has been a featured artist in Southwest Art magazine. His oils are sought by collectors in every part of the country due to their fresh and spontaneous nature which is universally appealing. Earl feels it is an ongoing challenge to convey his impressions of nature's beauty, incorporating panoramic views or minute details.

There Isn't Any More Bean Bake!

- 1 27-ounce can baked beans (B & M brand is good)
- 1 28-ounce can whole kernel sweet corn, drained
- ¼ pound bacon, cut into thin strips and lightly fried
- 1 large onion, sliced
- 1 Tablespoon (or more) brown sugar

Layer all ingredients in a casserole or decorative bean pot and bake at 350 degrees for 1 hour (or slightly longer). Makes 4 to 6 servings.

"This recipe comes from a resident in the historical and 'liveliest' ghost town in the West, Jerome, Arizona. Earl and I both lived and painted in Jerome . . . and ate a lot of baked beans there, too!"

Chapter IV
NEEDING DOUGH!

Quick Breads Yeast Breads
Potatoes Barley Grits & Rice

Quick Breads

Jinx and Bob Stringham
Jackson, Wyoming

Born in Washington State on Whidby Island, Jinx Stringham was raised on an Idaho cattle ranch. When she was a child, her father spent hours teaching her the ways of the wilderness and its wildlife. Her great love for them induces explicit renderings which have depth, clarity and strength that captures the imagination. From her studio in Jackson, Jinx produces her works of art and travels widely throughout the West gathering information and reference material to provide authenticity and proper atmosphere for her paintings. She is a member of the American Artists of the Rockies and the American Historical Artists Association.

Apple Dumplings

- 1 cup sugar
- ¼ teaspoon salt
- ½ cup butter or margarine
- 1½ cups water
- 1 teaspoon vanilla
- 1 cup Bisquick
- ½ cup water, scant
- dash of salt
- 1 tart apple, peeled and finely chopped

Place first 5 ingredients in 10-inch skillet. Cover and bring to a boil. In a bowl, mix Bisquick, water and salt to make a soft dough. Stir in chopped apple and drop by teaspoonsful into boiling sugar mixture. Cover, reduce heat to low and simmer for 15-20 minutes or until dumplings are cooked through and sauce is thick. Serve while hot. Makes 6-8 servings. Serve with sauce spooned over dumplings.

Russ Vickers

Banana Nut Bread

- 1¾ cup all-purpose flour
- 2¾ teaspoons baking powder
- ½ teaspoon salt
- ⅓ cup shortening
- ⅔ cup sugar
- 2 eggs, beaten
- 1 cup ripe bananas, mashed
- ½ cup walnuts, chopped

Sift together first 3 ingredients. In separate bowl, cream shortening, sugar and eggs together. Alternately add flour and bananas, beating well after each addition. Stir in nuts. Pour into 9"x5"x3" greased loaf pan and bake at 350 degrees for 1 hour. (Or pour into two 7½"x4"x3" loaf pans and bake at 350 degrees for 45 minutes.)

"This banana nut bread can be frozen and kept for several months. Very good and a nice change from the usual sweet roll."

Sally and Russ Vickers

Tempe, Arizona

Born in Paris, Texas, the son of a horse trader, Russ Vickers began riding at the age of four and started using the horses as his drawing models shortly thereafter. Russ thoroughly researches the periods he paints, collecting gear and artifacts and spending many hours gathering knowledge from history and reference books. His paintings, often small to miniature in size, have great depth and strength. His use of light and color are superlative, making his works popular and highly collected by western art lovers. He and his wife Sally live in the scenic area of Tempe, Arizona.

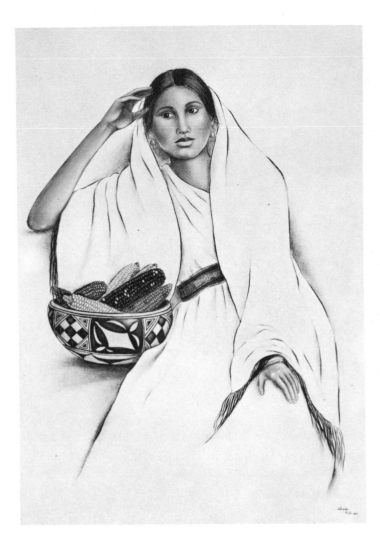

Sheila Hill

Albuquerque, New Mexico

Although her heritage is Taos Pueblo Indian, Sheila Hill was not raised in a traditional home at the Pueblo, but instead, lived in several parts of the country including New Mexico, Oklahoma, Utah and Alaska where she absorbed cultures and knowledge from other tribes. She attended the University of New Mexico where she received a degree in commercial art and worked as a commercial artist for several years as well as an exhibit designer for the Indian Pueblo Cultural Center. Sheila is intrigued with the beauty and quietness of the Indian women. "There is an air of innocence about them, a thoughtfulness, that I try to portray. Gentleness is my theme, for I have entered this world through gentleness and I shall leave it gentle. Encounters and visions I have had are captured within my drawings. I need go no further than my own thoughts. My drawings are not of real people, but rather portraits of feelings. Using simplicity and softness, I try to capture the essence of my Indian heritage."

Blue Corn Pancakes

- 1 cup flour, sifted
- ¼ cup blue corn meal
- 3 teaspoons baking powder
- ¼ teaspoon salt
- 1 Tablespoon sugar
- 1 egg, beaten
- 1 cup milk
- 2 Tablespoons vegetable oil

Mix together first 5 ingredients. In a separate bowl, combine egg, milk and oil. Add egg mixture to dry ingredients and stir just until flour is moistened. (Batter will be lumpy.) Cook on lightly greased griddle. Makes 8 medium-size pancakes. Serve with butter and hot maple syrup.

"Corn is the principal food of the Pueblo Indian people and is very sacred. The most popular corn is the blue corn; the flavor is superior to yellow corn's. It adds a special flavor to many foods and makes pancakes extra-delicious. You can substitute blue corn meal for yellow in any recipe."

Leulla and Tom Heflin
Rockford, Illinois

Born in Monticello, Arkansas, Tom Heflin has been a resident of Rockford, Illinois since 1946, where he lives with his wife Leulla and their five childrenm He travels frequently to gather reference materials for his paintings which reflect his sensitivity to nature and the majority of his artwork is done at his farm-studio in Elroy, Illinois. He has shown in may prestigious national art exhibitions and is listed in Who's Who in American Art *and* Who's Who in the Midwest. *Tom is also the creator of the beautiful book* Quiet Places.

Bran Muffins

- ■ 1¼ cups all-purpose flour
- ■ 3 teaspoons baking powder
- ■ ½ teaspoon salt
- ■ ½ cup brown sugar, packed
- ■ 2½ cups 40% Bran Flakes
- ■ 1¼ cups milk
- ■ 1 egg
- ■ ⅓ cup vegetable oil
- ■ ¼ cup nuts, chopped

Sift first 4 ingredients together. In a separate bowl, pour bran flakes and milk. Let stand for 2 to 3 minutes, then stir until cereal is soft. Add egg and oil; mix well. Add flour to cereal mixture and stir just until moistened. Add nuts and pour into greased muffin cups, filling ⅔ full. Bake at 400 degrees for 25 minutes. Makes 12 muffins.

"These muffins are Tom's favorite and are prepared for him each week as he spends four days a week at his farm studio."

175

Ellen and Wayne Baize
Fort Davis, Texas

Born and raised in Stamford, Texas, Wayne Baize has always lived the country life. Several years ago, he bought a small ranch west of Fort Davis, Texas where he raises registered Hereford cattle. The mountainous area, grass-covered and dotted with live oak trees continues to be a source of inspiration and retreat for the young artist. In life and in his art, Wayne has captured the serenity and peace of the West and the working cowboy. The beauty and majesty of the animals he portrays blend with the quiet dedication of his cowboys for an eloquent and realistic statement about life in the West. He began private art lessons while he was still in grade school and continued through high school. He studied with several fine artists including his friend Tom Ryan, who encouraged him to pursue the style Wayne has become known for. Drawing with colored pencils gives Wayne's work a compassionate softness and character that is universally appealing. While developing his technique, he farmed, ranched, worked in a feed store, lumber yard and western clothing store until his first one-man show, when he was able to pursue his fine art career completely. He participates in several annual shows including the Western Heritage Show in Houston, Texas, the OS Ranch Art Show at Post, the Governor's Invitational Art Show during Cheyenne Frontier Days and the Texas Cowboy Reunion at Stamford, Texas. His work has been featured in many fine western magazines and his signed, limited edition prints are released by Texas Art Press and Frame House Gallery. Wayne recently completed making his house a "home" with his new bride Ellen.

Buttermilk Biscuits

- **2 cups all-purpose flour**
- **1 teaspoon salt**
- **1½ teaspoons baking powder**
- **½ teaspoon soda**
- **2 Tablespoons wheat germ**
- **⅓ cup butter, melted**
- **¾ cut buttermilk**

Sift dry ingredients together. Mix butter and buttermilk together and add to flour mixture immediately. Stir only until flour is just moistened. Knead no more than 10 times on floured board. Roll out 4/5-inch thick and cut with biscuit cutter. Place on greased cookie sheet and bake at 450 degrees for 10-12 minutes or until golden brown. Makes 10 man-size biscuits.

Karyn and Ronald M. Herron
Helena, Montana

From the Big Sky Country, Ron Herron captures the intricate detail of life in his popular bronzes, many of which are done in exquisite miniature. He draws much of the authenticity and impressive spirit captured in his work from the limitless mountains and rangelands of Montana. Ron participates in many national invitational shows and his work is enjoyed by collectors nationwide.

Buttermilk Hotcakes

- **2 cups flour, sifted**
- **2 teaspoons baking powder**
- **1 teaspoon soda**
- **1 teaspoon salt**
- **2 eggs, beaten**
- **2 cups buttermilk**
- **4 Tablespoons shortening, melted**

Mix dry ingredients together in bowl. Add remaining ingredients and stir. Fry on hot (400 degrees) griddle. Delicious served with pork sausage gravy.

"This is Karyn's dad's recipe. They had a big family and the hotcakes, a pound of pork sausage and gravy went a long way!"

177

Esther Marie and Terry L. Versch
Altadena, California

Of Yaqui Indian and Hispanic descent, Esther Marie Versch was raised in the mining community of Rieptown, Nevada. After completing her art training at Pasadena City College she went on to win numerous awards for her work. Esther's watercolors are thoughtful renderings of the Indian traditions and ways. She goes beyond simple description, capturing the mystique and drama of Indian life that may be lost forever. Her art speaks of her personal involvement in the Indian culture. She is represented in several fine galleries and art shows and is a member of the Women Artists of the American West.

Coffee Can Pumpkin Bread

- 3½ cups flour
- 2 teaspoons soda
- 1 teaspoon salt
- 3 teaspoons cinnamon
- 2 teaspoons nutmeg
- 3 cups sugar
- 4 eggs
- 1 cup vegetable oil
- 1 16-ounce can pumpkin
- 1 cup nuts, chopped
- 1 cup raisins

Sift first 5 ingredients together and set aside. Cream sugar, eggs and oil, then stir in pumpkin. Combine flour and pumpkin mixtures and mix well. Grease and flour 4 1-pound coffee cans. Fill each can ½ full of batter and bake at 350 degrees for 1 hour. Makes 4 loaves.

"I use this recipe a lot. It was given to me by my friend Mary Miller and each time I use it I always think of her."

Vaughn and Keith Christie
Browns Valley, California

Forthright and lively western artist Keith Christie is best known for his beautiful bronze sculptures depicting the cowboy and his horse. Equally adept at drawing, Keith is the author of the book Jumping Cholla: Genesis of a Bronze Sculpture, *published by Northland Press. In it, he helps the collectors and admirers of bronze sculpture understand the process of creating a bronze, from the fundamental questions, such as how long it takes to produce a bronze casting and why it is so expensive. To widen the book's perspective and increase its usefulness he included the advice of noted experts in the field. He, his wife Vaughn and children live in beautiful Browns Valley, California.*

Cornbread

- 2½ cups flour
- 1 cup corn meal
- 2½ teaspoons baking powder
- 1 teaspoon soda
- 1 teaspoon salt
- 8 Tablespoons sugar
- 2½ cups milk
- 3 teaspoons lemon juice
- 2 eggs
- ½ cup vegetable oil

Sift first 6 ingredients together and set aside. Mix milk and lemon juice together and allow to sit for a few minutes to make sour milk, then beat in eggs and oil. Combine milk and flour mixtures just until flour is moistened. Pour into greased 9"x13"x2" pan and bake at 425 degrees for 30-40 minutes or until wooden pick inserted in middle comes out clean.

"This cornbread doesn't dry out or crumble like regular cornbread recipes tend to. I've been known to throw some wheat germ and an extra egg in if I think the meal we're having is a little on the 'light side' of nutritious."

Miriam and Bob Wolf
Laporte, Colorado

Cranberry-Cheese-Nut Bread

- 2¾ cups whole wheat flour (or 2½ cups all-purpose flour)
- ½ cup sugar
- ½ cup brown sugar, packed
- 3½ teaspoons baking powder
- 1 teaspoon salt
- 3 Tablespoons vegetable oil
- 1¼ cups milk
- 1 egg
- 1 Tablespoon plus 1 teaspoon orange peel, grated
- 1½ cups Cheddar cheese, shredded
- 1 cup cranberries, cut into halves
- ½ cup nuts, chopped

Preheat oven to 350 degrees. Grease **bottom only** of a 9"x5"x3" loaf pan. Mix all ingredients; beat 30 seconds. Pour into pan and bake 65-70 minutes or until wooden pick inserted in center comes out clean. Cool slightly; loosen sides of loaf from pan and remove. Cool completely before slicing. Will store, wrapped in refrigerator, for about a week.

"This is a very rich, delicious bread that is especially good for potlucks. Guests always want the recipe."

Vivian and Dick Spencer
Colorado Springs, Colorado

Dick Spencer is Texas born and raised. Educated at the University of Iowa, he served as a combat officer in the paratroops in Italy, France, Belgium and Germany during World War II. He has been with The Western Horseman magazine for over 30 years; the first 18 as editor, and since then as publisher. He has been a cartoonist "all his life" and began creating western bronze sculptures several years ago while he was recuperating from a broken leg. Many of his early sculptures were in a humorous vein as is this great recipe.

E. Z. Pancakes

- 1 cup Bisquick
- 1 egg
- ½ cup milk
- ¼ cup chopped pecans (or to taste)

"GIT AWAY, CONSARN YUH! YORE SPOILIN' MUH REPUTATION!"

"I'm neither a gourmet cook nor a finicky eater, and breakfast is one of my favorite meals . . . any time of the day or night! The recipe I selected, because I usually whomp this up when I want to surprise somebody, is for pancakes — or flapjacks, if you prefer.

My recipe is no big secret. You can come close to it by reading the directions on a box of Bisquick, but I change it just a *leetle* bit. I get a mixing bowl, and dump in one cup of Bisquick. Then I bust one egg in on top of that, and then a half 'a cup of milk. Then I usually just take a spoon and whip the heck out of the mess, digging in enough so most of the lumps are out of the Bisquick.

You'll find this is a bit thinner than the usual recipe of what pancake batter should look like, but this is what makes these pancakes special. Then you add some chopped pecans. Any amount, depending upon what you like and what you have. After you make 'em once, you'll decide whether to put in more pecans, or fewer, next time. About ¼ cup is good for starters. Whip the batter some more.

I like the frying pan heated, and with just enough oil or grease so the pancakes don't stick . . . but I don't want them "deep-fat fried!"

The next trick is to make lots of little ones, instead of a few big ones. I like to make 'em no bigger'n a baseball.

They'll cook pretty quick once you start them; and watch for the bubbles on the top side. When they get pretty much bubbled all over, I flip 'em with a spatula.

This recipe feeds two people — especially if you have some link or patty sausages to go with it, and some good hot coffee. Of course, I put lots of butter on them, and any kind of syrup that is handy. Or, for a change of pace, you might want to sprinkle them with powdered sugar.

It's an easy recipe to double, triple or quadruple — depending on how many you're gonna' feed, and how hungry they are. They always come out good, and I've cooked 'em over an open fire or a kitchen stove. Try this one; and if you don't like it . . . you wouldn't like any of my other recipes anyhow!"

181

Loretta and Joe Taylor
Cypress, Texas

Flour Tortillas

(Food Processor Method)

- 2 cups flour
- ½ teaspoon salt
- 1 teaspoon baking powder
- ⅓ cup Crisco, melted
- ⅔ cup warm water

Place all ingredients in food processor. Process until dough forms ball. Heat ungreased cast iron skillet or griddle on medium heat. (To test, sprinkle with few drops water; if bubbles skitter around, heat is just right.) While skillet is heating, divide dough into 12 parts and roll into balls. Flatten each ball by using thumb and forefinger, keeping each ball as round as possible. Use either a rolling pin or tortilla press to complete flattening process. (If you use rolling pin, work on floured surface, remembering that it takes time and practice to make perfectly round tortillas; oblong or square ones taste just as good!) Place a tortilla on hot skillet and cook until big bubbles appear on top side; immediately flip over and cook on bottom for about 5 seconds. Be careful not to overcook. Makes 12 tortillas.

"A gringo from Sabinol, Texas, Ann Woodley, created this recipe. For years I tried to make tortillas by watching the Mexican ladies; recording scoops, pinches, etc. My results were acceptable, but nothing to write home about until Ann shared her secret with me. These tortillas are truly delicious and get rave notices every time."

Pat and Dwayne Brech
Colorado Springs, Colorado

A native of southern Minnesota, Dwayne Brech began his art career when he and his family moved to Colorado in 1971. He became staff advertising artist for The Western Horseman *magazine and through his work met ranchers who offered first hand opportunities to paint and work in a ranch atmosphere. This experience combined with his determination to continue to improve his technique, accuracy and quality of art, make his paintings and drawings increasingly popular with collectors of western art.*

Golden Sweet Muffins

- 1¾ cups flour
- 2½ teaspoons baking powder
- ¾ teaspoon salt
- ½ teaspoon cinnamon
- ½ teaspoon nutmeg
- ½ cup raisins
- 1 egg, beaten
- ¾ cup skim milk
- ⅓ cup oil
- ½ cup winter squash, cooked

Mix first 5 ingredients, then add raisins. Make a well in the center of flour mixture. In a separate bowl, mix remaining ingredients; blend until smooth. Add, all at once, to dry ingredients and stir just until flour is moistened. Line muffin tins with paper inserts and fill ⅔ full. Bake in 375 degree oven for 20 minutes. Makes 12 muffins.

"A good and delicious way to use leftover squash."

Maggie Goodwin
Boulder, Colorado

Maggie Goodwin's work depicts the contemporary West; to her the most exciting of times, people and places. "Painting for me is a joyful experience, an exciting attempt to interpret what I see, and hope to show others." Art to Maggie is a lifelong search to improve her powers of observation and means of expression. She is a member of the Women Artists of the West association.

Good Grain Crackers

- **2 cups corn meal**
- **2½ cups whole wheat flour**
- **1 Tablespoon salt**
- **¾ cup oil**
- **½ cup sesame seeds**
- **1½ cups water**

Mix first 5 ingredients together, then add water and mix until it forms a sticky dough. Press mixture flat on cookie sheets and roll thin with glass. Score in 2-inch squares and bake at 325 degrees for 15-20 minutes. Be careful not to scorch; the thinner they are, the faster they cook.

"This cracker is a delicious, healthful snack food — perfect for studio parties."

HM

Carol and W. Steve Seltzer

Great Falls, Montana

Native Montanan and grandson of the late Olaf C. Seltzer, Steve Seltzer graduated from Montana State University and then moved to California where he studied with such artists as Donald "Putt" Putman and Sergie Bongart. Steve works primarily in oils and watercolors and believes the total quality of a painting is more important than either its subject matter or media. Steve's natural influence has been in the western field and his paintings are primarily of historical subjects with an emphasis on the Plains Indian culture. He is a charter member of the Northwest Rendezvous Group. This dedicated young artist lives with his wife Carol and their daughter in Great Falls, Montana.

Honey-Bran Muffins

- 2 cups whole wheat flour
- 1½ cups bran
- ¾ teaspoon salt
- 1¼ teaspoon baking soda
- 2 Tablespoons brown sugar
- 2 cups yogurt or buttermilk
- 1 egg, lightly beaten
- ½ cup honey
- 2 Tablespoons butter, softened
- ½ cup raisins (optional)
- ½ cup nuts (optional)

Mix first 5 ingredients together and set aside. Combine next 4 ingredients and add to flour mixture. Fold in raisins and nuts, if you wish. Fill muffin tins ½ full and bake at 400 degrees for 15-20 minutes. Makes 12 muffins.

"These delicious and nutritious honey-bran muffins (not to be confused with meadow muffins!) are one of the Seltzer family's favorite recipes. They are great with a main dish, as a breakfast treat or as a snack to fill up the artist when he's hard at work at the easel."

Jeri and Richard V. Greeves
Ft. Washakie, Wyoming

Indian Fry Bread

- 2 cups flour, or more
- 2 Tablespoons baking powder
- pinch of salt
- 1 cup warm milk (approximate)
- Crisco

Mix first 3 ingredients thoroughly. Add enough milk to make flour mixture into a dough. May need to use more flour. Cover and set in a warm place while heating oil or shortening. Divide dough into small, flat portions and fry in oil like doughnuts.

Cindi and Mark Swanson

Prescott, Arizona

Born in South Dakota, Mark Swanson began drawing at an early age and was encouraged to pursue an art career through the advice and tutelage of his artist uncles, Ray and Gary Swanson. He moved to Prescott several years ago to receive further guidance from Ray who has helped him expand his artistic talents and abilities. Many of Mark's paintings have his own leatherworks which he makes incorporated into them. His first love is the fur-trade era and the Old West which he brings to life on canvas. He has had several successful group showings and has been featured in Southwest Art Magazine.

Lefse

- ■ 1½ cups flour
- ■ ½ teaspoon baking powder
- ■ 1 Tablespoon sugar
- ■ ½ cup shortening
- ■ 3 cups mashed potatoes

Mix all ingredients together well. Form into small balls, then roll out paper-thin on floured surface. Fry on very hot griddle as you would pancakes. (They must be fried very quickly.) Looks similar to the flour tortilla.

"This is a Scandinavian Christmas tradition with the Swanson family. Eaten with butter, brown sugar or cinnamon-sugar spread on them and then rolled up and cut in half. They are best eaten at room temperature. Recipe freezes well. Of course, they're good any time, not just at Christmas!"

187

jodie Boren

Peggy and Jodie Boren
Abilene, Texas

After graduating from the Kansas City Art Institute, Jodie Boren worked in the advertising department of Hallmark Cards for several years before moving to Abilene to become art director for an ad agency. In 1968, he made the transition to fine art, concentrating on the West. Today, he is a regular participant in several prestigious art shows throughout the Southwest and has won awards in the three media he works in — oil, watercolor and drawing. His paintings have appeared on many publication covers and many have been reproduced as Christmas cards by Leanin' Tree Publishing Company. He has signed and numbered limited edition prints produced by Frame House Gallery and he is featured in the book Contemporary Western Artists *by Peggy and Harold Samuels, published by Southwest Art Magazine.*

Mexican Cornbread

- 1 cup buttermilk
- 1 cup yellow cornmeal
- 1 cup flour, sifted
- 3 Tablespoons sugar
- 1 teaspoon baking powder
- ½ teaspoon soda
- 1 teaspoon salt
- 1 egg
- 4 Tablespoons butter, melted
- 1 can whole kernel corn, drained
- 1 4-ounce can chopped green chilies
- 1 2-ounce jar chopped pimientos
- ½ pound Cheddar cheese, grated

Combine buttermilk and cornmeal. Let stand for 30 minutes. In a separate bowl combine next 5 ingredients. Add egg and butter to buttermilk mixture and mix well, then add to flour mixture and mix well again. Add last 4 ingredients and stir. Pour into a well greased 12"x10"x2" pan and bake at 375 degrees for 30 minutes.

"This recipe was given to us at a church picnic many years ago. Delicious with a big pot of beans and a green salad."

"Carol" Grende and Dave LaFord

Clarkston, Washington

Idaho-born "Carol" Grende LaFord has ridden horses in the area of the Snake and Clearwater Rivers most of her life. For many years she has owned and trained Appaloosas and this life-long love of animals has inspired her art. As a self-taught artist, Carol has developed a unique style of realism, creating moods of tranquility, stress or action in fine detail. Within the last few years she has developed her style in scratchboard and sculpture. Permanent displays of her work may be seen at Hell's Gate Park in Idaho and the Favell Museum in Klamath Fallsn Oregon. She has been a featured artist at the Cowgirl Hall of Fame and is a member of the Women Artists of America.

"Mixed Media" Muffins

- 2 cups any muffin or banana bread mix using whole grain flour, bran, etc.
- 1 cup nuts, chopped
- 1 cup dried fruit, chopped
- ½ cup grated carrots, coconut or carob chips
- 1 egg, whipped (more if mix is too grainy)

Combine all ingredients and pour into greased and floured muffin tins, filling about ⅔ full. Bake at 350 degrees for 20 minutes or until wooden pick inserted in middle of muffin comes out clean. Recipe can easily be doubled. Use your favorite nuts and fruit.

"I've always enjoyed making up recipes by adapting standard recipes. We backpack and these muffins are a good snack for the trail, giving us good fuel for the road!"

189

Beverly and Ray Swanson
Prescott, Arizona

Navajo Fry Bread

- 4 cups all-purpose flour
- 1 cup instant non-fat dry milk
- 8 teaspoons baking powder
- 2 teaspoons salt
- 2 cups warm water
- shortening

Combine first 5 ingredients and let stand for 10 minutes. Divide dough and roll into 2-inch balls. On floured surface, flatten balls with hand or rolling pin to ¼-inch thick. Heat 1 to 2 inches shortening in large frying pan on medium-high (350 degrees) heat. Fry bread pieces until brown on 1 side, turn and brown other side. Drain and keep warm. Serve hot with honey, powdered sugar or jam.

"Fry bread is our favorite food from trips to the Navajo reservations. The best fresh, hot fry bread can be obtained from the Window Rock Pow Wow. We like to eat it with honey dripping off the sides!"

190

Sharon and Ron Stewart
Scottsdale, Arizona

Pumpkin Bread

- 1¾ cups flour
- 1½ cups sugar
- 1 teaspoon salt
- 1 teaspoon baking soda
- ¼ teaspoon baking powder
- ½ teaspoon cloves
- ½ teaspoon cinnamon
- ½ teaspoon allspice
- 2 eggs
- 1 cup pumpkin
- ½ cup vegetable oil
- ⅓ cup water
- 1 cup nuts, chopped
- ½ cup raisins

Combine all ingredients in large mixing bowl; mix well. Grease **bottom only** of 2 loaf pans, 8½''x4½''x2½''. Pour into pans and bake at 350 degrees for 1¼-1½ hours or until wooden pick inserted in center comes out clean.

"This is another recipe from a good friend. I bake many loaves at holidays and give them to friends. Freezes well."

KEITH CHRISTIE '81
CHRISTMAS 1981

Vaughn and Keith Christie
Browns Valley, California

Sour Cream Donuts

- 3 cups flour
- 3 teaspoons baking powder
- 1 teaspoon salt
- ½ teaspoon nutmeg
- 3 eggs, beaten
- 1 cup sugar
- ½ cup sour cream
- 1 teaspoon baking soda
- ½ cup milk
- oil

Sift first 4 ingredients together and set aside. In large bowl, mix eggs and sugar. In small bowl, mix sour cream and soda, then add to egg mixture with milk. Mix well and add flour mixture; stir to mix. Turn dough onto floured surface, roll out to ⅜'' thick and cut with floured donut cutter. Fry with 2 to 3 inches of hot oil in deep-fat fryer or heavy kettle (at 375 degrees). Fry until golden brown, 1 to 1½ minutes on each side. Remove from oil and drain. Makes 3 dozen donuts.

Vivian and Dick Spencer
The Western Horseman Magazine
Colorado Springs, Colorado

Spencer's Easy-to-Make Beer Bread

- **3 cups Gold Medal self-rising flour**
- **2-3 Tablespoons sugar**
- **1 can beer, room temperature**

Mix all ingredients together. Place in greased 9"x5"x3" loaf pan and bake at 300 degrees for one hour. Remove, brush loaf with butter, return to oven and bake for 10 more minutes.

Yeast Breads

Pamela and Glen S. Hopkinson
Cody, Wyoming

Glen S. Hopkinson was born and raised in the Rocky Mountains and continues to make his home with his wife Pamela and their five children in Cody, Wyoming. His interest in art begann literally, at his father's (well-known western artist, Harold Hopkinson's) knee. When he was 16, he studied with the late Bob Meyers from whom he learned valuable discipline and an appreciation for authenticity. He later spent three years in Korea where he painted portraits of visiting diplomats and a seven-foot mural for a chapel in Taegu. Upon his return to the United Statesn Glen studied with Donald "Putt" Putman and was inspired by his use of color, light and shadow and was especially impressed with the importance of drawing well and using live models. Glen finished his formal art training with a B.A. from Brighan Young University in Provo, Utah and worked as an illustrator for a time before turning his efforts to fine art. During the past ten yearsn he has had much success in the art world with his paintings and sculpture. His works are in the permanent collections of the Montana Historical Society and the Wyoming Historical Society.

Applesauce Wheat Bread

- 2 packages active dry yeast
- 1 cup warm water
- 5 cups all-purpose flour
- 5 cups whole wheat flour
- 3 teaspoons salt
- 1 cup brown sugar
- ½ cup oil
- 3 cups warm water
- 4 Tablespoons applesauce

Dissolve yeast in 1 cup water. Combine next 3 ingredients in large bowl. Combine remaining ingredients in small bowl. Add yeast and sugar mixture to flour mixture and stir well. Turn dough out and knead. Shape into ball and place in well-greased bowl; let rise 35 minutes. Punch down and let rise again for 20 minutes. Place in 4 greased loaf pans and let rise 30 minutes or till dough reaches top of pans. Bake at 350 degrees for 30 minutes.

"This bread is so great that it makes a meal all by itself served with honey, butter and cold milk."

Judy and J. Shirly Bothum
Clarkston, Washington

J. Shirly Bothum was born on a Kansas sand hill farm and grew up in Oregon's Willamette Valley where his cowboy spirit flourished near the St. Paul rodeo. The rodeo arena also served as a classroom for his developing career as an artist. His fascination for the cowboy life and his artistic talent grew to be two closely related aspects of his life. He broke and trained horses on small ranches and participated in wild horse races and rodeos and he expressed his love of wildlife as he worked in various cow and sheep camps scattered through Oregon, Washington and Idaho through his drawings. He eventually turned to sculpting in bronze because he believes that the beauty and spirit of the animals and the nature of the men who ride and hunt them are enhanced by the three-dimensional power of this art form. A member of Safari Clubs and other wildlife organizations, Shirly contends that knowledge of our history is equally as important as the concern for the environment, and these thoughts are reflected in his creations.

Judy's Famous Cinnamon Rolls

- 2 packages active dry yeast
- 3 cups warm water
- 1 cup sugar
- 1 Tablespoon oil
- dash of salt
- 6-8 cups all-purpose flour

- ½ cup sugar
- 4 teaspoons cinnamon
- 1½-2 pints plain or whipping cream
- brown sugar
- butter

Dissolve yeast in warm water in large Tupperware bowl. Quickly mix in next 4 ingredients and cover tightly with lid. (Mixture will rise rapidly.) When double, punch down and roll into rectangle on lightly-floured surface. Mix ½ cup sugar and the cinnamon and sprinkle over rectangle. Roll up tightly, pinching edges to seal. Cut into about 20 slices. In 13"x9"x2" pan, mix cream with enough brown sugar to make mixture caramel-colored. Place rolls in pan and bake at 350 degrees for 1 hour. Remove from oven and brush tops with butter. Invert pan onto serving plate. Serve warm. Makes about 20 rolls.

"This recipe is the only one I've ever seen or tasted like this. You will notice that there is no butter rolled in the dough. The cream and brown sugar make them delicious. This was handed down from my grandmother who was a wonderful cook."

197

Anne and O. J. Gromme
Portage, Wisconsin

Danish Julekage

- 2 packages active dry yeast
- ¼ cup warm water
- 1 cup sugar
- ½ cup butter
- 2 cups milk, scalded
- 2 teaspoons salt

- 2 eggs, beaten
- 7 cups flour
- 2 cups candied fruit
- 1 cup raisins
- 1½ teaspoons cardamon seeds, crushed

Dissolve yeast in warm water. Mix sugar, butter and salt with hot milk in large bowl. When cool, add yeast and mix. Then add eggs and blend. Add about ⅔ of the flour and beat until smooth. Stir in fruit and cardamon. Add remaining flour gradually (turning dough onto floured surface and kneading in last of flour if necessary). Knead until smooth and elastic. Turn into greased bowl and let rise in warm place until double. Punch dough down and let rise again. Shape into loaves and place in 2 to 3 greased loaf pans, 9"x5"x3". Let rise until double. Bake at 350 degrees for 35-45 minutes or until loaves are golden brown and sound hollow when tapped.

"This is another of my mother's recipes from Denmark. I have had to fill in amounts since she was a "little of this and a pinch of that" cook, like so many! This is a favorite of all our family, especially at Christmas time."

Shari and Gerald Farm
Farmington, New Mexico

Honey-Whole Wheat-Molasses Bread

- **2 packages active dry yeast**
- **1 teaspoon salt**
- **3 cups whole wheat flour**
- **2 Tablespoons shortening**
- **½ cup molasses**
- **¼ cup honey**
- **1¾ cups hot water**
- **3 cups all-purpose flour**
- **butter**

Combine first 3 ingredients in large bowl. Combine next 4 ingredients in small bowl, then add to dry ingredients and beat with electric mixer for 3 minutes. Gradually add all-purpose flour and stir. Turn out onto floured surface and knead for 10 minutes. (Add more all-purpose flour if necessary so dough will be past "sticky" stage but not stiff.) Form into ball and place in greased bowl, rotating ball so it is greased on all sides. Let rise for 2 hours or until double. Punch dough down and divide into 2 balls, slapping hard to remove all air bubbles. Place on waxed paper and let rest for 10 minutes. Form into round, flat loaves and place on greased cookie sheet. Let rise 1 hour. Bake at 350 degrees for 35 minutes. Remove from oven and rub with butter.

"This bread has been a favorite of family and friends for years."

199

Tona and Buckeye Blake
Augusta, Montana

Buckeye Blake grew up in the West with an artist mother and a bull riding father helping to shape his western heritage. His artistic abilities became evident as a child and at age 17 he went to Hollywood to work for the motion picture studios. Soon missing the open spaces of the West, he returned and in 1978 settled in Montana. Since then Buckeye has participated in several prestigious art shows throughout the West and produced the highly-acclaimed Rainbow Trail *bronze of the funeral of C. M. Russell. He depicts a variety of subjects working with cowboys and Indian friends as his models. He, his wife Tona and son Teal make their home in Augusta, Montana.*

Old-Fashioned Coffee Cake

- ◼ **2 packages active dry yeast**
- ◼ **1 teaspoon sugar**
- ◼ **½ cup warm water**
- ◼ **1½ cups butter**
- ◼ **1 cup milk**
- ◼ **1 cup sugar**
- ◼ **4 eggs**
- ◼ **½ cup sour cream**
- ◼ **8-9 cups flour**
- ◼ **1 cup nuts, chopped**
- ◼ **1 cup raisins**
- ◼ **¾ cup sugar**
- ◼ **2 Tablespoons cinnamon**
- ◼ **½ cup butter, softened**
- ◼ **1 egg yolk**
- ◼ **¼ cup poppy or sesame seeds**

In small cereal bowl, dissolve yeast and 1 teaspoon sugar. Let stand until mixure rises to top of bowl. In sauce pan, melt 1½ cups butter, the sugar and milk, then combine with eggs and sour cream and mix in large bowl. Add yeast mixture and stir. Gradually add flour until dough is not sticky. Knead until smooth and elastic. Cover with damp cloth and let rise until double. Mix nuts, raisins, sugar, cinnamon and butter and set aside. Punch dough down and divide into 3 balls. Roll out each ball on lightly floured surface and spread with nut mixture. Roll up tightly and pinch edges to seal. Place in 3 greased loaf pans, 9"x5"x3". Brush top of loaves with egg yolk and sprinkle with seeds. Let rise until dough reaches tops of pans. Bake at 350 degrees until golden brown, 30-35 minutes. Cool on wire racks.

"This coffee cake recipe is from Tona's Jewish grandmother who brought it from Russia. Good any time!"

Genevieve and Robert F. Morgan
Helena, Montana

Povitica

- 2 packages active dry yeast
- ⅔ cup warm water
- 1 cup milk, scalded and cooled
- 1 cup sugar
- ½ cup butter
- 3 eggs
- ¾ Tablespoon salt
- 6 cups flour
- 1½ cups honey
- 3 egg yolks
- 3 teaspoons vanilla
- 1½ cups Half & Half
- 1½ teaspoons cinnamon
- 1 teaspoon cloves
- 1½ pounds walnuts, finely ground
- 3 egg whites
- ½ cup butter, melted

Dissolve yeast in warm water in large bowl. Add next five ingredients; beat until smooth. Gradually add flour, one cup at a time, until dough is not sticky. Knead until smooth and elastic; ten minutes. Cover and let rise slowly, two hours. In large saucepan, combine next six ingredients and cook over medium heat, stirring constantly. Reduce heat to low and add walnuts. Remove from heat and set aside. When dough has doubled in size, roll out *very thin* on large well-floured cloth. (I use a tablecloth and tape it under my kitchen table.) Rolling takes a while to get dough really thin. If dough should tear, just take piece from edge and patch. Beat egg whites, then add to melted butter and filling mixture. Spread mixture evenly over dough all the way to the edges. Roll up like a jelly roll. Curl it into a snail shape and place in large roasting pan. (Or cut and seal edges and bake in loaf pans or angel food cake pans.) Cover and let rise two hours. Bake at 325 degrees for 1½ hours or until golden brown. (May need to reduce heat to 300 for last 30 minutes if you have a "hot" oven.) To remove, tap pan and run knife around edge. Brush with butter and cool. (Smaller loaves bake in one hour.)

"This is a Yugoslavian sweet bread that I always make at Christmas and Easter. It's an old family recipe and was always served at all the weddings in my little hometown of East Helena. It became one of Bob's favorite foods before we were married and we were sent off on our honeymoon with a generous supply of it."

Mary and Verne Tossey
Portland, Oregon

A veteran of four years in the Army during World War II, Verne Tossey studied at the Art Student's League with Frank J. Reilly and for the next 25 years maintained a studio in New York City. He became such a well-known book and magazine illustrator that he traveled to many parts of the world, including a stint as a combat artist in Vietnam. Twelve years ago, Verne made the final break with New York and came West to be near his favorite subject matter and to concentrate on his fine art career. He and his wife Mary live in Portland, Oregon.

Sheepherder's Bread

- 2 packages active dry yeast
- 3 cups warm water
- ½ cup butter, melted
- ½ cup sugar
- 2½ teaspoons salt
- 9½ cups all-purpose flour

In large bowl, combine first 5 ingredients and set aside in warm place until mixture is bubbly, about 15 minutes. Then add 5 cups of the flour and beat with a heavy-duty electric mixer or wooden spoon until mixture forms thick batter. Stir in enough of remaining flour (about 3½ cups) to form stiff dough. Turn dough onto floured surface and knead until smooth and elastic, about 10 minutes; adding flour as needed to keep dough from sticking. Turn into greased bowl, rotating to grease all sides, cover and let rise in warm place until double, about 1½ hours. Punch dough down and knead into smooth ball. Cut a circle of aluminum foil to fit a 10-inch, 5-quart cast iron dutch oven. Grease inside of dutch oven and underside of lid with oil. Place dough in dutch oven and cover with lid. Let rise in warm place until dough pushes lid up about ½ inch, about 1 hour. Bake, covered with lid, at 375 degrees for 12 minutes. Remove lid and bake 30-35 more minutes or until golden brown and loaf sounds hollow when tapped. Remove from dutch oven and cool right-side-up on rack.

"Verne's idea of cooking is to turn the hamburgers over on a charcoal grill or to open a can of baked beans! This is not to say that he doesn't appreciate good cooking — he does — especially homemade breads and desserts. This is one of his favorite breads."

202

Pauline and Clark Bronson

Bozeman, Montana

Clark Bronson was born in Kamas, Utah and received his formal art training at the Art Instruction Institute in Minneapolis, Minnesota and the University of Utah at Salt Lake City. After serving as a staff artist for the State of Utah Fish and Game Department and then ten years as a successful free lance illustrator for many national publications, Clark engaged in the creation of bronze wildlife sculptures on a full-time basis in 1970. Since then he has won numerous awards for his artwork and is a member of the National Academy of Western Art, National Sculpture Society, Society of Animal Artists, and the Northwest Rendezvous Group. He is listed in Who's Who in American Art *and* American Artists of Renown. *He and his wife Pauline and their three children reside in Bozeman, Montana.*

Sourdough Pancakes

- 1 package active dry yeast
- 2 cups warm water
- 2 cups flour
- 1 teaspoon salt
- 1 Tablespoon sugar
- 1-2 eggs
- 3 Tablespoons oil
- ¼ cup milk
- 1 teaspoon baking soda

The night before, make starter by mixing first 3 ingredients. Next morning, add remaining ingredients. Spoon onto lightly-greased medium-hot skillet and cook on both sides until golden brown.

203

Grace and Robert L. Knox
Carlsbad, New Mexico

White Bread Plus

- 1 package active dry yeast
- ½ cup warm water
- 1 Tablespoon sugar
- 1 egg, beaten
- ½ cup shortening, melted (or vegetable oil)
- 2 cups warm water
- 1½ teaspoons salt
- ½ cup sugar
- 7½-8 cups all-purpose flour

Dissolve yeast and sugar in warm water in large bowl. Stir in next 5 ingredients. Gradually add flour, 1 cup at a time, until a fairly thick batter is formed, then pour batter onto floured surface and knead in remaining flour, about 10 minutes. Form dough into ball and place in well-greased bowl. Let rise until doubled in size. Punch dough down, turn and let rise again until double. Divide dough into 3 portions and shape into loaves. Place in well-greased loaf pans and let rise until dough reaches tops of pans. Place loaves in cold oven. Bake at 400 degrees for 15 minutes, then reduce heat to 375 degrees and bake for 25 minutes more or until golden brown and loaves sound hollow when tapped. Remove, turn out on racks and cool.

"This is a recipe I have used for almost 30 years. Original recipe called for cake yeast, lard and sifted flour. My husband and sons are spoiled to this bread and feel insulted when they have to eat 'store-bought.' This recipe came from the old *Joy of Cooking* book by Irma S. Rombauer which was given to me as a wedding gift. It has pulled me out of many tight spots and has made me into a 'fair-to-middlin' ' cook! I, in turn, give this book as a wedding gift and believe that it has saved many marriages!"

Potatoes

Miriam and Bob Wolf
Laporte, Colorado

Bob Wolf's Superior Hashbrowns

Get 6 fist-sized brown-skinned potatoes from garden or grocery store — 4 if you have a big fist, 8 if you have a small fist. Find also 2 tennis ball-sized white onions. Skin the onions and wash the potatoes. Dice onions and potatoes into ⅜-inch cubes. (¼-inch is too small and ½-inch is too big!) Chunks ending up as rectangles, trapezoids or half-moons will spoil the looks and/or taste of the finished dish! They may be discarded during preparation, to the delight of "Dawg" who is probably supervising and is heretofore unrewarded! Secure a large, 12-15-inch, black, used, cast-iron and at least 20-year-old skillet, 2 to 3 inches deep. Fry up 8 to 10 bacon strips on medium heat. Remove bacon and dump in diced potatoes and onions. Quickly stir and turn to coat with oil. Cook, turning frequently — test by taste often — if potatoes have a raw, starchy taste, they're not done yet! Do not allow them to stick to bottom of pan. Add oil if necessary. Mixture should never be dry or swimming in grease. When everything is "almost" but not "quite" done, add ¼ cup water and cover. Continue cooking, covered, for 5 to 7 minutes. Remove cover, add a generous amount of pepper, some salt and a bit of garlic (depending on what you plan to do with your personal life for the balance of the evening) and stir, turn, mix, etc. Turn heat up to medium-high and brown mixture (but do not burn), turning once. On the last turn add 2 Tablespoons flour, sprinkled over the potatoes evenly. Stir with large fork and reduce heat to low. Stir gently and place bacon strips on top of potatoes to warm. Cover and keep warm until fish, eggs or pancakes are done! Eat and enjoy! Serves 4 people (serves 2 if served outdoors with fresh trout fried alongside in a dry tent on a rainy night)!

Note: If burned, DO NOT EAT! Save for 1 year's supply of mousetrap bait!

Pamela Harr and Harvey Rattey
Bozeman, Montana

Pamela Harr was raised around the historical gold mining regions near Sacramento, California. Sculpture began to interest her during the three years she spent as a physical therapist working with hand-icapped children. She used it as a medium in her therapy program. She then spent several years on a cattle ranch in northeastern Oregon, gaining knowledge of the ranching life first-hand. In 1973, Pamela fused her diverse backgrounds and began learning bronze casting. Through her sculpture she portrays many of the events she has witnessed as well as stories and characters from the historical West. She and her husband, sculptor Harvey Rattey, live in Boze-man, Montana where they have their own foundry.

Har de Harr Sweet Potato Balls

- 2-3 large sweet potatoes
- salt to taste
- ½ cup honey or syrup
- ½ teaspoon cinnamon
- ½ cup nuts, chopped
- 1 Tablespoon butter
- ½ cup cornflakes, crushed
- 1 cup miniature marshmallows

Boil, peel and mash sweet potatoes. Salt to taste. Add next 4 ingredients. Generously butter hands and roll some of the mixture around a marshmallow until the size of a golf ball. Roll balls in cornflakes. Place on lightly-greased baking sheet and bake at 300 degrees for 15-20 minutes or until slightly browned.

"This recipe came from a good friend in Columbus, Georgia and always brings back memories of the years I lived in the South. This is a special treat I make on holidays."

Linda M. and John Budge
Laramie, Wyoming

Her studio in Laramie, Wyoming places Linda Budge in the heart of the Rocky Mountain area where her exposure to big game is maximized. She captures the wildlife in their natural surroundings with intimate accuracy in oil and watercolor. Linda feels deeply about her subject matter and paints what she experiences and her paintings depict her respect for big game wildlife in profound and realistic portraits. Linda is a member of the Society of Animal Artists.

Orange Praline Yams

- 4 pounds yams, peeled and quartered (or 2 40-ounce cans, drained)
- water
- ⅔ cup orange juice
- 5 Tablespoons Brandy
- 4 Tablespoons unsalted butter, melted
- ⅓ cup light brown sugar, packed
- 1 Tablespoon orange rind, grated
- 2 teaspoons salt
- 1 teaspoon ginger
- black pepper, freshly ground
- 3 egg yolks
- 1 cup pecans, chopped
- ⅔ cup light brown sugar, packed
- ½ cup unsalted butter, melted
- 1 teaspoon cinnamon

In large pan, boil yams in water to cover for 25-30 minutes or until tender. Drain and cut into thick slices. Preheat oven to 350 degrees. Butter an 11"x7" baking dish. Beat yams with electric mixer at medium speed for 2 minutes, until smooth. Add next 9 ingredients and beat for 1 minute. Spoon into baking dish. Mix last 4 ingredients together and spread evenly over yams. Bake for 45-50 minutes, until brown and bubbly. Remove from oven and let stand for 10 minutes. Makes 10-12 servings.

"This dish will appeal to any artist's palate!"

Nancy Glazier

Lindon, Utah

Nancy Glazier was born in Salt Lake City, Utah and was immersed in art and animals from an early age. All during her youth she sketched, painted and took art lessons at every opportunity. When she was 18, Nancy struck out on her own to "become an artist." There were many years of hardship and struggle, but she began training her eye and working with landscapes and portraits. Later she began studying native North American wildlife and was filled with a sense of discovery and excitement and began painting what she knew so well. Her beautiful oil paintings are a direct link between wildlife and civilization. "I feel the spirit of each animal come alive at some point while I'm painting. It is almost like a hidden spark I must fan into a flame, which warms my soul and is my reward. It is the joy of creation. This joy I desire to share with all who see my work."

Poor, Starving Artist Potatoes

- hot baked potatoes
- butter or margarine
- onion or garlic salt
- sharp Cheddar cheese, grated
- sour cream
- dill weed, fresh or dried
- bacon bits

Split hot potatoes in half lengthwise. Mash in lots of onion or garlic salt and butter, to taste. Top with a generous amount of cheese. Place in 300 degree oven until cheese melts. Dollop with a mixture of sour cream and dill weed and sprinkle bacon bits on top.

"Poor starving artists, and other artists as well, spend their best times painting, not cooking! This recipe is quick, easy, filling and cheap. Can also be used as a main dish. It was given to me by a good friend who is creative in everything she does. It has become a favorite of mine and is especially good with a green salad.

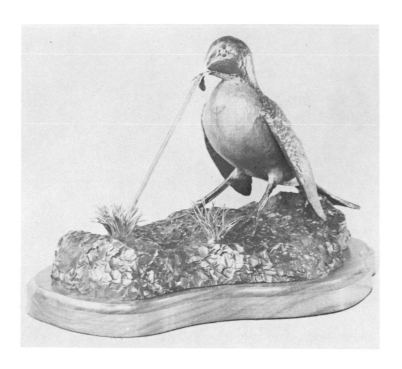

Miriam and Bob Wolf
Laporte, Colorado

Potato Souffle

- 8 large potatoes (4½-5 pounds)
- boiling water
- 8 ounces cream cheese, room temperature
- 1 cup sour cream
- 2 teaspoons garlic salt
- ½ teaspoon pepper
- 2 teaspoons fresh chives, chopped
- 4 Tablespoons butter
- paprika

Peel potatoes and cook, covered, in 5-quart pan with 1 inch boiling water for 40 minutes, or until potatoes are tender. Drain, then mash well. With electric mixer, beat together the cream cheese and sour cream; gradually beat into mashed potatoes until smooth. Beat in garlic salt, pepper and chives. Turn into buttered, shallow, 3-4-quart baking dish or casserole. Dot with butter and sprinkle lightly with paprika. Bake, covered, in 400 degree oven for 1 hour or until hot and crusty. Makes 12-15 servings. Do ahead tip: Instead of baking, cover and chill up to 3 days. To reheat, bring to room temperature, then bake as above.

"This is all of our family's **absolute** favorite dish in the whole world and has become a holiday and birthday tradition. It says it makes 12-15 servings, but it's never served that many, so far. Best to double the recipe for large families."

Barley, Grits & Rice

Jane and Jack Gellatly
Omaha, Nebraska

Barley Casserole

- 6 kitchen matches
- 1 large onion
- 8-10 stalks celery
- ¼ pound butter or margarine
- 1 cup barley
- 2 cans beef consomme
- 1 4-ounce can mushrooms
- slivered almonds

Place the large wooden matches between your teeth, distributed evenly. With jaw firmly set, finely chop one large onion (rigidly adhering to a clamped mouth will minimize the flow of salt water which could endanger the end result!) Finely chop celery, stalk and all. Melt butter and saute onion with celery until transparent. Remove vegetables from pan and add barley to drippings and cook, stirring constantly, until lightly browned. Combine onions, celery and barley in oblong baking dish. Pour consomme and mushrooms on top. Bake, covered, at 325 degrees for 3 hours. Sprinkle with slivered almonds toward end of baking period. Makes 8 servings.

"It's good and versatile — goes well with any entree, but is particularly nice with wild goose or duck at one-fourth the cost of wild rice!"

HM

Mary Ellen and James Boren
Clifton, Texas

Grits Casserole

- 1 cup grits
- 3 cups water
- ¼ pound Velveeta cheese, grated
- ¼ cup margarine
- 2 eggs, beaten
- salt and pepper to taste
- ¼ teaspoon minced onion or garlic
- ¼ cup milk
- 1 4-ounce can chopped green chilies
- ¼ cup sharp Cheddar cheese, grated (optional)
- paprika

Cook grits according to package directions using 3 cups of water. When done, add Velveeta cheese, stirring until melted. Add next 6 ingredients and pour into greased baking dish. Bake at 300 degrees for 45 minutes. Sprinkle with sharp Cheddar cheese and paprika, if you wish, and bake for 15 more minutes. Makes 8 servings.

"We think this is a super dish with ham or roast pork. The green chilies give it a nice zip that plain grits lack."

Don Troiani

Stamford, Connecticut

Don Troiani's strong background in art began with his studies at the Pennsylvania Academy of Fine Arts and New York City's Art Students League followed by many illustration assignments for top publishing companies including Time-Life, McGraw-Hill and American Heritage Publishing. With a keen sense of history, Don captures the American past in oils and watercolors. A respected antiquarian/historian, he uses his outstanding collection of American military artifacts to faithfully recreate the past, down to the Indian's small arms or the insignia on a soldier's cap. Don is a charter member of the Society of American Historical Artists, an organization dedicated to the preservation and portrayal of historical truth through art. He is also actively involved with the Company of Military Historians. His work is to be found in the collections of the Smithsonian Institute, the West Point Museum, the National Park Service, the State of Pennsylvania and the United States National Guard, as well as many noted private collections and museums.

Rissotto

- 2 Tablespoons butter
- 3 Tablespoons onion, minced
- 1 cup raw rice (imported Italian is best)
- ¼ cup Marsala
- 1 quart chicken stock
- ⅛ teaspoon Saffron
- ½ cup Parmesan cheese, grated
- ½ pound mushrooms, sliced
- ham slices (optional)

Melt butter in heavy saucepan and saute onion until golden. Add rice and cook on medium heat until rice becomes opaque. Add Marsala, reduce heat to low and simmer until it evaporates. Heat chicken stock to boiling, then add half to rice mixture and turn heat to high. As rice absorbs stock, gradually add more, stirring constantly. When liquid is almost absorbed, add saffron which has been dissolved in a little stock. In separate pan, saute mushrooms in butter. When all liquid is absorbed in rice mixture but rice is still creamy, stir in the Parmesan cheese and mushrooms. Thin ham slices may be added, if so desired. Serve immediately.

"The basic recipe is Italian and dates back to Roman times. It goes well with a plain meat dish such as pot roast or stuffed veal roast."

213

Miriam and Bob Wolf
Laporte, Colorado

Rocky Mountain Rice

- 3 cups sour cream
- 2 4-ounce cans chopped green chilies (mild or hot)
- 2½ cups (8 ounces) Monterey Jack cheese, grated
- 2½ cups (8 ounces) Longhorn cheese, grated
- 4 cups cooked brown rice
- salt and pepper to taste
- paprika

Combine sour cream and chilies and set aside. Butter a 1½-quart baking dish and layer half of rice in casserole; spread with half of sour cream mixture, top with half of cheeses and season to taste. Repeat layers and cover. Bake at 375 degrees for 25 minutes. Remove cover and bake 10 more minutes or until bubbly. Sprinkle lightly with paprika. Makes 6 to 8 servings.

"This is a great crowd pleaser. Recipe can be halved or doubled easily and may be assembled early in the day, refrigerated and baked later. Allow a little extra baking time for chilled rice."

Wolf's Orange Pilaf

- ½ cup celery, chopped
- ¼ cup green onions, chopped
- ¼ cup butter or margarine
- 1 cup raw brown rice
- 1 cup orange juice
- 1 teaspoon garlic salt
- 1 cup water
- 1 orange, peeled and cut in small pieces
- ¼ cup slivered almonds, toasted

Cook celery and green onions in butter in large skillet over medium-high heat until tender. Add rice and brown lightly, stirring frequently. Add orange juice, garlic salt and water, heat to boiling. Cover, reduce heat and simmer for 25 minutes or until rice is tender and liquid is absorbed. Stir in orange pieces and almonds and serve immediately. Makes 6 servings.

Chapter V
THE FINISHING TOUCH

Cakes & Frostings **Cookies, Pies & Pastry**
Cake Desserts **Special Desserts & Candy**

IF YOU'RE FULL, DESSERTS ARE GREAT FOR FINGER PAINTING!

HERB MIGNERY

215

Cakes & Frostings

Sherryl and Vince Evans
Ritzville, Washington

Born in Ritzville, Washington, Sherryl Evans was raised and educated there in the heart of the Big Bend farming region. She is largely self-taught, enjoying the versatility of pen and ink, watercolor and oil painting. She and her wheat farmer husband Vince have three children. Sherryl spends hours poring over books on old farming techniques, harness teams and wagons as well as early farm implements and equipment. She also goes to pulling contests, plowing exhibitions and draft horse shows whenever she can. This research and careful attention to detail is evident in her expressive paintings reflecting the farm environment. She is a member of the Women Artists of the West and is editor of West Wind, *their official bulletin. The organization was founded to unite and promote women artists who specialize in Western art and encouages its members to strive for technical excellence and the highest quality possible in all media.*

Apple Cake
- **1 cup walnuts, chopped**
- **2 cups sugar**
- **4 cups large apples, diced**
- **1 cup coffee, cold**
- **1 teaspoon baking soda**
- **2 cups raisins (optional)**
- **2 teaspoons cinnamon**
- **½ teaspoon salt**
- **2 teaspoons vanilla**
- **2 eggs, beaten**
- **1 cup butter or margarine, melted**
- **2½ cups flour**

Mix coffee and soda in small bowl and set aside. Melt butter and beat eggs. Place all ingredients in large bowl in the order they are listed, adding flour last. Mix well. Grease a 13"x9"x2" pan with shortening and dust with flour. Bake at 350 degrees for 50 minutes or until wooden pick inserted in center comes out clean. Cool and serve with butter sauce.

Butter Sauce
- **1 cup sugar**
- **½ cup cream**
- **½ cup butter**
- **1 teaspoon vanilla**

Bring all ingredients to a boil. Remove from heat and cool slightly. Serve warm over apple cake.

"We just pour the butter sauce over the cake and let it soak in. It keeps the cake super moist for as long as it lasts — which isn't very long at our house!"

Carol and W. Steve Seltzer
Great Falls, Montana

Artist's Pineapple Cake with Cream Cheese Frosting

- 2 cups flour
- 1½ cups sugar
- 2 eggs, beaten
- 2 teaspoons baking soda
- 1 cup walnuts, chopped
- 2½ cups crushed pineapple with juice

Mix all ingredients together. Pour into a greased 13"x9"x2" pan and bake at 350 degrees for 45 minutes or until wooden pick inserted in center comes out clean.

Cream Cheese Frosting

- 6 ounces cream cheese, softened
- ¾ cup butter, softened
- 1 teaspoon vanilla
- 2 cups powdered sugar

Cream first 3 ingredients. Gradually add powdered sugar. Spread on cooled cake and top with chopped nuts if so desired.

"This is a super easy but very delicious dessert. Your artist friends will think you've worked for hours when you serve this creation!"

Nadine and Bud Shafer
Helena Arts Council
Helena, Montana

Chocolate Applesauce Cake

- 1 cup raisins
- 2 cups flour
- 1 cup sugar
- 2 teaspoons baking soda
- 1 teaspoon cinnamon
- ½ teaspoon cloves
- ½ teaspoon nutmeg
- 1 Tablespoon cornstarch
- 3 Tablespoons cocoa
- ½ teaspoon salt
- 1 cup walnuts, chopped
- 1½ cups applesauce
- ½ cup vegetable oil
- powdered sugar

Bring raisins to boil in water to cover. Set aside. Mix next 9 ingredients together well. Drain water from raisins and add plumped raisins, walnuts, applesauce and oil to flour mixture. Mix well and pour into greased 9"x9" pan and bake at 300 degrees for 1 hour or until wooden pick inserted in center comes out clean. Cool and dust with powdered sugar.

"This recipe originated in the days of the Depression during the '30s. Since there were no eggs or milk in it, it could be made when you were out of them. This cake doesn't need to be frosted and will stay moist for a week if it lasts that long. Great for picnics, hunting trips or painting expeditions."

Arlene Hooker and Tom Fay
Great Falls, Montana

Arlene Hooker Fay has been doing portraits of Indian people since her girlhood in Browning, Montana close to the Blackfeet Reservation. A bout with polio slowed her down for a time, but in recent years she has won numerous awards, been represented in art shows throughout the country and has had many of her paintings published on greeting cards and stationery. Her work has been recognized in many art publications and she is a founding member of the Northwest Rendezvous Group in which she has been a consistent prize winner at their annual shows. Arlene's wit and humor are ever-present and regardless of how many plaudits come her way, she remains completely natural and unaffected. Her generous support of artists in general and her refreshing sense of humor have endeared her to all who know her.

Crazy Cake

- 1½ cups flour
- 1 cup sugar
- 1 teaspoon soda
- ¼ teaspoon salt
- 3 Tablespoons cocoa
- 1 teaspoon vanilla
- 6 Tablespoons oil
- 1 Tablespoon vinegar

Place all ingredients directly into an ungreased square pan, 8"x8"x2". Stir mixture just until lumps are out. Do not beat. Bake at 350 degrees about 40 minutes or until wooden pick inserted in center comes out clean. Makes a moist, heavy cake and you have only 1 spoon to wash. Frost with your favorite frosting or spread a little butter on top.

"This cake is for poor, lazy people who are desperate for chocolate **right now**! (I don't know why Miriam asked me to be in this cookbook. I can't cook and I can't draw! Why couldn't she just write a sex book like everybody else?!)"

Loretta and Joe Taylor
Cypress, Texas

Del Rio Spice Cake

- 2 jars plum baby food
- 2 cups self-rising flour
- 2 cups sugar
- 3 eggs
- 1 teaspoon cloves
- 1 teaspoon cinnamon
- 1 cup butter or margarine
- 1 cup pecans, chopped

Mix all ingredients, *by hand*, in large mixing bowl. Grease and flour a bundt pan. Pour in batter. Bake at 350 degrees for 1 hour or until wooden pick inserted in center comes out clean.

Bourbon Frosting

- ½ cup Bourbon (or substitute scant ½ cup orange juice or milk)
- 1 cup powdered sugar

Cream Bourbon and powdered sugar. Pour over cooled cake. Enjoy!

Claire and Don Doxey
Salt Lake City, Utah

Don Doxey was born in Ogden, Utah and received his B.S. and Master of Fine Arts degrees at the University of Utah in Salt Lake City and also studied at the American Art School in New York. He has won numerous prizes for his artwork and is featured in many collections including the permanent collections of the Salt Lake Art Center, Utah Art Institute, Benedictine Collection of New York, Westminster College and the Favell Museum.

Doxey Cake

- 2 cups sugar
- 3 cups plus 1 Tablespoon flour
- 1 teaspoon salt
- ½ cup cocoa
- 2 teaspoons baking soda
- 2 Tablespoons vinegar
- ⅔ cup vegetable oil
- 2 cups cold water

Combine all dry ingredients in bowl, then add vinegar, oil and water. Mix well. Pour into 13"x9"x2" pan. (If you want a layer cake, grease, flour and line bottom of 8" round pans with waxed paper before baking.) Bake at 350 degrees for 40 minutes or until wooden pick inserted in center comes out clean.

"Great, rich easy-to-make chocolate cake. Frost cooled cake with milk chocolate frosting. You can also serve it with whipped cream, caramel or white icing and it's just as good."

Milk Chocolate Icing

- 2 cups sugar
- ¼ cup white corn syrup
- ½ cup milk
- ½ cup shortening
- ¼ teaspoon salt
- 2 squares unsweetened chocolate
- 1 teaspoon vanilla
- powdered sugar

Mix first 6 ingredients in saucepanm Stir over low heat until chocolate and shortening are melted. Bring to a full boil, stirring constantly, for one minute. Remove from heat and beat until warm. Stir in vanilla and continue beating until smooth. Add powdered sugar, a little at a time, until desired consistency is reached.

German Chocolate Oatmeal Cake

- 1¼ cups boiling water
- 1 cup oatmeal
- ½ cup butter
- 1 bar (4 ounces) sweet chocolate
- 1½ cups flour
- 1 cup sugar
- 1 teaspoon baking soda
- ½ teaspoon salt
- 1 cup brown sugar
- 3 eggs

Combine first 4 ingredients and let stand for 20 minutes. Combine next 5 ingredients; stir well. Add eggs and oatmeal mixture to flour mixture. Beat with electric mixer on low speed until all ingredients are mixed. Pour into greased and floured 8" round cake pans and bake at 350 degrees for 35 minutes or until wooden pick inserted in center comes out clean.

Sherry and Herb Mignery
Estes Park, Colorado

Herb Mignery was born in the Sandhills town of Bartlett, Nebraska and grew up on a cattle ranch surrounded by the subject matter he most loves to sculpt. In his freelance artist days, he designed many rodeo brochures, illustrated articles for magazines like True West *and was employed to lend his western motifs to numerous ad agency layouts. The Thomas D. Murphy Company, the nation's leading calendar publisher, lists Herb's Cowtoon series of Western calendars as a top seller in its field for the past several years. Herb enjoys working in a variety of media, but his personal and professional favorite is sculpture. Whether he is portraying the flowing garments and colorful appearance of the mountain man, the wealth of character in a cowboy, the joy in a child's eyes or the humor found in this book's chapter illustrations, Herb conveys his honest sense of self and appreciation of his artform. He and his wife Sherry and their two daughters now make their home in Estes Park, Colorado.*

Brown Sugar Frosting

- 6 Tablespoons butter
- ¾ cup brown sugar
- ½ cup cream
- ½ cup pecans, chopped

Combine first three ingredients in small saucepan and bring to a boil. Reduce heat and stir until mixture thickens (about 3 minutes). Remove from heat, add pecans and frost cooled cake layer and top.

"Because German Chocolate Cake is my favorite, a friend found this recipe and gave it to Sherry to try. It is now my favorite."

HM

Patricia Warren and Ken Johnson
Fort Worth, Texas

Hershey Bar Cake

- 7 Hershey Bars (milk chocolate)
- 1 cup margarine or shortening, softened
- 2 cups sugar
- 4 eggs
- 2 teaspoons vanilla
- 2½ cups flour
- ½ teaspoon salt
- 1 teaspoon baking powder
- ½ teaspoon baking soda
- 1 cup buttermilk

Melt chocolate bars in double boiler. Cream margarine and sugar, then add chocolate. Add eggs, one at a time, beating well after each addition. Add vanilla and stir. Sift flour, baking powder and salt together. Mix buttermilk and 1 teaspoon soda together. Add flour mixture and buttermilk alternately to chocolate mixture. Pour into large angel food tube pan. Bake in 300 degree oven for 1½ hours. Needs no icing and freezes well.

"This cake will develop a shiny chocolate crust with moist, tender cake underneath. Great served well-chilled (almost frozen) with a scoop of vanilla ice cream and hot fudge sauce. Add some coffee and Grand Marnier on the side and you have a terrific finishing touch!"

Penny and Stan Johnson
Mapleton, Utah

Stan Johnson was born and raised in Crescent, Utah. He was a commercial artist for 11 years until he decided to be a full time sculptor 9 years ago. He loves the Indian people and creates his sculptures according to Indian traditions and legends. He, his wife Penny and their 10 children live in Mapleton, Utah where Stan maintains an art studio and foundry.

Inexpensive Fruitcake

- 2 cups sugar
- 1 cup margarine
- 1 teaspoon cloves
- 1 teaspoon allspice
- maraschino cherry juice plus water to equal 3 cups
- 1 teaspoon cinnamon
- 1 package raisins
- 1 cup gumdrops, cut (no black)
- 1 5-ounce jar maraschino cherries, cut up
- 1 cup walnuts, chopped
- 2 eggs, beaten
- 1 teaspoon vanilla
- dates or other fruit, cut up, if so desired
- 4 cups flour
- 2 teaspoons baking powder
- 1 teaspoon salt

Combine first 7 ingredients in large saucepan and boil for 20 minutes. Remove from heat and add gumdrops, cherries, walnuts, eggs, vanilla and dates. Mix flour, baking powder and salt, then add to rest of ingredients. Mix well. Line 2 loaf pans, 9" x 5" x 3" with aluminum foil; grease. Bake at 325 degrees for 2 hours or until wooden pick inserted in center comes out clean. Remove from pans; cool. Wrap in plastic wrap or aluminum foil and store in refrigerator.

"This is the only fruitcake we make in our family because no one liked the candied fruit in regular fruitcake. We tried gumdrops instead and everybody loved it. We also make it with chocolate chips instead of raisins sometimes. We look forward to this treat, made by my mother, Mildred Johnson."

Nancy Boren
Clifton, Texas

Italian Cream Cake

- ½ cup margarine
- ½ cup shortening
- 2 cups sugar
- 5 egg yolks
- 2 cups flour
- 1 teaspoon baking soda
- 1 cup buttermilk
- 1 teaspoon vanilla
- 1 small can flaked coconut
- 1 cup pecans, chopped
- 5 egg whites, beaten stiffly

Cream margarine and shortening, add sugar and beat until smooth. Fold in egg yolks and beat well. Combine flour and soda and add alternately with buttermilk to creamed mixture. Stir in vanilla, then coconut and nuts. Fold in egg whites just until blended. Pour into 3 greased and floured 8" round cake pans and bake at 350 degrees for 25 minutes.

Cream Cheese Frosting

- 1 8-ounce package cream cheese
- ¼ cup margarine
- 1 box powdered sugar
- 1 teaspoon vanilla
- pecans, chopped

Combine softened cream cheese and margarine. Add sugar and vanilla and blend. Frost cooled cake and sprinkle chopped pecans on top.

Laura and Hawley Woolschlager
Omak, Washington

Molasses Gingerbread Cake

- ■ 1 cup sugar
- ■ ½ cup shortening
- ■ 1 cup molasses
- ■ 1 cup buttermilk
- ■ 2 eggs
- ■ 2½ cups flour
- ■ 1 teaspoon baking powder
- ■ 1 teaspoon ginger
- ■ 1 teaspoon cinnamon
- ■ ½ teaspoon cloves

Cream sugar and shortening, then add eggs, 1 at a time, beating well after each addition. Add molasses and beat until blended. Combine dry ingredients and add to creamed mixture alternately with buttermilk. Line a 13" x 9" x 2" pan with waxed paper. Bake at 350 degrees for 50 minutes. Good plain or serve with a dollop of whipped cream sprinkled with finely chopped crystallized ginger.

"According to my mother, this recipe was passed down from my great-grandmother, Eliza Sterling who immigrated to America in the 1800s. She never learned to speak English and was a strict disciplinarian, but obviously, also had her sweet side!"

William E. Freckleton

Southwest Art Magazine
Houston, Texas

William E. Freckleton was born in California, grew up in Minnesota and received his formal education in journalism and business at Northwestern University in Chicago, Illinois. The development of his interest in art came through his study at the New York School of Interior Design during a summer hiatus from college and culminated in the spring of 1971 when he founded Southwest Art Magazine. Southwest Art *has begun to promote and foster the growth of art in the Southwest and recently Bill felt the time was right to move forward and encompass the performing and literary arts and also crafts, within a supportive, nonprofit organization that will preserve and promote all arts of the American West. To accomplish this goal, he established the Southwest Arts Foundation.*

Oatmeal Loaf Cake

- 1½ cups boiling water
- 1 cup oatmeal
- 1 cup sugar
- 1 cup brown sugar
- 1 cup vegetable oil
- 2 eggs
- 1⅓ cups flour
- 1 teaspoon cinnamon
- 1 teaspoon baking soda
- ½ teaspoon salt

Pour boiling water over oatmeal and let stand. Combine remaining ingredients and mix well. Add oatmeal mixture and stir. Grease and flour a 13" x 9" x 2" pan. Bake at 350 degrees for 35 minutes or until wooden pick inserted in center comes out clean. Frost immediately with coconut frosting.

Coconut Frosting

- ½ cup margarine or butter
- ¾ cup brown sugar
- 1 Tablespoon milk
- 1 cup nuts, chopped
- 1 small can flaked coconut

Bring first 3 ingredients to a boil for one minute. Add nuts and coconut. Remove from heat. Spread on hot cake as soon as you remove it from oven. Return cake to oven, placing it on middle shelf and brown under broiler for 5 minutes, being careful not to burn.

"This is a very rich, moist cake. It is good served with ice cream or whipped cream on top — making it taste even richer. It keeps well for over a week without drying out. Everyone likes this recipe and they usually come back for seconds!"

Mary and Verne Tossey
Portland, Oregon

Pineapple
Upside Down Cake

- ■ ⅓ cup shortening
- ■ ¼ teaspoon salt
- ■ 1 teaspoon vanilla
- ■ ½ cup sugar
- ■ 1 egg
- ■ 1½ teaspoons baking powder
- ■ 1¼ cups flour
- ■ ½ cup canned pineapple juice
- ■ ½ cup brown sugar
- ■ 5 slices canned pineapple
- ■ 5 maraschino cherries

Combine shortening, salt and vanilla. Gradually add sugar and cream well. Add egg and beat thoroughly. Combine baking powder and flour. Add flour mixture to creamed mixture alternately with pineapple juice, beating well after each addition. Generously grease an 8" x 8" x 2" pan (or cast iron skillet). Sprinkle brown sugar evenly over bottom, arrange pineapple slices on top, place cherries in centers and pour batter over all. Bake at 350 degrees about 45 minutes or until wooden pick inserted in center comes out clean. Invert onto serving plate. Let pan remain a few minutes. Remove and serve warm with whipped cream.

"This cake has a special flavor due to the pineapple juice. I use a heavy, cast iron skillet to bake it in."

Hildred Goodwine
Wickenberg, Arizona

Hildred Goodwine was born on a farm in Wayne, Michigan and has loved and painted horses since childhood. Her brush captures their personalities and creates moods of tenderness, sadness, humor, affection and playfulness. Her growth as an artist was aided by the confidence and continued support of her late husband Jim and the friendship and supervision of George Phippen and Willis Rue. Her favorite subject is horses and she paints or sculpts all breeds with equal enthusiasm. Her paintings have appeared on the covers of various horse publications and on Leanin' Tree Publishing Company greeting cards and as prints. Ranch life in Arizona, along with four children and a wide assortment of animals provide Hildred with a great deal of subject matter for her work.

Queen Elizabeth Cake

- ■ 1 cup boiling water
- ■ 1 cup dates, chopped
- ■ 1 teaspoon baking soda
- ■ 1 teaspoon vanilla
- ■ ¾ cup butter or margarine
- ■ 1 teaspoon baking powder
- ■ 1 cup brown sugar
- ■ 1 egg, beaten
- ■ 1½ cups flour
- ■ ½ teaspoon salt
- ■ ½ cup nuts, chopped

Pour boiling water over dates, add soda and let stand. Combine remaining ingredients and then add date mixture. Pour into a greased and floured 13"x9"x2" pan and bake at 375 degrees for 35 minutes or until wooden pick inserted in center comes out clean. Ice immediately.

Icing

- ■ 6 Tablespoons brown sugar
- ■ 3½ Tablespoons butter
- ■ coconut

Combine sugar and butter and boil 1½-2½ minutes. Spread on hot cake as soon as you remove it from oven. Sprinkle with coconut. Return cake to oven and broil till icing bubbles, about 2 minutes.

"This cake was my mother's recipe — one of her favorites."

Marian and Tom Flahavin

Spokane, Washington

Raised on the rolling wheatlands of southeastern Washington, Marian Flahavin was encouraged to pursue her art. She eventually earned her degree in art and worked for a number of years in graphic design. After her marriage, her husband Tom began to show and raise quarter horses. She then had a son and began drawing portraits of children and show horses and discovered the fascination with them that became her career. Her work has appeared on the cover of Quarter Horse Journal *and* The Western Horseman. *She has received many commissions and balances a backlog of collectors anxiously awaiting one of her oils or pastels depicting the contemporary Western way of life. Marian is a member of the Women Artists of the American West.*

Red Cake

- 1 teaspoon vinegar
- 1 teaspoon soda
- ½ cup shortening
- 1½ cups sugar
- 1 teaspoon vanilla
- 2 eggs
- 2 teaspoons cocoa
- 2 ounces red food coloring
- 1 cup buttermilk
- 1 teaspoon salt
- 2¼ cups cake flour

Butter Frosting
- 1 cup milk
- 3 Tablespoons flour
- 1 cup sugar
- 1 cup butter
- 1 teaspoon vanilla

Combine vinegar and soda in small bowl and set aside. Cream shortening and sugar, add vanilla and beat. Add eggs, one at a time, beating well after each addition. Make a paste of cocoa and some of the red food coloring, then add remaining coloring, mixing well. Add to shortening mixture. Combine flour and salt. Add flour mixture to shortening mixture, alternately with buttermilk and mix well. Add vinegar mixture and stir well. Pour into greased and floured 8" round cake pans and bake at 350 degrees for 30 minutes. Cool and split layers in half. Frost and refrigerate until serving time.

Cook milk and flour on low heat until thick, stirring constantly. Cream sugar and butter with electric mixer until very fluffy. Add vanilla and stir. Add one Tablespoon of flour mixture to sugar mixture and beat. Gradually add remaining flour mixture, beating constantly. Frost cooled cake. Refrigerate.

"This recipe was a wedding gift from the lady who made our wedding cake 22 years ago. It is the sort of recipe I love to pull out when I want something special for an event or just to 'color up' my life a little!"

Betty J. Billups and Bob Black

Gardena, California

After graduation from Art Center College of Design in Los Angeles, Betty Billups joined the Society of Illustrators and also studied with Reynold Brown and Donald "Putt" Putman. She later received a commission from the U.S. Army to do a painting of Sacajawea for the Bicentennial. Paintings by Betty hang in the Air Force and Los Angeles Sheriff's Department art collections as well as many other private and public collections. She participates in several invitational shows each year and is a member of the Women Artists of the American West. Through her realistic portrayals, she captures the celebration of the human spirit. She and her husband Bob reside in Gardena, California.

Glazed Rum Cake

- 1 package yellow cake mix
- 1 small package vanilla instant pudding
- 4 eggs
- ½ cup salad oil
- ½ cup water
- ½ cup rum
- 1 cup nuts, chopped
- ½ cup brown sugar
- ½ teaspoon nutmeg

Combine first 6 ingredients and mix well. Place ½ cup of the nuts in bottom of well-greased bundt pan. Pour ½ of the batter over nuts. Mix brown sugar, nutmeg and remaining nuts; sprinkle ½ of the mixture over batter. Add rest of batter. Sprinkle remaining brown sugar mixture over batter. Swirl with knife. Bake at 350 degrees for 1 hour. Remove from oven and pierce top with toothpick thoroughly. Glaze immediately.

Glaze

- ½ cup margarine
- 1 cup sugar
- ½ cup water
- 1 ounce rum

Boil first 3 ingredients until liquid. Remove from heat and add rum. Immediately pour over hot cake that has been pierced with toothpick. Cool cake *completely* before removing from pan.

"I was at a FFP (Future Famous Persons!) art show once and got this recipe from Katherine Ainsworth. It's well worth the effort — always a hit, anywhere!"

Cake Desserts

Karen and James H. Killen
Owatonna, Minnesota

Jim Killen's memorable watercolors earn much acclaim and after receiving many awards and honors at art shows, he was presented the President's Award as the "Outstanding Wildlife Artist" of the Ducks Unlimited National Wildlife Art Show in 1980 and 1981. One of his paintings was selected by the Nebraska Wildlife Federation as their print of the year in 1980 and in 1982 the Pintail Society of America chose Jim's design as their First Edition Pintail Print. Wildlife organizations are very important to him and his donated art has raised funds for Ducks Unlimited and other conservation organizations. Jim was a forest ranger prior to receiving his degree in art and his interest in nature, waterfowl and upland game are truly reflected in his distinctive watercolor paintings.

Frozen Mousse Cake

- 3 cups (12 ounces) chocolate wafer crumbs
- ½ cup plus 2 Tablespoons butter, melted
- 8 ounces semi-sweet chocolate, broken in pieces
- ¼ cup water, boiling
- ½ cup sugar
- 4 large egg yolks
- ½ cup Kahlua
- 4 large egg whites
- ¼ teaspoon cream of tartar
- 2 cups heavy cream, whipped
- 1 shot glass Kahlua

Preheat oven to 375 degrees. Lightly butter sides of 9" x 3" spring form pan. Combine crumbs and butter; press mixture firmly against bottom and sides of pan. Bake for 8 minutes. Set aside to cool. Melt chocolate pieces with ¼ cup of the sugar in top of double boiler. Remove from heat and beat in egg yolks. Return to heat and cook for 1 minute. Remove from heat again, thoroughly stir in Kahlua and set aside to cool. Beat egg whites and cream of tartar in chilled bowl with chilled beaters until stiff. Add remaining sugar and beat until stiff peaks form. Fold into chocolate mixture slowly. Add whipped cream and blend well. Place a shot glass in the center of baked crust. Spoon mousse around glass evenly and fill shell. Smooth out top, cover pan with plastic wrap and freeze for several hours or overnight. When ready to serve, remove spring form sides from cake and slide cake onto serving plate. Fill shot glass with more Kahlua and use as sauce for cake. (If time permits, you may want to make chocolate leaves to decorate cake by painting the underside of fresh ivy or rose leaves with melted sweet chocolate. Place on saucer and freeze. When ready to serve, peel leaves away and arrange on top of cake or decorate with chocolate shavings.) Makes 12 servings.

"This is a gorgeous dessert to behold and just as delightful to eat! It was featured in our local newspaper and I presented it to a Gourmet Supper Club one evening and all the guests raved. It is rich but not too sweet, keeps well in the freezer and can be made ahead of time."

Ginger K. Renner
Paradise Valley, Arizona

High Country Wild Raspberry Dream Cake

(This is not a recipe . . . it is an adventure! I would wish for all who read this, that someday they should be in the position to experience it!)

"In the summer of '65 (I think!), I was going back into much-loved country with my dear friends, Walt and Nancy Lozier, of the Box R Ranch which lies northeast of Cora, Wyoming. Back into the Wind Rivers — the Bridger wilderness country. Twice before, I had traveled that wild and wonderful country with the Loziers, but then I had been a guest (as in "dude!"). This time, I was going as assistant cook to Nancy and as part of the crew. There were 43 in the party, 25 dudes and the crew with a string of 88 horses and mules headed for 14 days in the back country. It's at times like that when necessity truly is the mother of invention. We were heading into New Fork Park for a layover when I spotted a patch of wild raspberries by the side of the trail about five miles from our camp. The trail, at that point, cut across the side of a *steep* mountain, the vines trailing up the slope and down the other side and boy, were they fat, ripe berries, and boy, was that mountain steep! Since the crew had to head on into camp to set up, I noted landmarks and during "layover day" when everyone was allowed to do their own thing, I headed back to the trail with two others and the three of us crawled up and down the side of that hill for several hours, getting scratched by the vines and sometimes sliding down the mountain! By the time we were through, we had a 3-pound lard can full of berries and 43 people back in camp who wanted to share them! Riding back to camp, I formulated the plan for extending the 6 (more or less) cups of raspberries to feed the whole party. We had a dedicated fisherman in the group, who I knew would be out until dark and who, I also knew, had a bottle of brandy in his duffle bag in camp. Normally, one wouldn't dream of going into a fellow camper's belongings, but this was a special occasion and called for special rules. I simply appropriated a cup and a half of the brandy, prepared to talk my way out of any trouble. We then took a gallon can of fruit cocktail, drained it, reserving the juice, and poured the brandy over the fruit and let it soak. Next, we mixed up a big batch of Nancy's wonderful camp cake. Then we mixed the reserved juice, some brown sugar, butter and some flour to thicken the mixture, cooked it up a bit on the edge of the fire, added the brandied fruit, poured it into a buttered # 10 dutch oven, spread Nancy's cake mixture on top, covered it, set it close to the fire, added some small coals on top and let it bake. I then enlisted the help of a boy on the crew and we built a sort of dam at the side of the creek. I took the largest mixing bowl we had, an aluminum one about 2 feet across, and whipped up 6 boxes of Dream Whip, added a bit of sugar, vanilla and a dollop of Brandy and set it in the dammed area of the cold stream. At that high altitude the whipped cream looked like a pile of clouds and, of course, the stream kept it icy cold. Dinner was served; then Nancy announced we had a special dessert, and for everyone to grab a bowl and file by the cook-fire to be served. She took the lid off the camp cake mixture, I gently folded the raspberries into the whipped cream and all 43 dudes and crew trailed by getting a great hot, juicy scoop of cake baked on top of brandied fruit with a huge scoop of cold whipped cream and raspberries on top! The good soul who contributed the Brandy was given proper credit and was delighted with the results. For several years thereafter, I would get Christmas cards from such places as New York, Detroit and Connecticut from dudes saying they still remembered the glorious dessert in the Wind River Mountains. I, too, savor the memory of it. It was, perhaps, my greatest culinary triumph. (Necessity mixed with a little luck can bring out the best in us sometimes!) If I could do it all again, with Walt and Nancy and other good friends, a blue sky and fat, red raspberries . . . believe me, I'd be on my way back to the mountains right now!"

235

Miriam and Bob Wolf
Laporte, Colorado

Dixie and George Morse
Prairie Village, Kansas

Hot Fudge Sundae Cake

- 1 cup flour
- ¾ cup sugar
- 2 Tablespoons cocoa
- 2 teaspoons baking powder
- ¼ teaspoon salt
- ½ cup milk
- 2 Tablespoons vegetable oil
- 1 teaspoon vanilla
- 1 cup pecans, chopped
- 1 cup brown sugar, packed
- ¼ cup cocoa
- 1¾ cup very hot water
- ice cream

Combine first 5 ingredients in 9" x 9" x 2" square pan. Add milk, oil and vanilla, stirring with fork until smooth. Stir in nuts. Spread mixture evenly in pan. Sprinkle with brown sugar and ¼ cup cocoa. Pour hot water over batter. Bake at 350 degrees for 40 minutes. Serve while warm, topped with ice cream and sauce from pan spooned over all. Makes 9 luscious servings.

"This is one of Bob's favorite desserts. We don't have it too often as it is very rich and certainly not low-cal, but it is wonderful for a birthday or as an extra-special treat for the "chocoholic" in the family!"

Pudding Cake

- 1 cup flour
- 1 Tablespoon butter, melted
- 1 cup nuts, chopped

Combine ingredients and press into 9" x 9" x 2" square pan. Bake at 350 degrees for 20 minutes. Cool completely.

Filling I

- 8 ounces cream cheese, softened
- 1 cup powdered sugar
- 1 cup Cool Whip

Combine and spread over cooled crust.

Filling II

- 1 small package instant chocolate pudding
- 1 small package instant vanilla pudding
- 2 cups milk

Whip puddings and milk together and spread over cream cheese mixture.

Topping

- 1 large carton Cool Whip
- ¼ cup nuts, chopped
- 1 Hershey bar

Spread Cool Whip over pudding mixture. Sprinkle with nuts and shaved Hershey bar. Freezes beautifully.

Fay and Hal Sutherland
Bothell, Washington

Born in New England, Hal Sutherland later moved to California, was employed by Walt Disney and went on to become a television producer and director before moving to Bothell, Washington to make painting a full time career. In television, he won an Emmy for the popular Star Trek series. In art, he has won numerous awards due to his use of brilliant color and a realistic approach to painting. Although his paintings reflect an avid interest in both historical and contemporary Americana, his subject matter is often intermingled with dramatic landscapes as well. Hal is listed in American Artists of Renown *and is a member of the Puget Sound Group of Northwest Painters and the American Artists of the Rockies Association.*

Persimmon Pudding Cake — "Texas Style"

- ■ 1 cup sugar
- ■ 1 teaspoon baking soda
- ■ ½ teaspoon cinnamon
- ■ 1 Tablespoon butter, melted
- ■ ½ cup milk
- ■ 1 cup flour
- ■ ¼ teaspoon salt
- ■ 1 teaspoon vanilla
- ■ 1 cup ripe persimmon pulp, skins removed
- ■ 1 egg
- ■ 1½ cups walnuts, chopped

Combine all ingredients and mix until smooth. Pour into a greased 1½-quart casserole and bake, covered, at 325 degrees for 1 hour. Remove cover and bake for 30 more minutes.

"This old recipe was inherited by Fay from her grandmother who hailed from Texas. It's one of the reasons I married her and has been one of my favorite dishes for 25 years! It's good right from the oven or served cold. It's advisable to cook two as the first one doesn't last long. Hope you like it as well as we do."

Cookies

Grandma Larsen's Kringler

- 5 cups flour, sifted
- 1 pound butter
- 2 egg yolks, slightly beaten
- 2 egg whites
- 1½ cups whipping cream
- 1 cup sugar

Cut butter into flour with pastry blender or fork until pieces are size of small peas. Add egg yolks and cream. Form into ball and knead lightly. Flatten on lightly-floured surface and roll out thick. Spread egg whites over dough and sprinkle sugar over top. Cut into narrow strips no wider than ⅜'' and form into pretzel shapes. Bake on cookie sheet at 375 degrees until just barely brown. Remove immediately.

"This is an old Danish recipe which my great-grandmother Simonsen brought with her to this country. We serve it at holidays, but it's good all year around."

Jan and Jim Ness
Bozeman, Montana

Jan Ness was born in Kenmore, North Dakota and has family ties to the historical homesteading in that area, since part of the original homesteads have been passed down from generation to generation and are still in the family. This is one reason why she feels such a strong commitment to preserving the majestic natural beauty and early heritage of the American West in her intricate and delicate miniature pen and ink drawings and oils. From her home in the beautiful and historic Gallatin Valley of southwestern Montana, Jan experiences and observes much of her subject matter first hand. Her work is found in collections in the U.S. and Canada as well as several prestigious art shows throughout the country.

Sherry and Truman Bollinger
Scottsdale, Arizona

Icebox Cookies

- 1 cup butter
- 2 cups sugar
- 2 eggs, well beaten
- 4 cups flour
- 1 teaspoon baking soda
- 1 teaspoon cream of tartar
- ½ teaspoon salt
- 1 teaspoon vanilla
- 2 cups nuts, chopped

Cream butter and sugar; add eggs. Add dry ingredients, mixing well; then add vanilla and nuts. Shape dough into 2 rolls, wrap in waxed paper and chill several hours or overnight. Slice thinly. Bake on greased cookie sheet at 375 degrees for 5 to 7 minutes. Remove at once to rack.

"We have found that we enjoy just cutting thin pieces of dough and eating them 'as is.' Saves on electricity!"

Mary Lea and Ken Carlson

Missoula, Montana

Ken Carlson is a highly-acclaimed Western and wildlife artist and his oils are prized by collectors. Many have won stamp design awards and have been reproduced in national publications. An unusual collection of fifty Carlson watercolor plates appears in Birds of Western America *and his limited edition prints are produced by Millpond Press.*

Kifli

- 4 cups all-purpose flour
- 2 cups butter or margarine
- 4 egg yolks, slightly beaten
- 1 cup sour cream
- 1¼ pound walnuts, finely chopped
- 1 cup sugar
- ½ cup milk
- 1 Tablespoon almond extract
- 1 egg, beaten
- powdered sugar

Cut butter into flour with pastry blender or fork, until pieces are size of small peas. Add egg yolks and sour cream; stir until combined. Turn out onto lightly-floured surface and knead into smooth ball. (If too sticky, use more flour.) Dough can be refrigerated until ready to use. In medium bowl, combine next 4 ingredients and blend well. Set aside. Divide dough into 4 parts and roll ¼ at a time into a 16''x12'' rectangle, ⅛'' thick. Cut into 2'' squares with pastry wheel. Place a generous ½ teaspoon of walnut mixture in center of each square. Fold 2 opposite corners over filling and pinch edges to seal. Place on greased cookie sheets and brush lightly with beaten egg. Bake at 400 degrees 10-12 minutes or until golden. Remove and roll in powdered sugar. Let cool on rack. Makes about 16 dozen.

"This was given to us by our friend Betty Stone from Sonoma, California, and is a super tea-time pastry or great with a good cup of coffee for dessert."

242

Ellen and Wayne Baize
Fort Davis, Texas

Kiflin

- 1¾ cups butter
- ½ cup sugar
- 7 ounces unblanched almonds, finely ground
- dash of salt
- 1 scant quart flour
- 3 cups powdered sugar
- 1 powdered vanilla bean

Cream butter and sugar; add almonds and salt. Add flour gradually, a little at a time, making a dough just thick enough to not crack. Roll out to ⅜" thick and cut crescents with a crystal glass 2" in diameter. Bake at 350 degrees for 20 minutes or until lightly browned. Mix powdered sugar and powdered vanilla. While kiflin is still hot, roll them in powdered sugar mixture. Cool on racks. Delicious served with ambrosia. Makes about 4 dozen cookies.

"This recipe is from the Rust Largent family here in Ft. Davis. They have a fine Hereford cattle ranch and are used to feeding cowmen and cowboys. I feel privileged to have eaten at their table many times. I know you will enjoy this recipe as much as I have."

Bobbie and Harry Brunk

Whitney, Nebraska

A Nebraska native, Harry Brunk spent several years as a commercial artist in Omaha and Lincoln before beginning his fine art career. He enjoys painting contemporary Western subject matter and has had his work featured on the cover of the Quarter Horse Journal. *He and his wife Bobbie now reside in Whitney, Nebraska.*

Oatmeal Cooky Bars

- 2 cups flour
- 2 cups quick-cooking oats
- 1 cup brown sugar
- ½ cup sugar
- 1 teaspoon salt
- 1 teaspoon baking soda
- 2 eggs
- ½ cup margarine, melted
- ½ cup vegetable oil
- 1 teaspoon vanilla
- 1 cup chocolate chips
- 1 cup butterscotch chips

Mix all ingredients by hand in large mixing bowl. Spread in 13''x9''x2'' pan and bake at 375 degrees for 20 minutes. Cool and cut into bars.

Miriam and Bob Wolf
Laporte, Colorado

Refrigerator Oatmeal Cookies

- 1 cup shortening
- 1 cup brown sugar
- 1 cup sugar
- 2 eggs, well beaten
- 1 teaspoon vanilla
- 1½ cups sifted flour
- 1 teaspoon salt
- 1 teaspoon baking soda
- 3 cups quick-cooking oats
- ½ cup nuts, chopped

Cream shortening and sugar. Add eggs and vanilla and blend. Add next 3 ingredients and mix well. Stir in oats and nuts. Shape into rolls, wrap in waxed paper and chill. Slice thinly and bake at 350 degrees on greased cookie sheet for 8-10 minutes. Makes about 5 dozen cookies.

"This was given to us by our good friends Linda and Tony Altermann of Altermann Gallery in Dallas and Connally/Altermann Gallery in Houston. It is an especially good snack to keep on hand in the fridge for after school. Kids love them."

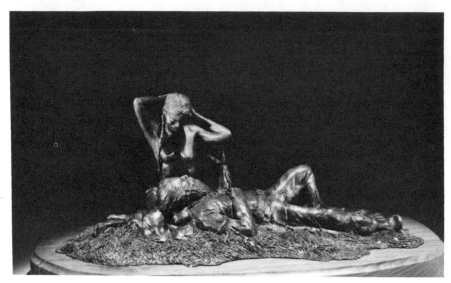

Pat Mathiesen and Ron Hecht
West Yellowstone, Montana

Pat Mathiesen's beautiful bronzes are done both in the traditional patina and in exquisitely detailed polychromes. They record, with great feeling, Western and Indian subjects which are rapidly disappearing and changing. She strives to capture details of life, dress and art which are or soon will be lost forever. Her frequent visits to the Indian lands of Arizona, New Mexico and Montana allow her to record and experience their ceremonies and traditions. Pat has exhibited at many invitational art shows and is an Honorary Artist Member of the Mountain Oyster Club. She and her husband Ron Hecht and children live in a lovely log house by the lake in West Yellowstone, Montana.

Shoebox Spice Cookies

- 2 cups raisins
- 1½ cups water
- 1 cup butter or margarine
- 2 cups sugar
- 3 eggs
- 1 teaspoon baking soda
- 1 teaspoon baking powder
- 1 teaspoon salt
- 1 teaspoon allspice
- 1 teaspoon cinnamon
- ½ teaspoon nutmeg
- 4 cups flour, sifted
- 2 teaspoons vanilla
- 1 cup walnuts, chopped

Place raisins and water in saucepan and bring to boil. Drain, reserving half the liquid. Cream butter and sugar. Beat in eggs, one at a time, mixing well after each addition. Add soda to raisin liquid and then add to batter. Combine next 6 ingredients and mix with batter. Add vanilla and blend well. Add raisins and nuts and stir. Refrigerate dough for 1 hour. Drop by Tablespoonfuls onto ungreased cookie sheets. Bake at 400 degrees for 10-12 minutes or until lightly browned.

"When I was a very small child in North Hollywood, California, I remember the excitement upon the arrival (every six months or so) of a shoebox filled with what to me were the most delicious cookies in the world!! It was mailed from Portland, Oregon by my great-grandmother whom I never met. Many years passed and the childhood cookies were forgotten until a few years ago while I was at a potluck party and bit into the exact same cooky! The thrill of finding the shoebox of cookies in the mailbox and the very 'specialness' of this childhood experience came rushing back from years before. I found the cook and she was kind enough to share her recipe and I pass it along to Miriam for her cookbook with love — which is where it originated. It is now our traditional Christmas cookie."

246

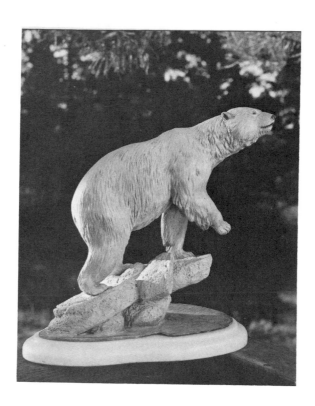

Lila and Jack D. Putnam
Franktown, Colorado

A noted sculptor of wildlife, Jack Putnam prepared for his career in fine art by being a wildlife photographer, a museum taxidermist, sportsman and conservationist. As a taxidermist he collected many animals and birds by making expeditions to many parts of the world including Alaska, Canada, Mexico, South America, Australia, New Zealand and Africa. In 1970 he created his first sculpture and has gone on to many awards and special commissions in the field of wildlife art. His work is in the permanent collection of several museums in the U.S.

Snickerdoodles

- 1 cup shortening
- 1½ cups sugar
- 2 eggs
- 2¾ cups flour, sifted
- 2 teaspoons cream of tartar
- 1 teaspoon baking soda
- ½ teaspoon salt
- 2 Tablespoons sugar
- 2 teaspoons cinnamon

Cream shortening and sugar. Add eggs and mix well. Sift next 4 ingredients together and add to shortening mixture. Chill dough for several hours or overnight. Roll dough into balls the size of walnuts. Combine sugar and cinnamon and roll balls in mixture. Place about 2" apart on ungreased cookie sheet and bake at 400 degrees for 8-10 minutes or until lightly browned, but still soft. (These cookies puff up at first, then flatten out with crinkled tops.)

"These are Jack's favorite cookies."

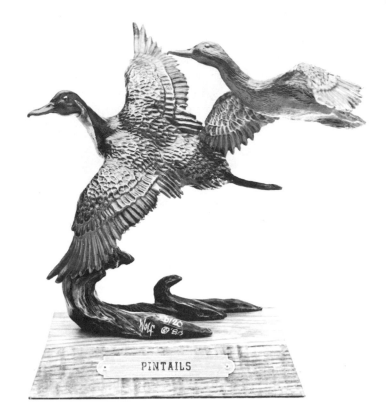

PINTAILS

Miriam and Bob Wolf
Laporte, Colorado

Sour Cream Cookies

- ■ ½ cup shortening
- ■ 2 cups sugar
- ■ 2 eggs
- ■ 1 teaspoon vanilla
- ■ 4 cups flour, *sifted
- ■ ½ teaspoon salt
- ■ 1 teaspoon baking soda
- ■ 1 cup sour cream
- ■ 2 Tablespoons sugar (optional)
- ■ 2 Tablespoons cinnamon (optional)

Cream shortening and sugar. Add eggs and beat until fluffy. Add vanilla and mix well. Add salt and soda to flour. Add dry ingredients to shortening mixture alternately with sour cream. Mix well. Chill for 1 hour. Drop by teaspoonfuls onto greased cookie sheet about 2" apart. Mix sugar and cinnamon (I keep an old salt shaker full of this mixture for toast, etc.) and sprinkle over cookies. Bake at 375 degrees for about 12 minutes. Cookies should still be soft and lightly golden.

"Another goody we don't have too often because we eat too many! These cookies are cake-like in texture and the recipe is over 100 years old. Bob's grandmother passed it on down through the family. They are just as good plain as they are with the cinnamon/sugar topping."

* Note: "In the past it was considered absolutely essential to sift flour in any cake or cooky recipe, and most recipes still call for sifted flour. Flour today, however, is sifted many times during milling before it is packaged and sold. I find that cakes and cookies are just as good when made with unsifted flour, and this certainly makes them easier to prepare. Several major flour companies, after extensive research, agree. To measure flour without sifting, scoop it up in a dry measuring cup and level it off with a straight knife. Don't tap or bang the cup or flour will settle. Better a little *less* flour than a little more in a cake or cookie recipe. You should continue to always sift flour in a sponge or angel food cake recipe, where the lightness of the flour will make it easier to fold in egg whites."

Pies & Pastry

Grace and Robert L. Knox
Carlsbad, New Mexico

Apple Impromptu

- 4 cups apples, pared, cored and sliced
- ¼ cup sugar
- ¼ teaspoon cinnamon
- 1 Tablespoon butter
- ½ cup sugar
- 1 teaspoon vanilla
- 1 egg
- ½ cup flour
- ½ teaspoon baking powder
- whipped cream or ice cream

Layer apples in well-greased 8-9" pie pan. Combine ¼ cup sugar and the cinnamon and sprinkle over apples. Bake, covered tightly, at 400 degrees for 20 minutes. Meanwhile cream next 4 ingredients and beat well. Mix flour and baking powder and add to creamed mixture, blending until smooth. Remove apples from oven and spread batter evenly over all. Return to oven and bake at 400 degrees, uncovered for 20-25 minutes or until golden brown. Serve warm with ice cream or cold with whipped cream. Makes 6-8 servings.

"I got this recipe from a ranch wife. This was one of the desserts at a round-up. It is very pretty and goes well with most meals. Ranch wives are so remarkable in so many ways that I am never surprised any more! They feed 15-20 cowboys by starting breakfast around 4:00 a.m., then around 10:00 a.m. they feed them again along with any other hands that have dropped by to help at the gathering and branding. Their food is always pretty to look at, tastes out of this world and looks like it would feed an army, but there is seldom any left!"

Angel Food Pie

- ◼ 4½ Tablespoons cornstarch
- ◼ ¾ cup sugar
- ◼ 1½ cups boiling water
- ◼ ⅜ teaspoon salt
- ◼ 3 egg whites
- ◼ 3 Tablespoons sugar
- ◼ 1½ teaspoons vanilla
- ◼ ½ teaspoon almond extract
- ◼ 1 pie shell, baked
- ◼ ½ cup whipped cream

Cook first 4 ingredients in double boiler until mixture is thick and clear, about 10 minutes. Beat egg whites with the 3 Tablespoons of sugar until thick and creamy. Pour cornstarch mixture over egg whites. Fold in flavorings and cool. When cool, fill baked pie shell and cover with whipped cream. Top with shaved chocolate or chopped nuts, if desired. Chill for at least 2 hours in the refrigerator.

Jimmie and Jim Powell
Richardson, Texas

Jim Powell grew up and worked in the ranch and farm country west of Fort Worth, Texas in an area where the Chisholm Trail was still visible for many miles, and in so doing, experienced life in the rural West. The community known as "White Settlement" was just that, the first place anyone other than Indians lived outside the old fort named for General Worth. He received his Bachelor's degree from Texas Wesleyan University and did graduate work at Hardin Simmons University in Abilene, Texas. Jim works in oil, pencil, pen and ink, but most enjoys using transparent watercolors to portray the warmth and subtleties of his surroundings. His lifelong interest in camping, hunting and fishing coupled with his constant research and study of Indian cultures and the ways of the West are expressed with true authenticity in his work. He has won numerous awards for his watercolors, is past president of the Southwestern Watercolor Society and is active in the National Association of Artists of the West and the American Artists of the Rockies Association.

Lynn and Joe Thomas
Boulder, Wyoming

Lynn Thomas was raised in rural Nevada of German, English and Indian heritage. She is a self-taught artist and has expressed her artistic talent since childhood. Lynn has become well known for her portrayals of the contemporary working cowboy, historical Western scenes and wildlife. She enjoys working with oils, watercolor and pencil and many awards and honors have come her way. She paints the life she lives and thus adds a fresh and original touch to her depictions of life in the West. Besides being a successful artist, she is also a musician, poet and photographer. She is an avid outdoorsman and ran a pack outfit in Wyoming's Wind River range for many years. Lynn is a member of the Women Artists of the American West.

I Chess Pie

- ■ ½ cup butter
- ■ 1 cup sugar
- ■ 3 eggs
- ■ 1 teaspoon vanilla
- ■ 1 cup walnuts, chopped
- ■ 1 cup raisins
- ■ 1 unbaked pie shell

Cream butter and sugar together. Add eggs and mix well. Stir in next 3 ingredients and pour into unbaked pie shell. Bake at 350 degrees for 40-50 minutes or until knife inserted in center comes out clean.

"My mother placed in a Pillsbury bake-off with this recipe. It's a very old family recipe, is delicious, unusual and *easy*. The currant pie is also quite wonderful."

II Currant Pie

- ■ 3 cups fresh currants
- ■ 1¼-1½ cups sugar
- ■ 3 Tablespoons Tapioca
- ■ ½ teaspoon salt
- ■ pastry for lattice-top pie

Wash and remove stems from currants; crush slightly. Combine next 3 ingredients, mix and add to currants. Pour into pie shell, top with lattice crust, crimp edge high. Bake at 425 degrees for 10 minutes; reduce heat and bake at 350 degrees for 30 more minutes or until mixture is set.

Charmalee and Don Prechtel
Creswell, Oregon

Grasshopper Pie

- 2 cups (24) cream-filled chocolate cookies, crushed
- ¼ cup butter, melted
- ¼ cup milk
- 1 7-ounce jar marshmallow cream
- 6 drops peppermint extract
- 6 drops green food coloring
- 2 cups whipped cream

Crush cookies in blender. Combine cookies and butter and press into 9" pie pan. Chill. Gradually add milk to marshmallow cream, mixing well. Add extract and coloring, then fold in whipped cream. Pour into pie pan and freeze until firm. Variation: Substitute ¼ cup green Creme de Menthe for the extract, coloring and milk.

Beverly and Ray Swanson
Prescott, Arizona

Hershey's Chocolate Pie

- 20 Hydrox cookies, crushed
- ¼ cup butter
- ½ cup milk
- 15 large marshmallows
- 6 1-ounce Hershey bars, plain
- ½ pint chilled whipping cream

Combine cookies and butter and press into 8" pie pan. (Save a few crumbs to sprinkle on top of pie.) Heat next 3 ingredients in double boiler until chocolate is melted. Cool to room temperature. Beat whipping cream in chilled bowl until stiff. Fold in *cooled* chocolate mixture. Spoon into pie shell; refrigerate at least 2 hours. Garnish with cookie crumbs, whipped cream or chopped nuts if so desired.

"This is a rich, delicious pie for chocolate lovers. Small pieces go a *long* way!"

HM

Linda and Gregory I. McHuron
Moose, Wyoming

Pink Lemonade Pie

- 1 graham cracker crust
- 1 6-ounce can frozen pink lemonade concentrate
- 1 can condensed milk
- 8 ounces Cool Whip

Combine lemonade and milk in blender until smooth. Fold into Cool Whip and pour into pie shell. Refrigerate at least 30 minutes.

"A real quickie, this pie is really great and can be put together in no time for those unexpected drop-ins. This recipe is from my mom's kitchen, origin unknown, results known!"

Kay and John Stobart
Potomac, Maryland

Born in England, John Stobart began at an early age to work out his philosophy of the work done by men and ships in deep and shallow waters and went on to study at the Royal Academy of Art. A devoted student of history and things maritime, his own perceptions of water, cloud, sun and wind shines through in his oil paintings. In the years of growing fame and recognition since he came to America, he has become well-known by leading maritime museums and scholars of maritime history. His work is grounded in thorough research and an intimate understanding of the ships, harbor scenes and the way of life of the seafaring people he paints. John's work is a feast for the eyes and the spirit in which all who care for the sea heritage of ships and men, the seas they sailed, and the skies they worked under, may enjoy. Maritime Heritage Prints are the sole publishers of his superb, limited edition prints which receive his close personal supervision and rarely number over 750 prints in each edition.

Rhubarb Pie

- 1½ cups rhubarb, cut in ½" pieces
- ⅞ cup sugar
- 2 Tablespoons flour
- 1 egg
- pastry for 8" 2-crust pie

Cut rhubarb and set aside. Mix flour and sugar, add egg and mix well. Add rhubarb and stir to coat with mixture. Pour into pastry-lined 8" pie pan. Cover with top crust that has slits cut in it. Seal and flute. Sprinkle with sugar, if desired. Cover edge with 2-3" strip of aluminum foil to prevent excessive browning; remove foil during last 15 minutes of baking. Bake at 425 degrees until crust is brown and juice begins to bubble through slits in crust; 40-50 minutes.

"This recipe is rather small in quantity and has a lovely custardy consistency. I got it out of a book when we visited Zambabwe, but I'm sure it's English. We like it served with thin cream."

Kay Riordan
Keystone, South Dakota

Kay Riordan is a well-known supporter and patron of Western art. Her background for many years has been in the Black Hills of South Dakota and she strives to promote her heritage on a continuing basis. This recipe is from her cookbook Historical Cookery of the Black Hills *which was made available by Kay to help produce revenue for museums, cultural and historical projects.*

Shoo-Fly Pie

- ½ Tablespoon baking soda
- ¾ cup boiling water
- 1 egg yolk, well beaten
- ½ cup molasses
- 2 Tablespoons butter
- ¾ cup flour
- ½ teaspoon cinnamon
- ⅛ teaspoon nutmeg
- ⅛ teaspoon cloves
- ⅛ teaspoon ginger
- ½ teaspoon salt
- ½ cup brown sugar
- 1 unbaked pie shell

Dissolve soda in boiling water; add molasses and egg; mix well. Pour mixture into pie shell. Mix remaining ingredients together with fork to make a soft crumb topping and spread on top of pie. Bake at 350 degrees for 30 minutes or until pie is firm.

"This is an old, old recipe going back to the War of 1812. The pioneer women brought this recipe across the prairies and the ranch cooks used it in modified form. The sticky molasses attracted every fly in the neighborhood, and usually a small boy was detailed to "shoo" the flies while the pie was cooling, sometimes with unexpected results!"

Jo Ellen and Gerald A. Bowie
West Point, Georgia

Southern Pecan Pie

- 1 cup brown sugar
- 2 Tablespoons flour
- 1½ Tablespoons butter, softened
- 1 cup light corn syrup
- 3 eggs, beaten
- ¼ teaspoon salt
- 1 teaspoon vanilla
- 1½-2 cups whole pecans
- 1 9" unbaked pie shell

Combine sugar and flour. Cream butter with flour mixture. Add corn syrup and eggs and beat with electric mixer until frothy. Add next 3 ingredients, stir and pour into unbaked pie shell. Bake at 325 degrees for 45 minutes or until firm.

Special Desserts & Candy

Tona and Buckeye Blake
Augusta, Montana

Cheese Blintzes

- 6 eggs
- 2 egg whites
- 2 cups flour
- 2 cups milk
- 1 teaspoon sugar
- 2 packages Farmer's cheese or cream cheese
- 2 Tablespoons sour cream
- 2 egg yolks
- 2 Tablespoons sugar
- 1 lemon rind, grated
- butter
- sour cream
- applesauce

Combine first 5 ingredients and mix well until smooth. Let batter stand in refrigerator for 30 minutes. Mix next 5 ingredients together and set aside. Lightly butter a 6-8" skillet; heat over medium heat until bubbly. Pour scant ¼ cup of the batter into skillet; immediately rotate skillet until thin film covers bottom. Cook until light brown. Run wide spatula around edge to loosen; remove crepes and stack, browned side up, placing waxed paper between each. Keep covered. Spoon about 1½ Tablespoons of the cheese mixture onto browned side of each crepe. Fold sides up over the filling, overlapping edges; roll up. Heat butter in skillet over medium heat until bubbly. Place blintzes seam sides down in skillet. Cook, turning once, until golden brown. Top each with rounded Tablespoon of sour cream and applesauce. Makes 12 crepes (6 servings).

Mary Ellen and James Boren
Clifton, Texas

Cheesecake

Crust

- 1⅔ cups graham cracker crumbs
- 2 Tablespoons sugar
- 1½ teaspoons cinnamon
- 6 Tablespoons butter, melted

Combine all ingredients and press into bottom and sides of 10" pan. Chill in refrigerator. Add:

Filling

- 3 3-ounce packages cream cheese, softened
- 1 teaspoon vanilla
- 3 eggs
- 1 cup sugar

Beat cream cheese thoroughly; gradually add sugar. Add eggs, one at a time, mixing well after each addition. Add vanilla. Stir in vanilla and pour into chilled crust. Bake in 300 degree oven until wooden pick inserted in center comes out clean, about 30 minutes. Remove from heat and spread with topping.

Topping

- 1 pint sour cream
- 3 Tablespoons sugar
- ½ teaspoon vanilla

Whip all 3 ingredients. Spread on baked cheesecake. Return to oven and bake at 500 degrees for 5 minutes. Cool and then chill in refrigerator for several hours. Serve very cold.

"This was given to us by a fellow art student at the Kansas City Art Institute in 1949. We have taken it all over the country and it is still our favorite cheesecake recipe. It is delicious served as is or with any fruit pie filling."

Tara and Lloyd Moore
Ellicott City, Maryland

Tara Moore's genuine love for animals and sincere concern for their welfare come vividly to life through her paintngs. Her colorful canvases are created with brush and palette knife. When she is not painting, she is traveling the globe in search of material. Experiences from her latest expeditions to the Canadian Arctic and to Zambia will be conveyed in a series of books along with her book on Labrador Retriever puppies. Tara is a member of the Society of Animal Artists and has had several highly-successful one-person shows throughout the country.

Cheesecake a la Cocoa

Crust

- 1½ cups graham cracker crumbs
- ⅓ cup brown sugar
- ⅓ cup butter, melted

Combine all ingredients and press firmly against bottom and sides of pie plate.

Filling

- 16 ounces cream cheese, softened
- 1¼ cups sugar
- ⅓ cup Hershey's cocoa
- 1 teaspoon vanilla
- 2 eggs

Blend first 4 ingredients. Add eggs, one at a time, beating well after each addition. Pour mixture into crust and bake at 375 degrees for 35 minutes. Remove and spread immediately with topping.

Topping

- 1 cup sour cream
- 2 Tablespoons sugar
- 1 teaspoon vanilla

Mix all ingredients and spread on hot cheesecake. Refrigerate for several hours or overnight.

Sue and Grant Speed
Lindon, Utah

Cherry Cheesecake

Crust

- 20 single graham crackers, crushed
- 3 Tablespoons sugar
- ¼ teaspoon salt
- ½ teaspoon cinnamon
- ⅓ cup butter, melted

Combine all ingredients and press into an 8" or 9" square glass baking dish and freeze overnight.

Filling

- 2 8-ounce packages cream cheese, softened
- 2 eggs, well beaten
- ¾ cup plus 2 Tablespoons sugar
- 2 teaspoons vanilla
- ¼ teaspoon salt
- 1 teaspoon fresh lemon juice

Combine and cream all ingredients in bowl. Pour into frozen crust and bake at 350 degrees for 18 minutes. Remove and spread with topping.

Topping

- 2 cups sour cream
- 4 Tablespoons sugar
- 2 teaspoons vanilla

Mix all 3 ingredients. Spread on baked cheesecake carefully so as not to break filling. Return to oven for 5 minutes. Cool and then chill for several hours. Serve with warm cherry sauce.

Cherry Sauce

- ¾ cup sugar
- 1 Tablespoon flour
- 1 egg
- 1 can pie cherries with juice
- red food coloring (optional)

Combine all ingredients and cook over medium heat until thick. Serve warm over chilled cheesecake.

"All I can say about this recipe is that it definitely gets us one step closer to the "Fat Farm," but what a way to go!"

**Evalyn Prouty Hickman
and Charles P. Hickman**

Fort Collins, Colorado

Chocolate Cloud # 9

- 10 graham crackers, crushed
- 1 cup butter or margarine, softened
- 2 cups powdered sugar
- 3 eggs
- 3 squares bittersweet chocolate, melted and cooled
- 1½ cups nuts, chopped
- 1 teaspoon vanilla

Grease an 8" square pan. Press half of graham crackers onto bottom. Cream butter and sugar, then beat in eggs, 1 at a time. Add chocolate and mix well. Stir in nuts and vanilla. Pour mixture over crumbs and sprinkle with remaining graham crackers. Chill in refrigerator for 6-8 hours. Serve by cutting into 8 squares and dot with whipped cream and cherries. Makes 8 servings.

"This is absolutely melt-in-the-mouth ambrosia! Very rich. Easy to make and you can make a day or so ahead."

Loretta and Joe Taylor

Cypress, Texas

Chocolate Pots de Creme

- 12 ounces semi-sweet chocolate morsels
- 5 Tablespoons sugar
- ¼ teaspoon salt
- 2 eggs
- 2 teaspoons vanilla
- 2 cups cream
- 4 Tablespoons Kahlua
- 2 Tablespoons Brandy
- whipped cream (optional)
- grated chocolate (optional)

Place first 5 ingredients in blender and blend for 10 seconds. Stop, then blend 10 more seconds. Heat cream to just before boiling (but **not** boiling) and add to chocolate mixture. Blend 10 seconds. Add Kahlua and Brandy and blend for 10 more seconds. Pour into demitasse or pot de creme cups. Chill for several hours. Serve topped with whipped cream and grated chocolate.

Miriam and Bob Wolf
Laporte, Colorado

Cold Lemon Souffle
(with Raspberry or Wine Sauce)

- 1 Tablespoon unflavored gelatin
- ¼ cup cold water
- 5 eggs, separated
- ¾ cup <u>fresh</u> lemon juice
- 2 teaspoons lemon rind, shredded
- 1½ cups sugar
- 1 cup whipping cream

Sprinkle gelatin over cold water to soften. Set aside. Mix egg yolks with lemon juice, rind and ¾ cup of the sugar. Cook in top of double boiler until lemon mixture is slightly thickened, about 8 minutes. Remove from heat and stir in gelatin until dissolved. Chill 30-40 minutes. Beat egg whites until stiff, gradually adding the remaining ¾ cup sugar. Whip cream until stiff. Fold egg whites and whipped cream into the yolk mixture until no white streaks remain. Pour into an attractive 2-quart souffle dish or casserole and chill at least 4 hours. Serve with raspberry or wine sauce. Makes 10 servings.

Raspberry Sauce

- 2 cups raspberries (fresh or frozen)
- ¼ cup sugar
- 3 Tablespoons Grand Marnier

Put all ingredients in blender and blend until smooth. Strain through a sieve, if so desired, and serve well chilled over souffle.

Wine Sauce

- ½ cup sugar
- 3 teaspoons cornstarch
- ½ cup water
- 1 Tablespoon fresh lemon juice
- 1 teaspoon lemon rind, shredded
- 2 Tablespoons butter
- ½ cup medium dry Rose wine (or dry white wine)

Combine sugar and cornstarch in small saucepan. Stir in next 3 ingredients until smooth. Add butter and bring to a boil. Lower heat and cook until thickened. Remove from heat and add wine. Chill, stirring occasionally. (The Rose wine gives the sauce a beautiful color.)

"This was a winner in a local cooking contest. Bob is always telling guests that if they really like what they're having, they had better get the recipe or remember it well because I never cook the same thing twice. While that's not quite true, I do love to experiment and I'm always breaking the rule 'never serve guests something you've never made before.' Cooking really is an art and if you have a good eye, a steady hand, imagination and creativity, you can really have a lot of fun with it! Bon appetit!!"

Tara and Lloyd Moore
Ellicott, Maryland

"UDDERLY IMPOSSIBLE!"

Hot Fudge Sauce

- 2 squares unsweetened chocolate
- 6 Tablespoons water
- ½ cup sugar
- dash of salt
- 3 Tablespoons butter
- ¼ teaspoon vanilla (or ½ teaspoon Brandy)

Place all ingredients in double boiler and melt. Serve hot over homemade or any other kind of ice cream.

"This recipe was handed down to me by my grandmother who was also an artist and a chocolate 'freak.' Naturally, the sauce tastes best on homemade ice cream made from fresh milk from a home-grown cow...!"

Carole and Jim Daly
Eugene, Oregon

Dream Cheesecake

- ¼ cup butter or margarine, melted
- 1 cup graham cracker crumbs
- 1 teaspoon cream of tartar
- 6 eggs, separated
- 3 Tablespoons sugar
- 19 ounces cream cheese, softened
- 1½ cups sugar
- 3 Tablespoons flour
- ½ teaspoon salt
- 1 pint sour cream
- 1 teaspoon vanilla

Have all dairy products at room temperature. Generously butter a 9" springform pan and make a collar out of aluminum foil attached to pan to make sides higher. Mix cracker crumbs and the ¼ cup butter, reserving ¼ cup of mixture. Press remainder in bottom of pan. Combine egg whites and cream of tartar and beat until foamy; gradually add 3 Tablespoons sugar and beat until stiff; set aside. Beat cheese until soft. Combine the 1½ cups sugar, the flour and salt. Gradually beat flour mixture into cheese. Add egg yolks, one at a time, mixing well after each addition. Add sour cream and vanilla; mix well. Fold egg whites into cheese mixture and pour into pan. Sprinkle with reserved crumbs. Bake in preheated oven at 325 degrees for 1¼ hours or until firm. Turn heat off, open oven door and leave cheese cake in oven for 10 minutes. Remove from oven and cool on rack away from drafts. Cake will shrink somewhat as it cools. Remove foil collar and chill.

"This cheesecake is delicious! Light and airy and full of calories! All of our kids love this treat."

Leulla and Tom Heflin
Rockford, Illinois

Lemon Lush

Crust

- 1 cup all-purpose flour
- ½ cup butter, softened
- ½ cup pecans, chopped

Combine ingredients and press into bottom of greased 13"x9"x2" pan. Bake in 350 degree oven about 10 minutes. Cool.

Filling:

- 1 8-ounce package cream cheese, softened
- 1 cup Cool Whip
- 1 cup powdered sugar

Combine and mix well. Spread over cooled crust.

Topping:

- 2 packages Lemon pudding
- 1 cup Cool Whip
- pecans, chopped

Prepare pudding according to package directions. (Do **not** use instant pudding.) Cool pudding completely and spread over cream cheese filling. Spread Cool Whip over pudding and sprinkle with pecans. Refrigerate until serving time. (You may substitute any flavor pudding.)

HM

Jimmie and Jim Powell
Richardson, Texas

Peanut Brittle — Powell Style

- 3 cups sugar
- 1 cup Karo syrup
- ½ cup water
- 3 cups raw Spanish peanuts
- 4 Tablespoons butter
- 1 teaspoon salt
- 2 teaspoons soda

Mix sugar, Karo and water in 3-quart saucepan. Boil until threads spin. Add peanuts and cook until mixture turns a pale golden color, stirring continuously. Remove from heat and add last 3 ingredients, stirring quickly. Pour at once onto well-buttered cookie sheet or pan, spreading about ¼" thick with spatula. Cool; break into pieces.

"You rarely see Jim Powell at an art show without his big white bucket of peanut brittle. He always makes sure that artists and spouses get at least one piece. Needless to say, he is always a welcome sight and has *many* friends!!"

Vivian and Harold I. Hopkinson
Byron, Wyoming

The son of a rancher near historic Fort Bridger, Harold Hopkinson has always loved the Wyoming mountains and prairies, their wildlife and men and captures their essence in his paintings. When World War II came, Harold joined the Navy and decided by the time of his discharge that he wanted to paint as a career. He received his B.A. and Master's degrees from the University of Wyoming, and after several years as a superintendent of schools in Byron, he began his professional painting career in earnest. He has won numerous awards and was featured in the book The Cowboy in RTH. *He and his wife Vivian still live in the quiet little town of Byron, Wyoming where Harold has his studio.*

Mom's Old-Fashioned Fudge

- ¹⁄₃ cup cocoa
- 3 cups sugar
- ¹⁄₈ teaspoon salt
- 1½ cups milk
- ¼ cup butter
- 1 teaspoon vanilla
- 1 cup nuts, chopped

Combine first 3 ingredients in 4-quart saucepan. Gradually stir in milk. Bring to a boil over medium heat, stirring constantly. Continue boiling without stirring until candy thermometer registers 234 degrees or until small amount of mixture dropped into very cold water forms a soft ball that flattens when removed from water. Remove from heat; add butter. Cool without stirring, to 120 degrees (bottom of pan will be lukewarm). Add vanilla; beat continuously with wooden spoon until candy is thick and no longer glossy, 5 to 10 minutes. Quickly stir in nuts. Spread in buttered 9"x5"x3" loaf pan. Cool until firm. Cut into 1" squares. Makes about 32 candies.

"Harold and his sister used to make this fudge when their mom went to town. He works pretty hard at his easel, so sometimes when he is ready for a break, he asks for this fudge. He doesn't have to ask twice, because I like it too!"

Karyn and Ronald M. Herron
Helena, Montana

Peanut Butter Cup Bars

- 1 package (⅓ box) graham crackers, crushed
- 1 cup peanut butter (smooth or chunky)
- 1 cup margarine, melted
- 2-2½ cups powdered sugar
- 1 12-ounce package chocolate chips

Mix first 4 ingredients and press into 7"x10" pan. In double boiler, melt chocolate chips, then spread over cracker mixture. Let stand 5 minutes. Cut into one-inch squares and refrigerate.

"This is an old favorite of my children. It tastes exactly like the peanut butter cups you buy at the store, but is much less expensive."

Betty and Roy Kerswill
Jackson, Wyoming

Pumpkin Squares

Crust

- 1 package yellow pudding cake mix
- ½ cup butter, melted
- 1 egg

Set aside 1 cup of cake mix. (Note: High altitude cooks should add 2 Tablespoons flour to cake mix before reserving cup.) Mix together remaining cake mix, butter and egg and press into greased 7"x13" pan.

Filling

- 1 30-ounce can Libby's prepared pumpkin pie filling
- ⅔ cup evaporated milk
- 2 eggs

Combine filling ingredients, mix well and pour into pan.

Topping

- ¼ cup sugar
- ½ teaspoon cinnamon
- 2 Tablespoons butter
- 1 cup reserved cake mix

Mix topping ingredients together and sprinkle evenly over filling. Bake at 375 degrees for 50 minutes or until firm. Cut into squares. Serve warm with whipped cream.

"The pumpkin 'pie' without the trouble! Delicious!"

HM

Kris Thorpe
Gallery Select
Seattle, Washington

Peanut Butter Mousse

■ **1 cup peanut butter (smooth or chunky)**
■ **1 cup sugar**
■ **8 ounces cream cheese, softened**
■ **2 Tablespoons butter**
■ **1½ cups whipping cream**
■ **1 Tablespoon vanilla**
■ **shaved chocolate**
■ **tart shells or chocolate candy shells (optional)**

Combine and cream first 4 ingredients together until smooth. Whip whipping cream and vanilla together. Fold into peanut butter mixture. Chill until mixture holds its shape when piped. Pipe small amounts into stemmed glasses, tart or chocolate candy shells. Top with shaved chocolate and serve well chilled.

"This dessert was served at the 1981 Stuart Anderson Western Experience Sale and as it turned out, artists, artists' spouses and guests were standing in line for seconds, thirds and yes, fourths of this scrumptious treat!"

Mimi and Ed Jungbluth
Ruidoso, New Mexico

Real Old-Fashioned Fudge

- ■ 2 squares unsweetened chocolate
- ■ ½ cup water
- ■ 2 cups sugar
- ■ 1 cup milk
- ■ ⅛ teaspoon salt
- ■ 1 teaspoon butter
- ■ 1 teaspoon vanilla

Heat chocolate and water in 3-quart saucepan, over medium heat, stirring constantly until chocolate is melted. Add sugar, milk and salt and continue cooking, stirring constantly, until sugar is dissolved. Then, boil, *without stirring*, until candy thermometer reaches 234 degrees (or until small amount of mixture dropped into very cold water forms a soft ball that flattens when removed from water). Remove from heat and cool, without stirring, to 120 degrees (bottom of pan will be lukewarm). Add butter and vanilla; beat continuously with wooden spoon until candy is thick and no longer glossy, about 5-10 minutes (mixture will hold its shape when dropped from spoon). Pour into pre-buttered plate or pan. Cool until firm and watch it disappear!

"Because my 'mother-in-love' is no longer here on earth, I wanted to share her 'secret' recipe with others in an attempt to memorialize her with something that is as special as she was. Mother Jungbluth started making this candy when she was a little girl in Lincoln, Nebraska and continued this family tradition all her life. (Incidentally, the term 'mother-in-love' came from my own dear mother, Nelle Hadley Hobbs . . . because *we* are 'in-love' we gain that new 'mother.' And I did!)"

Murlene and Joe Grandee
Arlington, Texas

Joe Grandee was born in Dallas, Texas and began his illustrious career at the age of ten with art projects at school. From then on it was a long and hard, but steady course to success. After high school, Joe studied at the Aunspaugh School of Art in Dallas and his accuracy in portraying animals and people is credited to Vivian Aunspaugh. It was the accepted pattern in art school to pursue a career in commercial art, but this approach was not for Joe. He decided to hold out for a career in fine art while running a small ranch in east Texas for his parents. He eventually moved back to Dallas and continued to paint, giving many to friends and relatives but doing little about selling them. He then met his wife Murlene who became his greatest admirer, discerning critic and press agent. In the years to follow, they collected an impressive and vast array of Western equipment, clothing and accoutrements which helped greatly in Joe's efforts to depict the old West on canvas as it really was. He also began using live models to capture the true essence of a scene. Although not primarily a portrait painter, he has done some portraiture of famous political figures and movie stars as well as the famous Twenty Mules of Death Valley for the U.S. Borax Company. His talents go beyond painting and the results are his beautiful and accurate bronze sculptures. He has appeared at the White House, on national television and was named the First Official Artist of the State of Texas. He is also the subject of a book entitled The West Still Lives by Joy Schultz.

Snow Ice Cream

- 2 large eggs, beaten well
- 2 Tablespoons vanilla
- 1 large can evaporated milk
- few drops lemon juice (optional)
- 2 cups sugar
- large pan of <u>clean</u> snow

Mix first 5 ingredients in large bowl until sugar is dissolved. Then add snow, a large spoonful at a time, until a thick slush is achieved. (Be sure your snow is fairly free of pollution! Scrape away surface snow from an embankment and dig in!) Have serving bowls chilled and ready (soup bowls are good), along with a hungry husband and a bunch of kids and dogs.

"When? Any ol' snowy day! Some folks like to put the mixture on medium-low heat and cook it into a custard, then cool in refrigerator before adding snow, but the old country way is as above. Good eating!!"

VI MIXED MEDIA
**Pickles
Sauces & Batters
Potpourri**

Pickles

Vaughn and Keith Christie
Browns Valley, California

Margaret and Joe Halko
Cascade, Montana

Crunchy Fresh-Pack Dill Pickles

- ■ 20-25 pickling cucumbers (4" in diameter)
- ■ 2 gallons water
- ■ 1½ cups pickling salt

Soak cucumbers in salt water overnight. Rinse.

Alum Mixture
(per quart)

- ■ ⅛ teaspoon alum
- ■ 1 clove garlic
- ■ 2 fresh dill weeds (or seeds)
- ■ 1 red chili pepper
- ■ 1 grape leaf

Place first 4 ingredients of alum mixture in each of 6 hot quart jars. Pack cucumbers in jars, leaving ½" headspace. Top each with grape leaf.

Canning Brine

- ■ 3 quarts water
- ■ 1 quart cider vinegar (5-6% acidity)
- ■ 1 cup pickling or non-iodized salt

Combine brine ingredients; bring to a boil. Cover jars with boiling brine, leaving ½" headspace. Wipe rims of jars. Seal and process in boiling water bath for 10 minutes. Makes about 6 quarts of pickles.

Zucchini Pickles

- ■ 4 quarts zucchini, sliced
- ■ 1½ gallons water
- ■ 1 cup pickling or non-iodized salt
- ■ 6 white onions, sliced
- ■ 2 green peppers, sliced
- ■ 5 cups sugar
- ■ 1½ teaspoons celery seed
- ■ 3 cups vinegar
- ■ 2 teaspoons mustard seed
- ■ 1½ teaspoons tumeric

Soak cucumbers in salt water overnight. Add onions and peppers to zucchini and soak for 1 more hour. Drain. Combine remaining ingredients in large kettle and bring to boil. Add zucchini, onions and peppers and boil for 1 minute. Pour mixture into hot quart jars, leaving ½" headspace. Seal.

"This recipe came into use the year the zucchini grew out of our ears! Zucchini is a never-fail crop and this is a never-fail recipe!"

Sauces & Batter

HM

Bobbie and Harry Brunk
Whitney, Nebraska

Brunk's Spaghetti Sauce

- 1 pound lean ground beef
- ½ cup onion, chopped
- ½ cup green pepper, chopped
- 1 small can tomato sauce
- 1 small can tomato paste
- ½ cup catsup
- ½ cup hot water
- 1 teaspoon oregano
- 1 teaspoon garlic salt
- salt and pepper to taste

Brown beef with onions and green peppers. Drain. Add rest of ingredients, cover and simmer for 20 minutes. Serve over cooked spaghetti. Makes 4 to 6 servings.

Brenda and Don Gray
Union, Oregon

Don Gray, his wife Brenda and their three children live near his birthplace in northeast Oregon's Grande Ronde Valley. After graduation from Eastern Oregon State College, Don taught high school art classes for a short time before embarking on a successful fine art career in 1971. His paintings have been exhibited at museums and galleries throughout the Western states and he has a one-man show at the Oregon State Capitol hosted by the goveror. His work has been featured in Southwest Art and Art West magazines. In 1978, a lifelong interest in Western art brought Don together with writer Rick Steber and photographer Jerry Gildemeister to produce their own book entitled Rendezvous, stories about Oregon's past. Their latest book, Traces, is a tribute to the last surviving pioneers who traveled the Oregon Trail.

Don's Favorite Spaghetti Sauce

- 1 onion, chopped
- 1 green pepper, chopped
- 2 cloves garlic, minced
- 1½ Tablespoons olive oil
- 1½ pounds lean ground beef
- 1 small can mushrooms
- 1 28-ounce can tomatoes, cut up
- 1 10¾-ounce can tomato puree
- 1 12-ounce can tomato paste
- 1 15-ounce can tomato-herb sauce
- 1 cup water
- ½ cup red wine
- 1 beef bouillon cube
- 2 Tablespoons parsley, chopped
- ½ teaspoon oregano
- ½ teaspoon thyme
- 2 bay leaves

In large skillet, saute first 3 ingredients in olive oil. Add ground beef and brown. Drain. Transfer beef mixture to large kettle and add remaining ingredients. Cover and simmer for 3 hours, stirring occasionally. Remove bay leaves.

"I'm not bad at boiling hot dogs, and I can whip up a mean Rice-A-Roni when the occasion calls for it, but other than that I don't hold a candle to Brenda! Her spaghetti sauce has my hot dogs beat any day of the week!"

Susan Hallsten McGarry
Southwest Art Magazine
Houston, Texas

Southwest Art Magazine was established in 1971 to serve the arts community west of the Mississippi River. The basis for the magazine was to communicate between art galleries, artists and the art public. Biographical and historical, the magazine features artists in articles designed to best feature their artwork. As the magazine grew in scope and size it has reached people around the world and is read by more than half a million passengers on eight different airlines. It has become a success 'story' for artists and a collector's guide to quality art. Susan Hallsten McGarry was previously a free lance writer and arts critic and joined Southwest Art as its editor in 1979.

HM

Easy-Best Spaghetti Sauce

- 2 Tablespoons olive oil
- 1 large onion, chopped
- 5 cloves garlic, minced (or to taste)
- 1 pound mushrooms, cut in halves
- 1 large can Italian plum tomatoes, cut up
- 1 large can tomato paste
- 2 Tablespoons brown sugar
- 2-3 teaspoons garlic salt (or salt)
- ½ teaspoon Worcestershire sauce
- 1 Tablespoon (or more) Italian seasoning
- ⅓ cup parsley, minced
- ½ cup Chianti wine

Heat olive oil in large dutch oven and saute next 3 ingredients until transparent. Add remaining ingredients and simmer for 1-1½ hours. If sauce gets too thick, thin with additional wine.

"Every once in a while, I get a *craving* for spaghetti! I've tried many different recipes, but this one, which I have concocted over the years, is my favorite and seems to appeal to almost everyone. The sauce is excellent as is, but you can also add meat or simmer meatballs or Italian sausage in it. It freezes well and ages beautifully. It also makes great 'Italian omelets.' "

Sherryl and Vince Evans
Ritzville, Washington

Evan's Special Tomato Sauce

- 2 pounds lean ground beef
- 1 large onion, diced
- ½ cup brown sugar
- 1 teaspoon parsley flakes
- ¼ teaspoon black pepper
- ½ teaspoon salt
- dash garlic salt
- dash oregano
- 2 teaspoons Worcestershire sauce
- 10 drops Tabasco sauce
- 1 2½-ounce jar mushrooms, sliced
- 2 15-ounce cans Hunt's special tomato sauce
- 1 15-ounce can water
- 1 12-ounce can tomato paste

In large electric skillet,* brown beef and onions at 325 degrees. Add next 8 ingredients and cook for 2 minutes. Add remaining ingredients and mix thoroughly. Reduce heat to 225 degrees for 30-45 minutes. Serve over spaghetti or use with your favorite lasagna recipe. lasagna recipe.

*Can also cook on stove over medium heat in frying pan, then reduce heat to low and simmer.

Sue and Grant Speed
Lindon, Utah

All-Purpose Green Chili Sauce

- 1 pound lean ground beef
- 1 clove garlic, minced
- ½ onion, minced
- salt and pepper to taste
- ½ teaspoon cumin (comino), freshly ground
- ½ bottle green chili taco sauce
- 1 can refried beans
- 1 small can jalapeno bean dip
- 2 cups Cheddar cheese, grated

HM

Combine beef, garlic, onion, seasonings and brown in skillet. Drain. Add rest of ingredients and simmer for about 30 minutes, stirring frequently to avoid sticking to pan. Serve as a bean dip, or with fresh, hot flour tortillas as a main meal, or as a taco filling. This is a very versatile recipe.

"We first tried this as a dip at a New Year's Eve party in 1972. We liked it so much we have served it every year since then at our annual Christmas party. I added the refried beans to the recipe. It's tasty; enjoy!"

Lila and Jack Putnam
Franktown, Colorado

Crisp Batter for Shrimp or Fish

- 1 cup flour
- ½ teaspoon sugar
- ½ teaspoon salt
- 1 egg
- 1 cup ice water
- 2 Tablespoons vegetable oil

Beat batter ingredients in bowl with hand beater until smooth. Deep fry batter-dipped foods in 2-3 inches of oil at 375 degrees.

Potpourri

HM

Miriam and Bob Wolf
Laporte, Colorado

Brandied Cranberries

- **1 pound fresh or frozen cranberries**
- **2 cups sugar**
- **½ cup water**
- **½ cup Brandy or Rum**

Spread cranberries in single layer in 13"x9"x2" pan. Combine sugar and water and pour mixture over cranberries. Cover tightly and bake at 300 degrees for 1 hour. Cool slightly. Add Brandy or Rum. Do not refrigerate. Serve at room temperature.

"This is one of the many wonderful recipes passed on to me by my dear friend Ruth Clarke. It is especially good at holiday time with traditional turkey or ham. It also makes a wonderful and unusual topping for vanilla ice cream!"

Homemade Mincemeat

- 2 cups lean beef (venison, elk or buffalo), chopped
- 4 cups tart apples, finely chopped
- 2 cups raisins
- 2 cups currants
- 1 cup citron, chopped
- 1 cup suet, chopped
- 2 cups brown sugar
- 1 10-ounce jar currant jelly
- 1 cup plum juice (preferably wild)
- 1 cup chokecherry juice
- 1 cup coffee
- 3 Tablespoons meat extract
- 2 cups beef broth
- 1 Tablesoon cinnamon
- 1 Tablespoon cloves
- 1 Tablespoon nutmeg
- 1 teaspoon salt

Carol and Earl Cox
Lakewood, Colorado

Carol Cox was born and raised near the Black Hills of South Dakota on a ranch that was homesteaded by her grandparents in the 1880s. Carol has been painting the Western scene for about 15 years and is particularly noted for her wildlife paintings and portraits of women in Western history. She participates in several Western art shows and auctions and her work has been featured on greeting cards produced by Leanin' Tree Publishing Company. She is a member of the Women Artists of the American West.

If meat is not ground, put through grinder, then cook until tender. Add all other ingredients and simmer for 6 to 8 hours, adding water or juice as needed. Use what you need and freeze remainder. This makes a very delectable but rich filling for pies. Also good as tarts and in cookies.

"This recipe has been handed down through three generations of my family. It came from the kitchen of an early settler along the banks of the Belle Fourche River in South Dakota. Those pioneers had a dugout house in the river bank when they first settled there in 1887 next to my grandfather's homestead. The lady of the house gave it to my grandmother and we have made it ever since. It is still the best I have ever tasted."

Pamela and Glen S. Hopkinson
Cody, Wyoming

On-Location Granola

- 3 cups rolled oats (or combination of rolled oats, wheat and rye flakes)
- ½ cup unprocessed wheat bran
- 1 cup toasted wheat germ
- ½ cup soy flour
- ½ cup non-instant nonfat dry milk
- ¼ teaspoon salt
- ½ cup unhulled sesame seeds
- ½ cup unsalted cashews, almonds or peanuts
- ½ cup unsalted sunflower seeds
- ½ cup unsweetened shredded coconut
- ½ cup corn oil
- ½ cup honey
- 3 Tablespoons brown sugar (optional)
- 1 teaspoon vanilla
- ½ cup dried fruit, finely chopped (apples, prunes, peaches, etc.)
- ½ cup raisins

Combine first 10 ingredients in a very large mixing bowl. Combine oil, honey and brown sugar in small bowl and mix well. Pour over dry ingredients and fold until well coated. Spread in pan and bake in preheated 250 degree oven for about 1 hour, or until light brown in color, stirring occasionally. Remove from oven and immediately fold in dried fruit and raisins. Cool and store in airtight container. Makes about 7½ cups or 15 ½-cup servings (9.4 grams of protein per serving).

"Unlike many granolas, this one is high in complete protein. It's great on top of desserts, in cookies and as munchies."

Robert E. and Joni Falk

Phoenix, Arizona

Bob Falk was born in Chicago, Illinois and received his formal art education at the Chicago Art Institute and the Institute of Design. He came by his artistic abilities naturally and by the age of 13 had painted his first mural. He has received numerous awards for his drawings and is a member of the Arizona Artist's Guild and the Scottsdale Artist's League and recently completed a 5-year commission, designing calendars for a Minnesota firm. Bob's art has its humorous side at times, and he has created over 70 drawings depicting outhouses which are available in print and will be featured in an upcoming book. He and his artist wife Joni live in Phoenix, Arizona and have their studios in Scottsdale.

THIS IS WHERE ALL THE ARTISTS HANGOUT —

Special Turkey Dressing

- 2 cups celery
- 1½ medium onions, chopped
- 1 pound bulk pork sausage
- 1 Tablespoon margarine
- 1½ loaves semi-dry bread, torn into small pieces
- 2 cups milk
- 2 cups water
- 1½ Tablespoons poultry seasoning
- 1 Tablespoon salt

Saute first 3 ingredients in margarine. Combine bread, milk and water, then add sausage mixture and seasonings. Thoroughly blend all ingredients with hands, squeezing mixture through fingers so that bread is completely saturated. This is enough stuffing to fill a 10-pound turkey with some left over. Put excess in casserole or foil and bake along with turkey.

"This is a different and tasty dressing that is delicious. My mom has made it for us every Thanksgiving which makes it even more special to me."

Charlen and E. Leroy Jeffery

Anchorage, Alaska

Scalloped Pineapple Casserole

- ½ cup unsalted butter, softened
- ¾ cup sugar
- 4 eggs
- 1 20-ounce can crushed pineapple, drained
- ½-1½ teaspoons fresh lemon juice
- ¼ teaspoon nutmeg
- 3 cups white bread cubes, firmly packed (about 5 slices)

Cream butter and sugar in large bowl until smooth. Add eggs, one at a time, beating well after each addition. Gently stir in pineapple, then blend in lemon juice and nutmeg. Fold in bread cubes and spoon into buttered 1½-quart baking dish. Bake in preheated 350 degree oven 50 minutes or until top is light golden brown. Very good served with ham or pork chops, as a side dish, or as a dessert.

HM

Miriam and Bob Wolf

Laporte, Colorado

Survival Bars

- 1½ cups honey
- 1½ cups protein powder
- 1 cup non-instant, nonfat dry milk
- 1 cup wheat germ
- 1 cup quick-cooking oats
- 1 cup sesame seeds
- 1 cup sunflower seeds
- 1 cup smooth peanut butter
- 3 cups dried fruit, chopped
- 1 cup raisins

Boil honey to hard boil stage, 250 degrees on candy thermometer. Combine next 6 ingredients in large bowl; mix well. Mix slightly cooled honey and peanut butter together and add to dry ingredients. Add dried fruit and mix well with hands. Mold into 3-inch bars and bake at 275-300 degrees for 10-12 minutes. Do not overbake or bars will be crumbly. (Note: Any dried fruit is good. You may also pat mixture into 13"x9"x2" pan sprayed with Pam and bake as directed. Cool and cut into bars.) Helpful hint: I use kitchen scissors to cut fruit; much easier than chopping.

Doug Marcy

Estes Park, Colorado

A Special Recipe for All Starving Artists Everywhere

"On the great road of life the path marked 'Fine Arts' is chosen with reservations, for it is not an easy course to follow. The way is poorly marked and fraught with unseen dangers. In some way or another every artist must 'pay his dues' and the term 'starving artist' often becomes more than just a phrase. This recipe is for all 'starving artists.' It is very traditional and dates far back in history. Each generation has added new twists in the preparation, but the basic ingredients remain the same":

- ■ **1 Creative Person (preferably young in spirit and energy)**
- ■ **1 Large Imagination (an endless supply is nice and usually produces the best results)**
- ■ **1 Handful of Dreams (used as incentive and filler)**
- ■ **Talent (any amount will suffice as it will increase with time and effort)**
- ■ **Tools of chosen medium (you can never have enough!)**
- ■ **Perseverance (the secret ingredient)**

Combine a person with exciting dreams in a consistency of challenge, success, money and recognition and allow to stew until nearly boiling over. Quickly add imagination and let simmer for a short time. Then place in pre-arranged environment conducive to creative endeavors and provide with tools of chosen medium. Garnish with any special talent and allow to rise.

"At this point you are well on the way to having an artist of at least modest success. To make a *starving* artist, simply add debt up to the neck, poor promotion up to the elbows and 'How long did it take?' up to the ears. Stir in a little public non-understanding, poorly run art shows and self-centered profiteers. Allow artist to struggle without help for several years and cool. Note: Overcooling at this point will produce half-baked 'real' job seekers. A properly developed and seasoned starving artist requires that certain special touch provided by the secret ingredient.

"To feed your starving artist, simply add faith, love, encouragement and an occasional 'ooh' and 'ah.' The end results are guaranteed to be satisfying and profitable every time!"

LASTING IMPRESSIONS

We thank all of the artists, their spouses, art organizations and sponsors who contributed so much to this book.

INDEX

293